THE LIBRARY OF GREAT PAINTERS

MATISSE

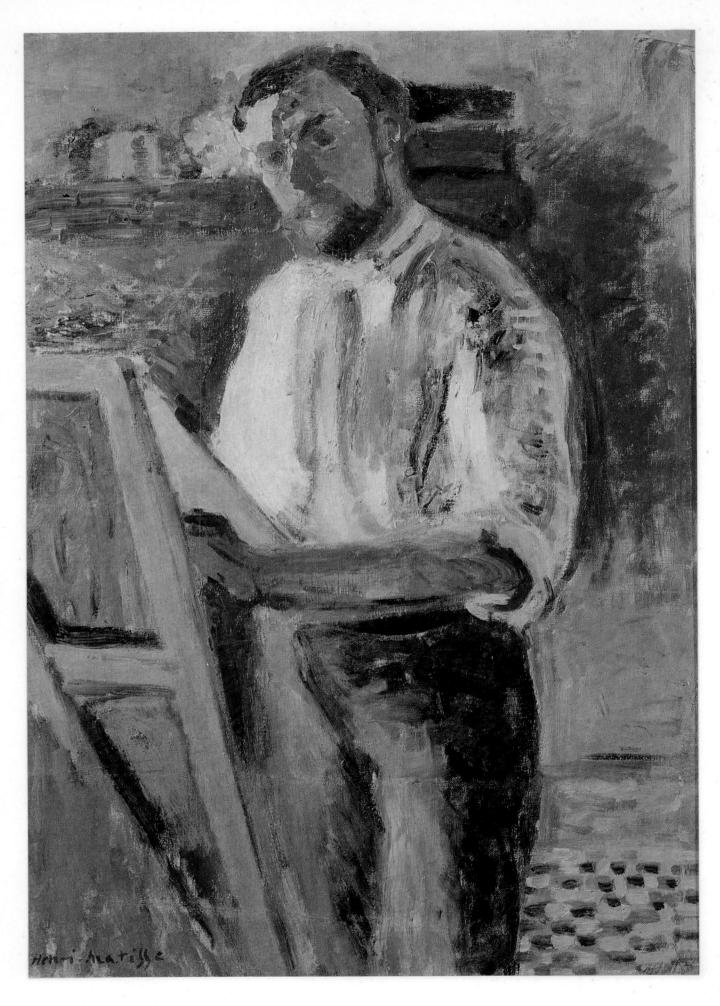

LIFT PICTURE FOR TITLE AND COMMENTARY

HENRI

MATISSE

 $T E X T B \Upsilon$

JOHN JACOBUS

Professor of Art, Dartmouth College

THE LIBRARY OF GREAT PAINTERS

HARRY N. ABRAMS, INC., Publishers, NEW YORK

In Memory of MILTON S. Fox

MARGARET L. KAPLAN, Editor

Standard Book Number: 8109–0277–X
Library of Congress Catalogue Card Number: 72-6633
All rights reserved. No part of the contents of this book may be reproduced without the written permission of the publishers
HARRY N. ABRAMS, INCORPORATED, NEW YORK
Picture reproduction rights
reserved by S.P.A.D.E.M., Paris

Printed and bound in Japan

CONTENTS

PREFACE AND ACKNOWLEDGMENTS 7

HENRI MATISSE 11

SCULPTURE 53

DRAWINGS 61

GRAPHICS AND BOOK ILLUSTRATION 75

BIOGRAPHICAL OUTLINE 83

COLORPLATES

- 1 SELF-PORTRAIT Private collection, Paris Frontispiece
- 2 WOMAN READING (LA LISEUSE) Musée National d'Art Moderne, Paris 89
- 3 NUDE IN THE STUDIO (NU DANS L'ATELIER) Bridgestone Museum, Tokyo 91
- 4 THE INVALID (LA MALADE) Baltimore Museum of Art. Cone Collection 93
- 5 MALE MODEL (L'HOMME NU, LE SERF) Collection Mr. and Mrs. Pierre Matisse, New York City 95
- 6 NOTRE-DAME Tate Gallery, London 97
- 7 NOTRE-DAME IN THE LATE AFTERNOON Albright-Knox Art Gallery, Buffalo, N.Y. Gift of Seymour H. Knox 99
- 8 THE PATH IN THE BOIS DE BOULOGNE (SENTIER, BOIS DE BOULOGNE)

 Pushkin Museum, Moscow 101
- 9 THE ATTIC STUDIO (STUDIO UNDER THE EAVES, L'ATELIER SOUS LES TOITS)

 Fitzwilliam Museum, Cambridge, England 103
- 10 CARMELINA Museum of Fine Arts, Boston. Tompkins Collection, Arthur Gordon Tompkins Residuary Fund 105
- 11 LUXE, CALME ET VOLUPTÉ Private collection, Paris 107
- 12 THE GREEN STRIPE (MADAME MATISSE, PORTRAIT À LA RAIE VERTE)

 The Royal Museum of Fine Arts, Copenhagen. J. Rump Collection 109
- OPEN WINDOW, COLLIOURE (LA FENÊTRE, FENÊTRE OUVERTE)

 Collection Mr. and Mrs. John Hay Whitney, New York City 111
- 14 SKETCH FOR JOY OF LIFE (JOIE DE VIVRE) Private collection, San Francisco 113
- 15 STANDING NUDE (NU DEBOUT) Tate Gallery, London 115
- 16 LE LUXE I Musée National d'Art Moderne, Paris 117
- 17 LANDSCAPE WITH BROOK (BROOK WITH ALOES) Private collection, U.S.A. 119
- 18 HARMONY IN RED (LA DESSERTE ROUGE, HARMONIE ROUGE)

 The Hermitage, Leningrad 121

- 19 DANCE The Hermitage, Leningrad 123
- 20 MUSIC The Hermitage, Leningrad 125
- 21 RED STUDIO (L'ATELIER ROUGE, LE PANNEAU ROUGE) Museum of Modern Art, New York City. Mrs. Simon Guggenheim Fund 127
- PINK STUDIO (THE PAINTER'S STUDIO, L'ATELIER ROSE) Pushkin Museum, Moscow 129
- 23 THE PAINTER'S FAMILY The Hermitage, Leningrad 131
- 24 STILL LIFE WITH AUBERGINES Musée de Peinture et de Sculpture, Grenoble 133
- 25 MOROCCAN GARDEN (PERVENCHES) Florene M. Schoenborn-Samuel A. Marx Collection, New York City 135
- 26 ZORAH ON THE TERRACE (SUR LA TERRASSE) Pushkin Museum, Moscow 137
- 27 ENTRANCE TO THE KASBAH (LA PORTE DE LA KASBAH) Pushkin Museum, Moscow 139
- 28 MADAME MATISSE The Hermitage, Leningrad 141
- 29 COMPOSITION: THE YELLOW CURTAIN Collection Marcel Mabille, Brussels 143
- 30 GOLDFISH Florene M. Schoenborn-Samuel A. Marx Collection, New York City 145
- 31 BATHERS BY THE RIVER Art Institute of Chicago 147
- 32 THE MOROCCANS Museum of Modern Art, New York City. Gift of Mr. and Mrs. Samuel A. Marx 149
- 33 THE PIANO LESSON Museum of Modern Art, New York City. Mrs. Simon Guggenheim Fund 151
- 34 SUNLIGHT IN THE FOREST (COUP DE SOLEIL)

 Collection M. and Mme Georges Duthuit, Paris 153
- 35 THE PAINTER AND HIS MODEL Musée National d'Art Moderne, Paris 155
- 36 THE ARTIST AND HIS MODEL Collection Dr. and Mrs. Harry Bakwin, New York City 157
- 37 INTERIOR AT NICE (GRAND INTÉRIEUR, NICE) Art Institute of Chicago. Gift of Mrs. Gilbert W. Chapman 159
- 38 STILL LIFE WITH APPLES ON PINK CLOTH The National Gallery of Art, Washington, D.C. Chester Dale Collection 161
- 39 INTERIOR WITH PHONOGRAPH (INTERIOR AT NICE, INTERIOR WITH MIRROR)

 Collection Mrs. Albert D. Lasker, New York City 163
- 40 DECORATIVE FIGURE (FIGURE DÉCORATIF SUR FOND ORNAMENTAL)

 Musée National d'Art Moderne, Paris 165
- 41 YELLOW ODALISQUE National Gallery of Canada, Ottawa 167
- WOMAN WITH A VEIL (PORTRAIT OF MLLE H.D.) Collection Mr. and Mrs. William S. Paley, New York City 169
- 43 STUDIES FOR DANCE I Musée Matisse, Nice-Cimiez 171
- 44 WINDOW IN TAHITI (PAPEETE, VUE DE LA FENÊTRE) Musée Matisse, Nice-Cimiez 173
- 45 MUSIC Albright-Knox Art Gallery, Buffalo, N.Y. 175
- 46 DOMINICAN CHAPEL OF THE ROSARY, VENCE 177
- 47 THE SORROWS OF THE KING Musée National d'Art Moderne, Paris 179
- 48 THE SNAIL (L'ESCARGOT) Tate Gallery, London 181

PREFACE AND ACKNOWLEDGMENTS

Although the subject of innumerable books and articles, the art of Henri Matisse remains incompletely known, even to students and specialists. The reason is simple: the extraordinary profuseness and richness of his total oeuvre in various mediums. The present work, general in scope, seeks to characterize the artist chiefly through his largescale figure compositions and interior studies. My contention is that Matisse was one of the few radical painters of the early twentieth century who consistently and successfully executed paintings on a large scale, in the tradition of the Grand Manner. Consequently, the more intimate side of his art, as seen in still life, landscape, and portrait, will be relatively slighted, though not overlooked. Works other than painting (sculpture, drawing, and graphics) are treated in separate sections, since this study appears in a series concerned with painting. Matisse's remarkable efforts in these areas nonetheless demand consideration alongside the paintings. Much research and analysis remains to be done, and it is possible that forgotten or overlooked works will appear. Exact dating of Matisse's work is still in the process of refinement. The present work generally follows certain new dates recently proposed by Mme Marguerite Duthuit, the painter's daughter, and incorporated in the catalogue of the Centennial Exhibition, Paris, 1970.

I am indebted to Fritz H. Landshoff for providing the opportunity to write this book; to Milton S. Fox for constant encouragement. Many questions have been kindly answered by Mme Duthuit and by Mr. Alfred H. Barr, Jr. My work has been aided by the staffs of innumerable museums and by private collectors. In particular, the directors and curators of the Pushkin Museum, Moscow, and the Hermitage, Leningrad, must be singled out for their generous cooperation over a period of several years. Moreover, my work has been stimulated by the conversation and criticism of many friends, notably Robert Rosenblum, Albert Elsen, William Bailey, Leland Bell, Moira Roth, Carol Duncan, and Franklin Robinson. Thomas Hess and Dorothy Seiberling helped with the location of photographs. However, the most indispensable aid was provided by Barbara Adler Lyons, whose unstinting efforts in seeking out illustrations and information made the book possible in the first place. The final typescript was prepared by Michael and Elizabeth O'Donnell, and the text sympathetically edited by Margaret Kaplan. Dirk J.V.O. Luykx was responsible for the sensitive arrangement of words and pictures.

MATISSE

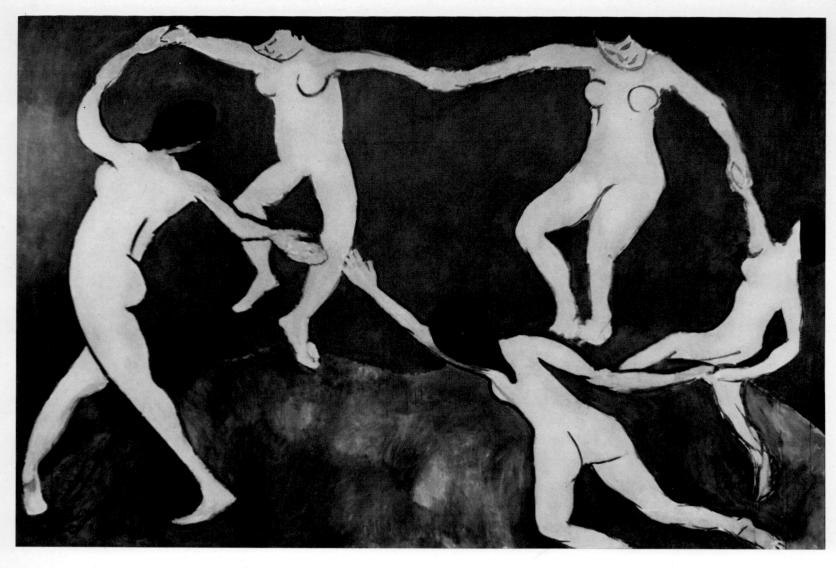

1. DANCE. 1909. Oil on canvas, 8' 6 5/8" × 12' 9 5/8". Museum of Modern Art, New York City. Gift of Governor Nelson A. Rockefeller in honor of Alfred H. Barr, Jr.

Henri-Matise

The world that Henri Matisse left behind at his death on November 3, 1954, was vastly changed from that which had initially sustained his talent in the Paris of the 1890s. At the time the undisputed art capital of the Western world, that city of the Belle Époque would surely strike us today as parochial if not provincial. The Parisian art world was still, on the eve of the twentieth century, inward-oriented, self-contained, and largely unconcerned with events elsewhere. There existed numerous coteries, ranging from traditional to radical, that claimed their various supporters. For at least a century Paris had been an international magnet, a focus drawing artists from all over the world, and it was, in fact, destined to play that unique role for another quarter century. Center of a strict and hierarchic academic establishment, the Paris of the nineteenth century had nonetheless nourished a rapid succession of revolutionary movements in the visual arts, and, in 1900, some of its finest moments had yet to be acted out. It was this milieu that Matisse, born in a small town in the north of France on the last day of the old year, 1869, entered when he came to Paris as an aspiring art student in the autumn of 1891, in his twenty-second year. He was a late starter, having previously begun a career

in law, which he had studied in Paris in 1887–88. At first without knowledge of the new tendencies in painting, he sought, though with reluctance, to become a student of Adolphe Bouguereau, one of the lionized academic luminaries of the day—only to find himself denied official acceptance to the École des Beaux-Arts. Discovered by a less hidebound master, the gentle Gustave Moreau, he was invited to join that painter's atelier in 1892. Over the next decade and more, Matisse would very gradually discover the new movements in French painting, progressing steadily but with great deliberation, selecting, rejecting, and then returning to various new tendencies as he sought to find himself as a painter.

Throughout his long career, Matisse's art was nourished and replenished by a variety of nineteenth-century movements: Neoclassicism, Realism, Impressionism, and Post-Impressionism, though not necessarily in that order. As a whole, Matisse's style is inconceivable and inexplicable without this tradition, and yet he developed into one of the most inventive of twentieth-century masters, one of the few painters of the first half of the century who continue to have a major influence on the younger paint-

ers of today. Matisse's artistic roots were pronouncedly Parisiah, and yet his late works thoroughly transcended this stylistic locale. They became a major influence on the international art culture of the later twentieth century to a degree that is not remotely equaled by some of the other masters of the School of Paris: painters as different as Braque and Bonnard, who, like Matisse, were also concerned with the sensuous transformation into pigment of an optically perceived reality, no matter how different their individual stylistic affiliations might be.

In this respect, Matisse's art moves beyond the restricted ambiance of such close personal friends as the painters Marquet, Camoin, and Bonnard, men whose art was primarily directed toward the winding up and completion of a particular vision inherited from the past. In the larger sense, Matisse's career instead must be seen as parallel to the quests of those like his non-Parisian contemporaries, notably Kandinsky and Mondrian. Both of these artists had started at roughly the same point in time and style, although in different national traditions. More swiftly than Matisse, they transcended the materialistic realism of the late nineteenth century, and, in a political sense, went further into the worlds of abstract and nonobjective painting. With Matisse, the struggle to transcend the world of visual perception was much more time-consuming, painstaking, and even poignant. He remained to his last days committed to the pictorial transformation of the world of appearances, creating works that were untroubled with systematic metaphysical speculation, works that yet remain pregnant with the germ of a new spirit, works that still serve as a key foundation for the new abstraction and even the new realism of the later twentieth century.

Matisse's nominal historical position was as leader of the Fauves, just as Picasso and, to an extent, Braque would be considered the leaders of the Cubists. However, Fauvism was a fragile, short-lived movement, one which never possessed a formulated program, not even after the fact. Of all the Fauves, it was only Matisse who went on to still greater achievements in the direction of intense though simplified color harmonies and refined draftsmanship. His contacts with Albert Marquet, beginning as early as 1892; with André Derain, in 1899; and subsequently with the other painters who were grouped together in the "cage of wild beasts" at the 1905 Autumn Salon-Maurice Vlaminck, Georges Rouault, and others -certainly served to reinforce Matisse's own commitment to bold color effects. However, the group seems to have coalesced more through the coincidences of several personal tastes than out of the development of a common program for a new painting. Probably Matisse gained as much if not more from his study of Old Masters in the Louvre, from his preoccupations with Cézanne, Gauguin, and other recent masters, and his personal encounters with such older painters as Pissarro, Signac, and Cross. If Fauvism had not existed as a movement around 1905, it probably would have made very little difference in the overall development of Matisse's art. Sadly, most of his Fauve associates have been gradually eclipsed in reputation over the years, largely because they failed to sustain much of their initial promise. Some, it is true, were hardly more than belated Impressionists, but others, like Derain, were painters of considerable talent and intelligence who, in later career, were tempted into a traditionalism that lacked the mark of individuality and adventure found in the work of Matisse.

Matisse's nominal rival through most of his career was

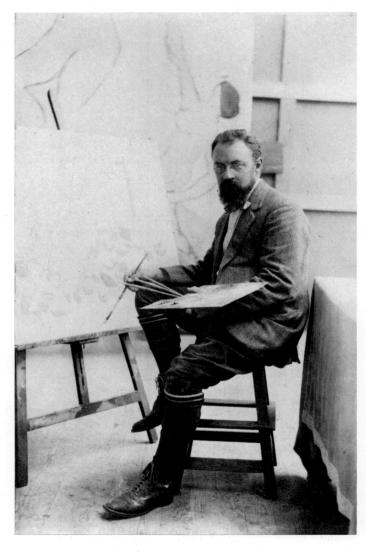

2. Matisse in his studio, c. 1909-10

3. Study for GIRL IN GREEN. 1921. Pencil, 12 × 9 1/2" (sight). Collection Mr. and Mrs. Ralph F. Colin, New York City

Picasso. Significantly, the two artists preserved a cautious friendship, together with a profound respect for each other's works, for a half century. They even exhibited together in 1945, and at an early date their works were avidly collected by the same people: Gertrude Stein and her relatives, their friends the Misses Cone, Dr. Albert C. Barnes, and the two Muscovites Sergei Shchukin and Ivan Morosov. It is, however, interesting to reflect that while Matisse's final works foreshadow art movements that were yet to be born at the moment of his death in 1954, Picasso at that juncture was paradoxically embarking on a long retrospective dialogue with the past, commencing a reflective study of specific works by Delacroix, Velázquez, Manet, and others, a sustained project that also embraced themes from his earlier work. The multiple and often contradictory trajectories of these two long careers frequently intersect, and we can even detect exchanges of admiration in certain pictures, where one of them develops and reinterprets a theme previously explored by the other. However, their points of departure and of culmination were curiously alien, even though they shared, each in his own way, certain serious interests: the interpretation of the human face and figure, the specific environmental quality of the artist's studio, and, in some of their more ambitious compositions, deeply personal

4. GIRL IN GREEN. 1921. Oil on canvas, 25 $1/2 \times 21$ 1/2''. Collection Mr. and Mrs. Ralph F. Colin, New York City

attitudes concerning the human condition, either as it exists or as it ought ideally to exist.

More than that of any other twentieth-century painter, Matisse's total oeuvre, seen in its gradual unfolding, appears as a logical continuation of earlier quests: specifically, those that reach back to Poussin, Chardin, Watteau, Courbet, Manet, and Cézanne. The emphasis here is upon "continuation." He consulted these masters frequently, but they were not so much objects of passive meditation as springboards for his own restless, ongoing search for a style that was uniquely his, one which never remained static but was always growing and maturing, deviating but never changing essential direction from beginning to end, even as it approached abstraction. Moreover, his growth appears more inwardly consistent than that of Picasso, who alone among his contemporaries would be able to outdistance him in the richness of stylistic variation. Unlike the more mercurial Picasso, Matisse as a young artist studied the great masters with painstaking care, postponing his nominal "graduation" from student ranks. Hence, in later career he had less need of extensive renewal from the past; indeed, he was able to turn to traditional styles in his later years with less selfconsciousness, with results that were constructive rather than disruptive to his inner growth.

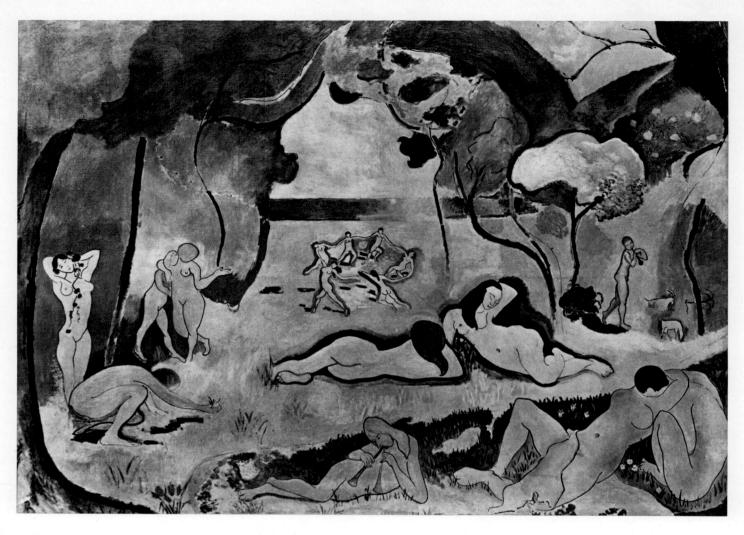

5. JOY OF LIFE. 1906. Oil on canvas, 68 1/2 × 93 3/4". © The Barnes Foundation, Merion, Pennsylvania

Picasso's early work indicates an impulsive prodigy, a sensibility that absorbed lessons with incredible speed. Matisse's beginnings were altogether different, rather plodding, never pedestrian but occasionally pedantic. He saw to it that his base in the traditions of his chosen craft was solid almost to excess. His earliest original paintings tend to be still lifes (though he did produce academic figure drawings at that time), and only slowly did he expand, first to landscape and then to major figure paintings. Throughout his career he remained devoted to these three genres, frequently combining them as the principal themes of his life gradually emerged. Each of the primary genres-still life, landscape, and figure composition—would appear, their roles and importance constantly shifting, in his lifelong quest to record and transform on canvas the appearance of the artist's habitual environment, the studio. In effect, Matisse conducted a private dialogue between himself and his working space together with its contents: models, other works of art, and those inanimate objects whose sole purpose was to stimulate the creation of the pictorial image. In a literal,

representational way, the majority of his works were comments on the creative process, and hence certain of his pictures are professionally as well as personally autobiographical. They describe not the artist's personal sentimental feelings about other humans (as is so often the case in Picasso's pictures devoted to the subject of the artist and model), but rather manifest the artist's efforts to create an autonomous pictorial life in each individual work.

Matisse's unremitting concern with his profession is visible even in the major paintings of his family seen as a group, where his wife and children are frequently placed in close association with his other offspring, his paintings and sculptures. Matisse never went to the tendentious extreme of Courbet, whose enormous *Atelier* (1854–55) sought, with a single gesture, to recount the artist's personal and professional encounters over a period of several years, with an allegorical telescoping of time and space. In Matisse's treatment of the studio, sometimes no more than a temporarily inhabited hotel room, the artist is often unseen, or if he is actually present, his posi-

tion is marginal, fractional, sometimes coming only in a mirror reflection. He wished not to stress the central, heroic role of the artist in the midst of his struggles, but rather to indicate his fleeting presence, leaving the work itself as the only possible hero. He intended his work to reflect a state of balance and repose in its completed form when it was finally ready for contemplation by the spectator. He did not wish it to express the often strenuous effort which he, the artist, had put into its creation as a matter of professional problem solving. The layman is thus meant to be excluded from the artist's world of tensions, uncertainties, and triumphs, but is instead offered a completed work which, in Matisse's hope, would have a calming, evocative effect that would serve to lift the beholder beyond the limits of his own mundane experience. It is almost as if he were implying that the life and goals of the artist at work could serve as a model for those engaged in other pursuits.

Not only did Matisse employ his studio as a constant motif, but he had a vision of how an artist's studio should be decorated. While many of his early paintings suggest the customary working interior, with its haphazard collection of objects of varying source and value, by 1909 he had reached a more elaborate, mature view, one that featured his own paintings as a major part of a carefully conceived ensemble. Contemporary with his negotiations with the Russian collector Sergei Shchukin, which resulted ultimately in Dance and Music (1910; colorplates 19, 20), he conceived a parallel scheme for an imaginary studio of his own which he explained to a journalist acquaintance, Estienne, in the spring of 1909. Matisse imagined a three-story studio in which Dance ("something calling at once for an effort and also giving a feeling of relaxation") would dominate the ground level. "On the second floor we are in the heart of the house, where all is silence, pensive meditation. Here I picture a scene of music making with attentive listeners." In truth, the listeners vanished from Music in the hieratic, almost symbolic version delivered to Shchukin, but the contrast with the effort and energy of Dance is still unmistakable. "Then, on the third floor, all is peace; I paint some people lying on the grass, engaged in talk or lost in dreams" (Les Nouvelles, April 12, 1909). In actuality, this third panel, markedly changed from its original design, emerged as Bathers by the River, completed only in 1916/ 17 (colorplate 31). While Matisse's concepts as outlined here are partly inconsistent with respect to expressive and psychological mood, they indicate a desire to convert his studio into an artful paradise, to create an ambiance relying upon calculated figure compositions to establish a state of mind that would lead to further creative effort. The very fact that Matisse painted and kept in his studio a full-size study for *Dance* (fig. 1)—its left margin visible at the extreme right of *Pink Studio* (1911; colorplate 22) and appearing as the backdrop for other works of the

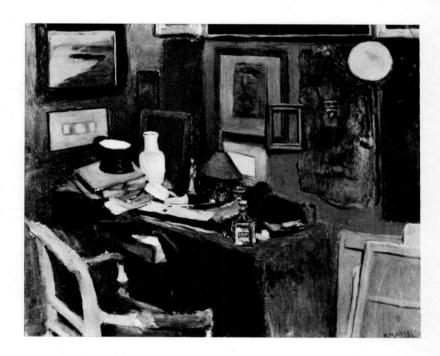

6. INTERIOR WITH TOP HAT. 1896. Oil on canvas, 31 $1/2 \times 37$ 3/8''. Collection M. and Mme Georges Duthuit, Paris

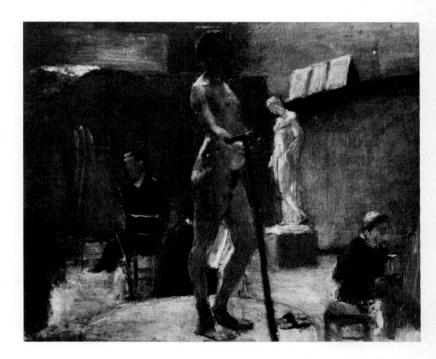

7. STUDIO OF GUSTAVE MOREAU. 1894–95. Oil on canvas, 25 $5/8 \times 31 \, 7/8''$. Private collection, Paris

period—is indicative that this journalistic account was more than a fleeting fantasy. Indeed, it helps explain the sequence of monumental studio variations over the next few years, and predicts the way in which he converted his various temporary residences in Nice during the 1920s into uniquely calculated pictorial environments—a phenomenon that is amply demonstrated in *Moorish Screen* (1922; fig. 36)—through the use of carefully assembled objects and fabrics that overwhelm the ordinary models.

The themes of dancers and musicians and of "people lying on the grass, engaged in talk or lost in dreams," all emerged from his seminal masterpiece of 1906, Joy of Life (colorplate 14, fig. 5), an arcadian composition that not only marked his apogee as a Fauve but pointed the way beyond. Together with the Neo-Impressionist Luxe, calme et volupté of the previous season (colorplate 11), this painting set the stage for a series of even more monumental figure studies that would ultimately lead Matisse to transform his previously realistic image of the artist's studio. These paintings would turn it into a world inhabited by detached, uninvolved models serving as the passive consorts of beautifully shaped or textured inanimate objects. With these two calculated "masterpieces" of the period 1905-6, both painted in his Paris studio after studies made in the south of France, he established contact with the nearly lost tradition of mythological "Golden Age" paintings which had been central to the works of Titian, Poussin, and Watteau, not to mention such late nineteenth-century masters as Puvis de Chavannes and even, in a special sense, Gauguin. Very few twentieth-century painters have joined Matisse in the perpetuation of the vision of a terrestrial paradise populated by gods in human guise, or humans in godlike attitudes. In projecting his imaginary studio and in working out the actual decorative canvases of Dance and Music for Shchukin, the artist had achieved a significant fusion of two elements in his work. He had found that the visions of a mythological harmony that he had expressed again and again in his large figure compositions of 1905-10 could be expressively (and not just anecdotally) incorporated in his studio concept, a theme that reached back to his dark pictures dating from before 1900. Stretching a point, it might be contended that the whole of his subsequent work is predicated upon this illuminating insight.

Matisse's early paintings of the studio motif were, in effect, expanded still lifes, and only gradually did the live model intrude. A case in point is the *Interior with Top Hat* (1896; fig. 6). It is clear that we are here looking at a corner of the artist's studio. The hat itself is something of a decoy, since the majority of the objects are pictures, frames, and stretchers hanging on or stacked against the wall. The tones of the picture are essentially somber, and evoke memories of his very earliest painting, *Books and Candle* (1890; Musée Matisse, Nice-Cimiez), a picture painted before he had returned to Paris as an art student the following year. As with most of the still lifes of this period, we are face to face with an emerging talent

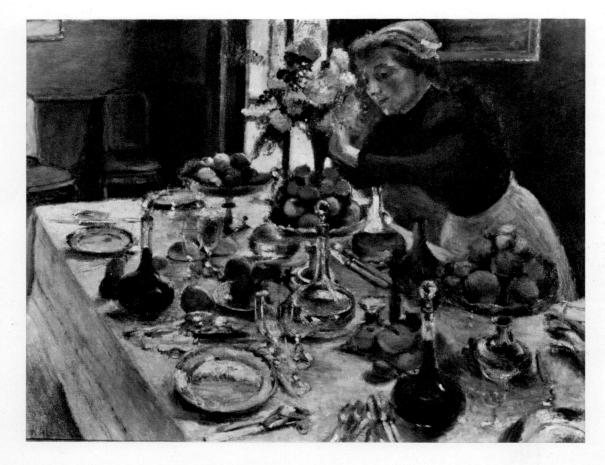

8. LA DESSERTE. 1897. Oil on canvas, 39 1/2 × 51 1/2". Collection Mr. and Mrs. Stavros Niarchos, Paris

which quickly and instinctively mastered the art of composing traditionally arranged objects on a table or seen against a wall in a realistic manner. It is not surprising, therefore, to discover that some of his early copies after Old Masters were works in this genre by Chardin and Jan de Heem, and that some of his original compositions of this period appear as pastiches in the manner of Courbet and Manet. In short, he was beginning his personal statement as an artist (even though he was still a student) in a style that, by avant-garde standards of the 1890s, was already outmoded. Ironically, however, this realism was hardly acceptable to the artist who wasbriefly and, we must suppose, grudgingly—his master at the Académie Julian, the academic hero of the day, Adolphe Bouguereau. Unwittingly, Matisse was, in his early work, caught among several extremes: the novel color and composition of Synthetist and Nabi painting which at that point constituted one advanced extreme of Parisian art; the fashionable Art Nouveau style; and the sentimentally frigid Classicism of the admired Salon masters. As yet he was barely aware of new tendencies, but his instincts led him to recoil from the banality of academic work or from something so immediately popular and transient as Art Nouveau.

His pencil studies of the live model dating from the early 1890s (fig. 76), or alternatively of antique plaster casts, are strongly outlined and crisply linear. However, in detail we sense a conflict between certain contours that are of a realistic definition and others that suggest an effort to approach the codes of academic idealization. In any case, these drawings were not to the liking of Bouguereau, and Matisse was refused formal admission to the École des Beaux-Arts. Luckily he was discovered sketching on his own in the courtyard of the École by the more open Gustave Moreau, and was invited to become an unofficial student in the latter's atelier, where he worked, off and on, with time out for trips to Brittany and the south of France, until after Moreau's death in 1898. With Moreau's encouragement he copied works of a variety of masters in the Louvre—a learning method that was considered novel for the day. Moreau did not impose his own distinctive style and taste upon Matisse, or upon his other pupils, for that matter, but encouraged them to study life around them as well as the paintings hanging in the museum. Moreau's own manner, traceable ultimately to Delacroix, with his mordant symbolic themes featuring a rich tapestry of slender, languid figures, seems to have had little bearing on Matisse's personal style either then or later. It is not out of the question, however, that Matisse, in his large allegorical figure compositions of

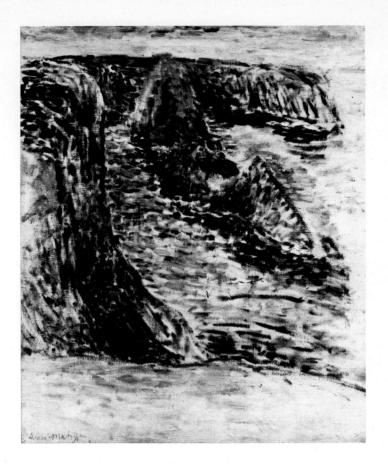

9. ROCKS AT BELLE-ÎLE. c. 1898. Oil on canvas, 25 $5/8 \times 21$ 1/4''. Stephen Hahn Gallery, New York City

1905–10, was reacting, in his striking simplicity of strong color and contour, to the overburdened detail and affectedly flaccid design of Moreau's suggestively erotic scenes.

In any event, Matisse's painting Studio of Gustave Moreau (1894-95; fig. 7) is a rare picture of the period which demonstrates his determination to treat the human figure with the same somber realism that he had already mastered in his still lifes. The live model, back-lit, dominates the central foreground, and in the right distance a standard studio prop, an antique plaster cast of a standing figure, is caught in a highlight. It is unimaginable that such open brushwork and emphatic realism would have been tolerated in any other atelier of the day. The somber hues indicate that Matisse was not interested in the often fervid colors in Moreau's own work, and, in fact, the liberation of his palette would take place not in the studio but in the face of nature itself, during his summer trips to Brittany in 1895-97. Even then the process appears to have been a slow, gradual one and not the result of a sudden revelation.

His discovery of the new, postrealist art movements was slow, almost as if, in a period of several years, he was reliving the history of the past thirty years in his own

10. THE ABDUCTION OF REBECCA, AFTER DELACROIX. 1899. Ink

work. During the later nineties, however, he did not neglect his study of the masters in the Louvre either, and in 1896 he exhibited publicly for the first time. Significantly, he presented his work neither at the official Salon nor at the Salon des Indépendants, frequently the scene of exhibition for radical artists from Seurat onward (and where Matisse would exhibit his Neo-Impressionist Luxe, calme et volupté in 1905). Instead, reflecting the caution of his art at the time and his middle-of-the-road position, he submitted four works to the Salon of the Société Nationale des Beaux-Arts, whose president at that time was Puvis de Chavannes, and they were accepted. The Société Nationale had separated itself a few years previously from the official Salon, and had originally been headed by the renowned genre painter Meissonier. Since it did not look with favor on radical innovations but was receptive to individual efforts of a modest or stylish sort (Sargent, Boldini, and Carolus-Duran exhibited here), this was an appropriate place for

Matisse to make his public debut. His success was such that the state purchased Woman Reading (c. 1894; colorplate 2). But the following year a more ambitious and daringly hued picture, La Desserte (1897; fig. 8), was poorly received. This picture, undertaken with the encouragement of Gustave Moreau, who felt that his student was ready for a large-scale effort, marks the beginning of a long transitional period in Matisse's art, one that would not end until his Fauve paintings of 1905. In effect, it was the second phase of his prolonged student effort, one which witnessed his initiation into various aspects of modernist painting. Yet it was also a period in which the artist swung back and forth between daring color experiments and a return to the darker palette of his very first paintings, albeit with a command of compositional structure that reached far beyond the modest, if limitedly successful, efforts of his earliest works. This period would also witness his beginnings as a sculptor, and, toward its end, his first tentative efforts as a printmaker.

La Desserte is an intriguing picture, mixing boldness of touch and novelty of viewpoint (the spectator is looking down upon a luncheon table from a very close vantage) with a certain conventionality. It lacks the sense of release from the realist tradition that would appear in the Corsican and Toulouse landscapes of 1898, and in many respects it is not as satisfactory a picture as several of the cliffside views painted at Belle-Île during his last Breton summer, 1897. While many of the details of La Desserte are exquisitely rendered with a genuine luminosity, the composition is overloaded and the density of the pigment is uneven, tending to pile up more heavily toward the center of the picture. And if there is an Impressionistic sense of sparkle emanating from the objects on the cloth at the center, there is also a rather compromising lugubriousness in the colors of the periphery. Nonetheless, it remains an important landmark in Matisse's early career, and the picture's contradictions clearly indicate the struggle that he was undergoing at the time. In his later works we rarely see the conflicts and dilemmas faced by the artist in the process of creating a picture, but here they are in full view.

By 1898, Matisse had commenced his integration into the mainstream of contemporary art. He had encountered Impressionism the previous year through the appearance of the truncated Caillebotte legacy at the Luxembourg Museum, and had been introduced to Pissarro, who was then painting some of his most luminous late Impressionist views of Paris from the upper-floor windows of

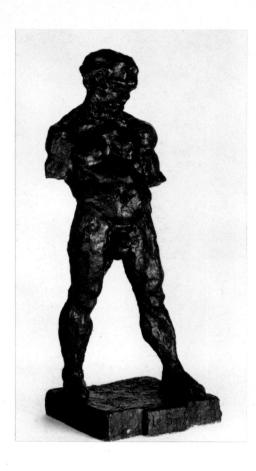

left: 11. THE SLAVE. 1900–1903. Bronze, height 36 1/8". Baltimore Museum of Art. Cone Collection

right: 12.
THE MODEL
(NU AUX SOULIERS
ROSES). 1900.
Oil on canvas,
29 1/2 × 22 7/8".
Collection G. Daelemans,
Brussels

various buildings, rounding out his career with a series of paintings that returned in touch and sensibility to the pioneering Impressionist works of the 1870s. No doubt these works would challenge Matisse over the next few years as he studied alternately Notre-Dame and the Pont Saint-Michel from his upper-floor studio window overlooking the quais of the left bank. It was Pissarro who encouraged Matisse to visit London in order to see the work of Turner, a trip that the older master had made during 1870-71, as had Monet. The trip was a prelude to a long voyage that would keep Matisse away from Paris for most of 1898. Nothing in his subsequent work is directly indebted to the English Romantic master, but this totally new experience with a kind of painting that could not have been seen in Paris may have provided a necessary jolt which permitted his next phase to develop with extraordinary freedom.

The paintings that Matisse produced during 1898, in Corsica and then in the environs of Toulouse, give us the first clear indication of his uniqueness. Powerfully rich in color, small in scale, and boldly brushed, they are free of the understandable inhibitions that grew out of a Parisian atelier ambiance. Justifiably, they have been called Proto-Fauve. Almost exclusively landscapes, they threatened to turnt he direction and emphasis of Matisse's career to-

ward that of the Impressionists themselves, but their stepped-up, highly personal hues precluded that route. However, it is clear from the evidence of the paintings and of Matisse's own later testimony that his taste for Mediterranean light was first established at this time. True, twenty years later, when he began his habitual winter sojourns on the Riviera, he was more preoccupied with the subtle nuances created by this limpid light in interiors; but during his first protracted experience with the sun of the south of France he was bewitched by its intense exterior dazzle. Free of the internal politics and the competitive hassle of an art capital, Matisse here gave vent to lyrical feelings that would ripen a decade later in larger, more disciplined, and more ambitious canvases. He was even able to transfer some of his newfound enthusiasm for rendering light by means of intensified juxtapositions of saturated colors to an occasional interior study, one of the most challenging and successful being The Invalid (1899; colorplate 4).

Matisse returned to Paris early in the year 1899, and his stylistic development entered a series of troubled, perplexing phases. The easy flow of minor but satisfactorily personal pictures ended, though not abruptly. His discovery of Cézanne at this juncture (he purchased Cézanne's *Three Bathers* from Vollard at this time) almost

certainly demonstrated to him that his days of study were not yet over, that there were works by contemporary painters that he needed to study meticulously before he could embark on a career entirely his own. Regrettably his master, Gustave Moreau, had died in his absence. Fernand Cormon, the academic painter who subsequently took over Moreau's studio, dismissed Matisse on the flimsy pretext that he was over-age, and the artist had to find other working quarters. To complicate matters, his interests were acquiring still other, somewhat contradictory dimensions: he came under the influence of Signac and of Neo-Impressionism through a reading of De Eugène Delacroix au Néo-Impressionnisme, which had appeared serially in the Revue Blanche in 1898, during his absence, and was issued in book form in the following year. Quite possibly it was while under its spell that he made his pen-and-ink study of Delacroix's Abduction of Rebecca (1899; fig. 10), which, according to Jean Puy, a fellow student and future Fauve, produced consternation because it seemed to reverse the scale of values, replacing highlights with shadows and vice versa. This observation is in fact exaggerated. Matisse's aim with this study was to provide the figures with a greater sense of relief by surrounding them with extraordinarily broad, overstated shadows. What emerged was a style of drawing that would prove to be the black-and-white equivalent of Fauve painting and, consequently, perhaps the most important study that the artist ever made from the works of a recognized master.

In rapid succession to his involvement in the theory and practice of Neo-Impressionism (there are loosely conceived paintings in this mode which may even have been painted during his last weeks in Toulouse in early 1899), Matisse abruptly became interested in the problems of three-dimensional modeling posed by the art of sculpture. He had purchased a Rodin bust from Vollard at the same time that he acquired Cézanne's Three Bathers, and an inconclusive meeting with Rodin took place shortly thereafter. Such concerns with modeling would somehow seem altogether contradictory to his interest in the diaphanous space and surface of Neo-Impressionist painting as manifested in its mosaic of dots or short brush marks. Moreover, both concerns appear foreign to the lyrical flow of brushwork and design of his immediately preceding Toulouse landscapes. However, it is out of such contradictory concerns that Matisse was forging the foundations of his career around 1900. None of these experiences were capricious adventures; all proved useful as his work ripened over the next decade. Indeed, the great "blue" nude studies of 1900, notably the *Male Model* (colorplate 5), suggest that he was already prepared to fuse the lessons of Cézanne and Rodin into a work totally his own. As for Neo-Impressionism, its ultimate consequences would not be felt until 1904–5, when Matisse had the opportunity of meeting Signac in person.

At this crucial moment in his development, poised on the brink of establishing a definitive artistic personality, economic circumstances were partly responsible for a certain contraction and retreat. In order to make ends meet he was forced (together with his close friend Marquet) to work as a day laborer on the decorations of the Grand Palais, then being rushed to completion for the World's Fair of 1900, and during 1902 he was obliged to return for a time to his family's home in Bohain. Grim though this period must have been, it resulted in the unheralded *Attic Studio* (1903; colorplate 9), in which the theme and format of so much of his life's work would be tentatively announced in a style that was still not free of early dark tendencies, but one which showed little evi-

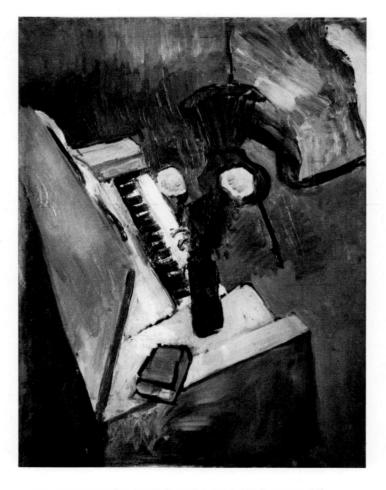

13. INTERIOR WITH HARMONIUM. 1900. Oil on canvas, 28 $7/8 \times 21$ 3/4''. Musée Matisse, Nice-Cimiez

dence of the strenuous, seemingly contradictory interests of the preceding twenty-four months.

Ever since the mid-nineties he had been making acquaintance with artists who would ultimately form the Fauve contingent at the 1905 Autumn Salon. Some of these were fellow students from the Moreau atelier, the most important of whom was Albert Marquet, eventually Matisse's neighbor at 19 Quai Saint-Michel. He did not meet André Derain until 1899, during a brief stay in Carrière's studio, and through him came to know Maurice Vlaminck. Marquet surely reinforced his impulse to make many studies of Notre-Dame through his studio window, several of which are clearly Proto-Fauve, but the major tendency of Matisse's art from 1900 to 1903 was toward a drying-up of color, until he had passed the important stage of tight compositional study marked by Carmelina in 1903 (colorplate 10). The design density of this, one of his most conservative and traditional works, was a significant catharsis, a self-verification that he had mastered the foundations of his craft. His self-imposed, prolonged apprenticeship was nearing its end; it had, in fact, but one further step to take. This involved a return to a more receptive attitude toward primary colors in their full intensity. For this to come about, a return to a Mediterranean atmosphere was necessary, and the means were put at Matisse's disposal by Signac and Henri-Edmond Cross during the summer of 1904 at Saint-Tropez. This period witnessed a notable revival of Neo-Impressionist painting, and in particular the work of Cross was reinvigorated at about this time by a switch in subject matter. Where earlier he had been concerned with rural, peasant subjects, he now began to employ more arcadian themes, with landscapes populated by nude figures in recreational attitudes along sunlit shores. Matisse fell in with this motif and also with a luminosity of style that had been absent from his works for several years. The first study for Luxe, calme et volupté was executed during this stay at Saint-Tropez, in a fairly open, loose style that was not yet Neo-Impressionist in a doctrinaire fashion. From this preestablished image he executed the final version in Paris during the winter of 1904-5, and it was subsequently shown at the Salon des Indépendants that spring. Signac was so sure that he had made a major convert to his style from the ranks of gifted younger artists that he immediately purchased the picture—only to discover a little more than a year later that in fact Matisse had been using this technique as a momentary vehicle leading to the discovery of his own proper idiom.

However, it was actually across the bridge of a momentarily revived Neo-Impressionism that Matisse, and

also Derain (who had accompanied him to Saint-Tropez in 1904), found their road to Fauvism. It was a course of development that differed from that of Vlaminck, whose use of saturated color had been more daring, even unwise, and still different from the road to be followed by Dufy and Braque. Interestingly, Dufy later confessed that seeing Luxe, calme et volupté had served to disenchant him with whatever lingering Impressionism remained in his work at that time.

The meticulous working out of this Cythera-like theme in Matisse's work served as a prologue for his breakthrough into a personally evolved Fauvism during his stay at Collioure during the summer of 1905. Several Neo-Impressionist canvases were painted there, but their mosaic-like effect was transformed into something more vibrant in the Open Window, Collioure (color-plate 13), with its broad, continuously painted patches of saturated color. After this achievement the road was open, leading to the two portraits of Mme Matisse, Woman with the Hat (Collection Mr. and Mrs. Walter A. Haas) and The Green Stripe (colorplate 12), which were painted upon his return to Paris in the fall. Exhibited together in a single room in the Autumn Salon of that year, together with equally challenging works by Derain, Rouault, Henri Manguin, Jean Puy, and Louis Valtat, the eclipse of Signac's systematic mode was definitive. Fauvism's unique if transitory Indian summer of the old Impressionistic vision had coalesced into a communal celebration of color created by a group of artists working not so much in concert as in parallel, developing an art movement of brief duration out of overlapping but not exactly consonant enthusiasms.

Luxe, calme et volupté established the theme, and the smaller Fauve canvases of middle and late 1905 clarified the new style. The result was Joy of Life (fig. 5), the most prescient, far-reaching single effort that Matisse ever made. In its final, monumental form it appeared at the Salon des Indépendants in 1906, though its original conception would seem to reach back to studies made from nature at Collioure the previous summer. Frontal rather than diagonal in its spatial organization, with bolder liberties taken with space-scale relationships, and featuring flat planes of color rather than a pseudo-atmospheric assemblage of mosaic-like, staccato brushstrokes, Matisse's art here achieved a harmony of style and theme which established his independence as an artist capable of working on a vast scale and in a decorative style that already bears a hint of architectural aspirations. Far and away the largest canvas that he had attempted up to this point (its dimensions exceeding five and a half by

14. BLUE NUDE, SOUVENIR DE BISKRA. 1907. Oil on canvas, 36 1/4 × 55 1/8". Baltimore Museum of Art. Cone Collection

seven and a half feet), its design was a model of balance and clarity, and the control of its dense color a demonstration of the artist's emotional response to a hallowed, traditional arcadian theme, an emotion tempered by intellectual restraint. Not only the source of several subsequent works, *Joy of Life* is the fulcrum of his early career and the necessary preliminary summation of the complex, unified urges that would drive his painting forward for another half century.

The calming atmosphere of this rich yet sparsely designed canvas appears to have put aright the tortured, unresolved fantasies of his teacher, Gustave Moreau, while solving, in a unified set of gestures, the inner tensions and contradictions of his own work of the previous years. Ironically, it may have been the unusual size of the picture's format that was the key; ironically because in the past, in some of his more ambitious early works, notably La Desserte (1897) nearly a decade before, it seems to have been the scale of his ambitions that in the end precluded a total success. With Joy of Life the possibilities of

decorative gesture provoked by mere size seem to have unlocked a tendency that was, in the next five years, destined to expand still further in his most monumental figurative works. One can only conclude that at last, after much deliberate and cautious preparation, Matisse was ready to set forth on his own. In so doing he became the last member of a race of painters whose genealogy stretches back to Titian and his older contemporaries, Bellini and Giorgione, and which reaches the twentieth century through the classicizing figurative compositions of Cézanne and Renoir. And yet, in spite of these unmistakable historical affiliations (which were probably only half conscious in the artist's mind at the moment of creation), this is a painting that clearly speaks in a language of the twentieth century. While the theme of Joy of Life was universal and idyllic, its style was not only new but susceptible of yet more growth and intensification. Its linking of past and present is in every respect reminiscent of Manet's Déjeuner sur l'herbe (1863). The psychic and erotic tensions that Cézanne had brought to subjects of

15. PINK NUDE. 1935. Oil on canvas, 26 imes 36 1/2''. Baltimore Museum of Art. Cone Collection

this sort, or the sentimentality that Renoir infused into his treatments of similar motifs, are here eliminated. Out of this objective balance of forces, one rivaling the equilibrium of Poussin or Ingres, Matisse found his true métier as a poet.

The ensuing half decade saw Matisse working in a variety of genres: still life, interior, portrait, and land-scape. Moreover, it was the period of several great early bronzes: Reclining Nude I (fig. 16) and La Serpentine (fig. 64). However, the most significant creations of this period of early maturity were the large figure compositions, several of which were in effect clarifying "blowups" or monumental condensations of themes taken from Joy of Life. This series led through the two versions of Le Luxe (1907; colorplate 16, fig. 20), and culminated in the Dance and Music of 1910 (colorplates 19, 20). Then, abruptly, as if his appetite for the grouping of human figures were exhausted, the key expressive position in Matisse's art is given over to the great studio allegories of 1911–12.

The direction followed by Matisse in the years after 1906 is exceptional from many points of view. Unlike his Fauve friends, he seems not to have flirted seriously with the then nascent Cubist techniques. He appears to have been determined to solve the problem of modeling a figure simultaneously with the creation of a sturdy decorative rhythm of line and a powerful contrast of large, flat areas of color and value. His goal was perhaps similar to that of the Cubists, but his means were totally opposite (the goal being the reconciliation of two inherently contradictory problems: to provide, if not literally an illusion, at least a sense of volume for the figure represented, while at the same time maintaining the integrity of the canvas's surface through overall design). That Matisse was convinced of his own personal methods at this point saved him from the crisis that overtook many of his contemporaries when they first encountered Cubism. Of the Fauves, only Braque contributed to the new movement, one that many must have seen as a rival for leadership to the barely established Fauvist group. For the rest,

16. RECLINING
NUDE I. 1907.
Bronze, height 13 1/2".
Museum of Modern Art,
New York City.
The Lillie P. Bliss
Bequest

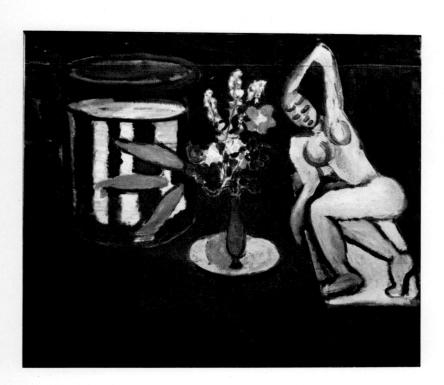

17. GOLDFISH. 1909. Oil on canvas, 32 $1/4 \times 36$ 3/4''. The Royal Museum of Fine Arts, Copenhagen. J. Rump Collection

Derain, Dufy, and even Vlaminck, after testing out certain of the constructive lessons of Cézanne in ways that might be called Proto-Cubist in the years 1907–10, returned to either a neotraditionalist eclecticism based upon various nineteenth-century achievements or to a fashionable accommodation to bourgeois taste. Their later work was often skilled, but it was outside the mainstream.

In effect, Matisse was the only Fauve who derived lasting benefit from the movement's unique dedication to saturated color. His entire career is predicated upon refining this investigation, which was tentatively begun in his small landscapes of 1898, momentarily put aside, only to be reformulated in a more definitive fashion in 1905. His concern for color was always closely integrated with his preoccupation with suggestions of depth and of relief in or upon the canvas: in other words, the problems of spatial illusion and bodily modeling. His effort in pulling together into a single formula all of these needs and urges generated much tension in his work in 1907. A comparison of the *Blue Nude*, *Souvenir de Biskra* (fig. 14) and *Le Luxe I* and *II* is instructive. The

reclining blue figure is ponderous, muscular, earthbound, with the woman surrounded by a lush landscape fragment that serves to press the figure forward, heightening the sense of tactile volume to an unusual extreme, while also echoing, in its design, the simple decorative contours of the body's outline. Contrary to this is the decorative etherealization that has taken place with the major figures of Le Luxe I and II and their relationship to a landscape, which is established through contrast rather than repetition. In effect, Le Luxe I is the canvas in which the transition from a ponderous to a contoured figure can still be seen, the artist having left this work as an indication of his personal struggles. Blue Nude (whose subtitle refers to a trip to Algeria the previous year) may be considered a late Fauve work by virtue of its forceful, complex palette. In contrast, Le Luxe II opens the way to a period of harmony—of simplified yet powerful forms and color contrasts.

Blue Nude's impact is clarified through a comparison with the bronze Reclining Nude I (1907), a work that is often the subject in subsequent paintings of the next decade, being transformed finally into a garden figure in the 1917 Music Lesson (fig. 34). But in spite of the fact that color is here used to heighten the sense of relief,

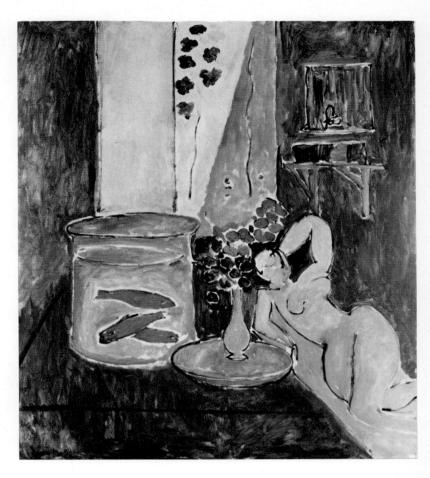

above: 18. GOLDFISH AND SCULPTURE. 1911. Oil on canvas, 45 3/4 × 39 3/8". Museum of Modern Art, New York City. Gift of Mr. and Mrs. John Hay Whitney

left: 19. RECLINING NUDE III. 1929. Bronze, height 7 7/8". Baltimore Museum of Art. Cone Collection

working in concert with the massive outlines and exaggerated shadows above and below the torso, one can still detect the latent linear arabesques underneath. This phenomenon points toward the distant as well as the near future of Matisse's art, and an examination of Pink Nude (1935; fig. 15), like Blue Nude also a part of the Cone Collection, in conjunction with its Fauve predecessor points out the inner unity of the artist's development across a long period of time. These two works seen together underline the evolutionary growth of his style through the apprehension and presentation of the female figure. Indeed, the Pink Nude, a picture whose pose and rather Ingresque proportions were arrived at only after many trials and modifications, ends up as an almost mirror-like reinterpretation of the Blue Nude, painted nearly three decades earlier.

The two versions of Le Luxe likewise illustrate

Matisse's tenacity in developing a particular theme or figure type over a protracted period. Le Luxe thematically emerges as a less episodic, more monumental treatment of the earlier Luxe, calme et volupté. These are essentially bathing compositions, and one senses motifs in both that might have been borrowed or transformed from Cézanne and Gauguin. But Matisse, unlike all his Parisian contemporaries, finally chose to emphasize the latent arabesque rather than to concentrate upon the constructive, volumetric aspects that are constantly present in the compositions of Cézanne. It is here that Matisse parts company not only with the Fauves but also with those who would shortly become Cubists. Perhaps alone of all major Parisian painters of the years around 1907, he did not become involved at this juncture in studying those aspects of Cézanne's art, the structured brushstroke and the abruptly turned or juxtaposed

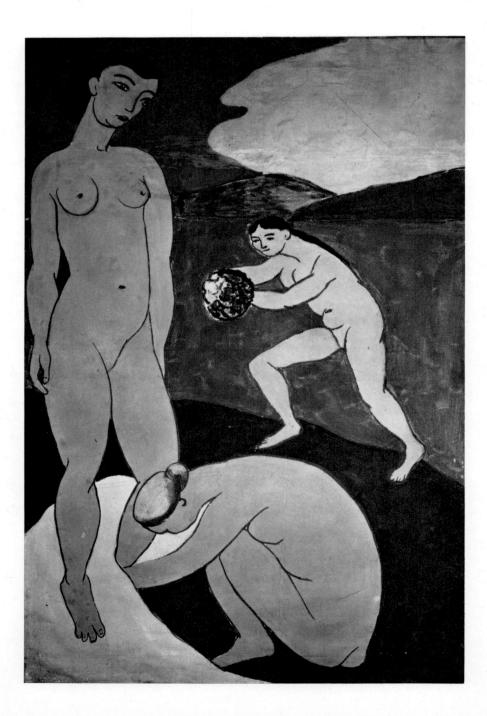

20. LE LUXE II. 1907. Casein, 82 1/2 × 54 3/4". The Royal Museum of Fine Arts, Copenhagen. J. Rump Collection

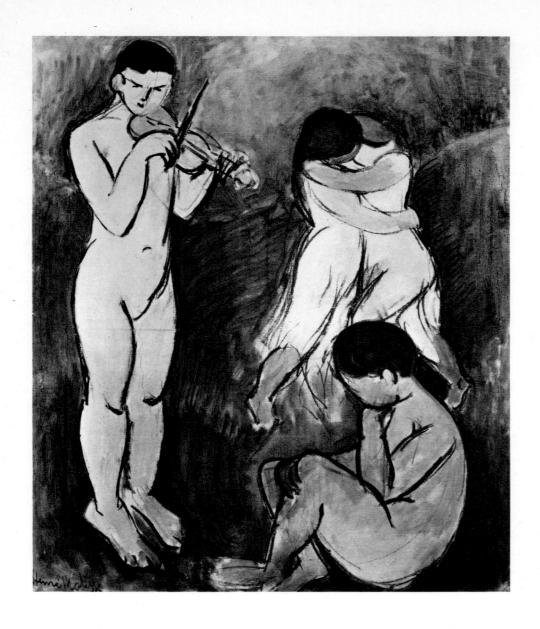

21. MUSIC (Sketch). 1907.
Oil on canvas, 28 3/4 × 23 5/8".
Museum of Modern Art, New York City-Gift of A. Conger Goodyear
in honor of Alfred H. Barr, Jr.

22. FIVE BATHERS (COMPOSITION II). First study for *Bathers by the River*. c. 1910. Pen, ink, brush, aquarelle, 8 1/2 × 11 3/8". *Pushkin Museum, Moscow*

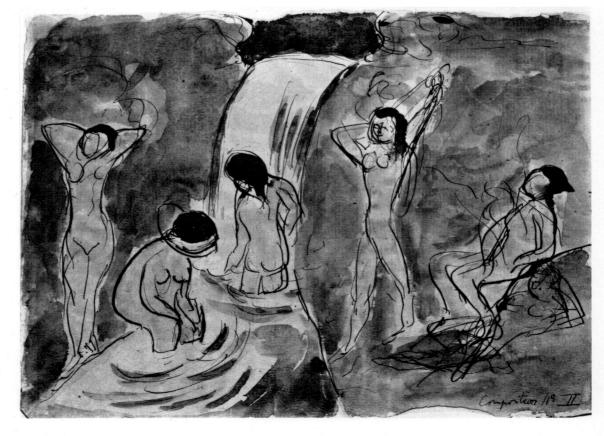

illusionistic plane, which were pointing toward Cubism. Matisse had absorbed these aspects into his own style several years earlier, shortly after he had purchased the *Bathers* from Vollard in 1899, and by 1907 he had no real need to relive that experience. *Standing Nude* (colorplate 15) is an indication that he briefly considered this alternative, but the second version of *Le Luxe*, together with subsequent figure studies, indicates that he rather quickly rejected this mode as irrelevant to his development at that time.

Thus, Matisse makes no direct contribution to the initial development of Cubism—unless it is possible that Picasso, around 1907, shortly after he had made Matisse's acquaintance through the Steins, was influenced by the sight of such figure studies of 1900 as the Male Model (colorplate 5), the pictorial equivalent of the bronze Slave (fig. 11). These years that witnessed the turbulent evolution of Cubism were, for Matisse, a time of harmony and fulfillment. The trials and contradictions of the previous fifteen years, the era of his debut as a painter, were over. However, simply because he failed to follow the new movement—although he would later investigate some of its more decorative features, temporarily incorporating them into his art in the years around 1914—it would be a mistake to think of Matisse as slackening off at this point. Rather, his large-scale, simplified decorative style, most in evidence in the figurative work of the period, was his distinctive alternative to Cubism. He was now working alone in a highly personal idiom, in contrast to the Cubists, whose efforts tended to be collaborative or cooperative. A small group of enlightened patrons could be counted on to acquire his major works, and even to propose commissions (as was the case with Dance and Music, 1910). He continued to show his work at the Independent and Autumn Salons, but many of his finest works thereupon vanished into foreign collections (especially those of the Russians Shchukin and Morosov),

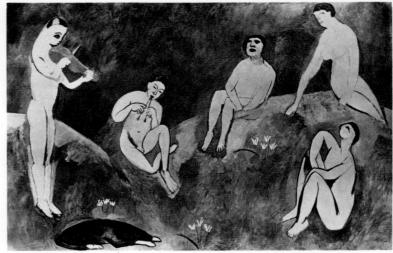

and were thus not readily available to be seen by younger painters or critics. It would obviously be wrong to assume that Matisse had been absorbed into anything like an establishment coterie at this point. Nevertheless, the avant-garde would henceforth be identified with the Cubists, the Fauve "movement" having, to all intents and purposes, vanished by 1908.

Moreover, Matisse's status as a maître was to a degree established by the opening of an Académie Matisse in 1908, which lasted until 1911, although the artist became progressively less interested in his professorial duties toward the end. This is also the epoch of his lengthy article "Notes of a Painter," published in La Grande Revue, December 25, 1908. This article, combining both theoretical and practical reflections, probably grew out of his teaching experience—weekly atelier criticisms, some of which were recorded by Sarah Stein, one of his pupils and a respected friend, whose husband Michael was a patron of the Académie Matisse. Sarah Stein's notes dating from 1908 were published only in 1951 (as Appendix A of Alfred Barr's extensive monograph on the painter), and they form an interesting companion to "Notes of a Painter." From all reports, Matisse's teaching might be judged traditional, as he was concerned with providing his many students (few of whom were French) with a firm classical grounding, echoing much of his own experience of fifteen years before. Likewise, "Notes of a Painter" is a classical, though certainly not academic, statement, especially when read in the context of the Cubist, Futurist, and Abstract art manifestoes that appeared over the next decade.

Matisse's observations in this article are remarkably

lucid. His theory is actually extracted from his own practice as a painter, and yet these concepts are so all-encompassing as to provide a multitude of applications. After apologizing for addressing his audience in verbal rather than in pictorial form, he states:

What I am after, above all, is expression. . . . I am unable to distinguish between the feeling I have for life and my way of expressing it.

Expression to my way of thinking does not consist of the passion mirrored upon a human face or betrayed by a violent gesture. The whole arrangement of my pictures is expressive. The place occupied by figures or objects, the empty spaces around them, the proportions, everything plays a part.

These remarks can most immediately be set alongside such contemporary paintings as Harmony in Red (actually, as his lines were written, still Harmony in Blue) of 1908-9 (colorplate 18). More interesting, however, is the discovery that these fundamental concepts apply to the structure of a powerful Fauve study such as The Green Stripe (1905; colorplate 12), which at first glance seems to be impulsive, Expressionistic in countenance, and only later strikes us as rationally expressive as a color composition. Matisse's notion of "expression" is also perfectly reflected in his several versions of Dance, where the integral, abstract quality of the line serves to convey the nature of the strenuous action, making possible the progressive reduction and simplification of the figural image as the artist returns over and over again to this theme. Matisse continues:

Composition is the art of arranging in a decorative manner the various elements at the painter's disposal for the expression of his feelings. . . . All that is not useful in the picture is detrimental. A work of art must be harmonious in its entirety; for superfluous details would, in the mind of the beholder, encroach upon the essential elements.

It is remarkable that this doctrine, hardly more than a rephrasing of classicizing ideals that reach back to the Renaissance, was the conceptual scaffolding upon which Matisse constructed not merely his monumental decorative style of this period but also the more intimate, small-scale manner of the 1920s and the once again decorative, even more architectural style of the late 1940s and early 1950s. These lines, together with those quoted below, could serve as a commentary to such diverse works as the

delicate Still Life with Apples on Pink Cloth of about 1925 (colorplate 38), or the vast, abstract Snail of 1953 (colorplate 48).

Speaking of the "condensation of sensations which constitutes a picture," Matisse describes his approach to one of his major motifs:

Supposing I want to paint the body of a woman: first of all I endow it with grace and charm, but I know that something more than that is necessary. I try to condense the meaning of this body by drawing its essential lines. The charm will then become less apparent at first glance, but in the long run it will begin to emanate from the new image. This image at the same time will be enriched by a wider meaning, a more comprehensively human one, while the charm, being less apparent, will not be its only characteristic. It will be merely one element in the general conception of the figure.

There could be no better explanation of the method by which the artist developed the composition of Le Luxe from the first to the second version. Often, in subsequent works, we can see a similar process in operation, though occasionally, as in the confrontation of The Music Lesson (fig. 34) with The Piano Lesson (colorplate 33), we cannot be sure that the application of the above-quoted arguments concerning "condensation" will tell us which of the two canvases was conceived and executed first, this because of a relatively abrupt change of style that was occurring in the artist's work at this time, a decade after the writing of "Notes of a Painter." Much later, however, in the painting of the *Pink Nude* (1935), Matisse had the canvas photographed many times in the course of its execution, revealing a process in which the image is distilled and reduced to an increasingly arbitrary arabesque, the inner modeling being correspondingly flattened in the process.

By 1910 Matisse's work was being shown abroad, notably in Germany, Russia, and the United States. In New York City Matisse was introduced via his drawings, selected by Edward Steichen and presented by his fellow photographer Alfred Stieglitz at his "291" Gallery in 1908 and 1910. Remarkably, two noted specialists in early Italian painting, Bernard Berenson and Frank Jewett Mather, were among the artist's earliest and most articulate champions. Berenson's retort to *The Nation*, apropos of its slighting review of the 1908 Autumn Salon, attacked the ridiculing observations of the magazine's

correspondent: "I have the conviction that he [Matisse] has, after twenty years of very earnest searching, at last found the great highroad travelled by all the best masters of the visual arts for the last sixty centuries at least. Indeed, he is singularly like them in every essential respect. He is a magnificent draughtsman and a great designer."

Mather, writing two years later in the New York Evening Post, refers to Matisse's concept of the body as a "powerful machine working within certain limits of balance," adding later: "It differs in no essential respect from that of great draughtsmen of all ages. A Matisse drawing, looked at without prejudice, is no more bizarre than a study of action by Hokusai or Michelangelo. It belongs in the great tradition of all art that has envisaged the human form in terms of energy and counterpoise."

Continuing by drawing analogies between these contemporary works and certain recently discovered tempera studies by Tintoretto, Mather notes: "The Frenchman is a kind of modern Pollaiuolo." Given that Mather admits his unfamiliarity with Matisse's paintings, and that in 1910 he would not have known of *Dance*, on which the artist was then working, this is a most prescient com-

25. BLUE WINDOW. 1911. Oil on canvas, $51 \ 1/2 \times 35 \ 5/8''$. Museum of Modern Art, New York City. Abby Aldrich Rockefeller Fund

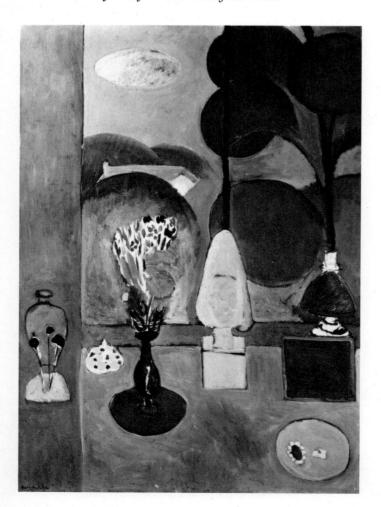

parison. The tense interrelationship of the figures in Pollaiuolo's famed engraving of the *Battle of the Nudes* possesses many of the qualities of tense action and energy that Matisse introduces in the Shchukin version of *Dance*; in both images the energy is expressed through the abstract flow and abrupt arresting of movement in the lines themselves.

What is especially interesting in the commentaries of both Berenson and Mather is that they establish Matisse's importance in relation to historical figures of commonly accepted worth. Writing in a different cultural context, Apollinaire in 1909 indulged in this paradox: "To tell the truth, M. Henri Matisse is an innovator, but he renovates rather than innovates." Potentially meaningless, this bon mot nonetheless aptly makes an important point concerning the artist's position vis-à-vis the Cubist avant-garde of the day, and also characterizes the artist's philosophy as revealed in "Notes of a Painter." However contemporary and unsettling Matisse's paintings may have been to many at the time—in terms of bold patterning, simplifications of volume, and interplay of color—his roots in the past were at least implicitly present; in fact, he made his attitude unmistakable in a passage from the "Notes": "I feel very strongly the bond between my old works and my recent ones. But I do not think the way I thought yesterday. My fundamental thoughts have not changed but have evolved and my modes of expression have followed my thoughts. I do not repudiate any of my paintings but I would not paint one of them in the same way had I to do it again."

For an artist whose destiny was to reach so far beyond the confining limits of that nineteenth-century realism in which he started, it is remarkable that he did not feel the need to disown his earlier work. Instead, it remained important to him, and he could carry the weight of his accumulated personal history with grace and indulgence. The ultimately transcendental nature of his late work, if not as obvious as in a Kandinsky or a Mondrian, was nonetheless recognized by Matisse himself in 1953, in a brief introduction to a publication on his chapel at Vence (colorplate 46). There he noted how the Beaux-Arts teachers of his youth had valued only those observations made after nature, and derided anything coming from the imagination as mere "chiqué." He continues: "Throughout my career I have reacted against this opinion, to which I could not submit myself, and this struggle has been the source of the different avatars along my way, during which I have sought for possibilities of expression beyond the literal copy."

Without doubt, the tension between the subject as

perceived and the demands of his artistic materials and means provided a permanent source for renewal in Matisse's art.

For many observers, Dance and Music remain the climactic works of the artist. Commissioned in 1909, painted and exhibited at the Autumn Salon in 1910, temporarily rejected but finally accepted by Shchukin, they represent, in effect, two-thirds of a vision for the expressive decoration of an artist's studio, the final third of which is represented by Five Bathers (Composition II; fig. 22), a small study of about 1910 which is almost certainly the first project for Bathers by the River (colorplate 31). While the completed monumental version of Matisse's Bathers (1917) is one of his most important ventures in the direction of a decorative Cubism, the early study is in a manner consonant with Dance and Music, and evokes the ambiance and, in a more generalized way, the theme of Le Luxe (1907). Five Bathers also evokes certain compositions of Gauguin in both theme and layout. Matisse was familiar with Gauguin's work as early as the late 1890s, and the importance of his influence in the development of the younger artist's larger figurative compositions, not to mention his choice of motifs, has yet to be fully explored.

Because of the overwhelming clarity of composition in these pictures and the way in which they sum up and partly conclude ideas launched earlier in the decade, they have tended to obscure the importance of the next major series of large-scale works, the four so-called "Symphonic Interiors" (colorplates 21-24), all works of 1911. In fact, the major paintings of these two productive years, 1910 and 1911, would seem to be intimately linked as different aspects of the studio theme. Dance, Music, and Bathers each addresses itself to the question of decorating the artist's studio; three of the four "Symphonic Interiors"—Red Studio, Pink Studio, and Still Life with Aubergines—are concerned with a spiritualized, decorative "representation" of it; the fourth, The Painter's Family, establishes a domestic contact and context for them. When these seven monumental works are considered together, we discover a fascinating dialogue between the various layers of art and life. We are simultaneously aware of the life of the model or motif and the complementary life of the design or composition, and especially the interplay between the two. Together they represent a manifesto on the creative process that is more fundamental and original than the concise passages of "Notes of a Painter." It would not seem that the four major paintings of 1911 were conceived as a series, given their varying dimensions. More likely they multiplied in

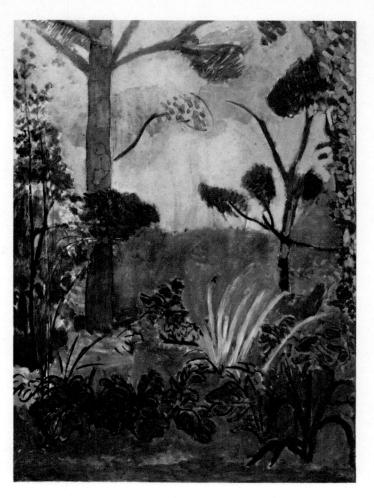

26. PARK IN TANGIER. 1911–12. Oil on canvas, $46\ 1/2 \times 31\ 1/2''$. National Museum, Stockholm

an entirely spontaneous fashion and set the stage for later, though less monumental, pictorial views into the artist's studio. The chief difference in the later pictures is the frequent inclusion, within the image itself, of the artist's own presence.

Of the smaller paintings of 1911, Blue Window (fig. 25) is perhaps the most remarkable. Though unrelated in format, it follows the coloristic and compositional principles of Red Studio. That is to say, the entire ground of the picture is of a single hue, although individual objects are allowed to retain their own local color. This results in an effect in which the objects seem to float in a kind of aqueous space, an imaginary pictorial atmosphere analogous to the aquariums to be found in the numerous paintings of goldfish of this period. Blue Window was painted for the famous couturier and bon vivant Paul Poiret, who refused to accept it. Given Poiret's later patronage of the designers of Art Deco in the 1920s, together with the subject of the painting, an open window, one is inclined to suspect that the present picture might originally have been destined to serve as part of a coordinated interior design by one of the fashionable

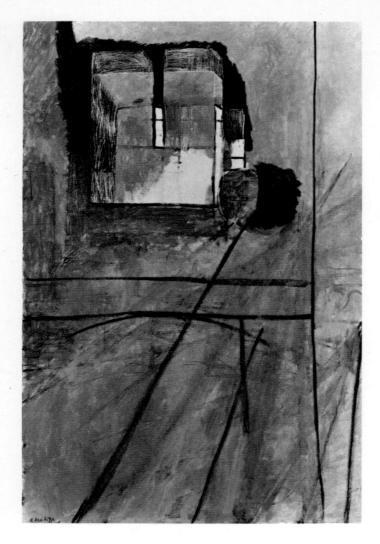

above: 27. VIEW OF NOTRE-DAME. 1914. Oil on canvas, 57 $3/4 \times 37''$. Private collection, New York City

below: 28. STILL LIFE AFTER DE HEEM. 1915–17. Oil on canvas, 71×87 3/4". Florene M. Schoenborn–Samuel A. Marx Collection, New York City

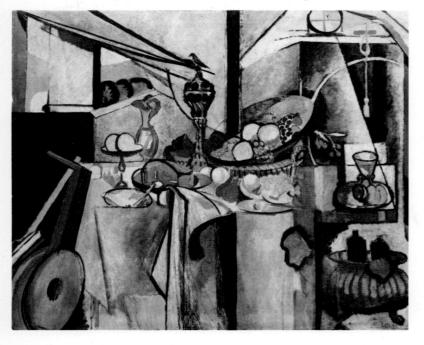

decorators of the post-Art Nouveau epoch. The style that Matisse developed, or, more exactly, "condensed" here, one based upon comparing a variety of spherical and rounded forms, is one of his more abstract, and would certainly lend itself to architectural purposes.

After the protracted effort of the previous five years, with much of it related to two intertwined themes—the revived arcadian composition and the heroically scaled interior, both of which were hinged upon Matisse's deep-felt emotions and associations with the studio—it is not surprising that he sought new stimuli to sustain at least a part of his work in the second decade of the century. In 1910 he had traveled to Munich to see an exhibition of Muslim art, in company with his old friend of student days Albert Marquet. Late the following year he returned to North Africa (having been there in 1906), and this trip was followed by another during the winter of 1912-13. His companions on these trips were his Fauve friends Marquet and Charles Camoin. These voyages abroad are unique in his career in that they were working trips, resulting in major series of paintings as well as retained impressions that would serve as the inspiration for other compositions carried out in the studio after his return. Park in Tangier (fig. 26) and Moroccan Garden (colorplate 25) are representative of the earlier trip, Zorah on the Terrace and Entrance to the Kasbah (colorplates 26, 27) of the second. These remarkably hued, atmospherically intense studies made on the scene hardly prepare us for the synthetic, even symbolic masterpiece The Moroccans (1916; colorplate 32). Here, in an unusual tripartite format, the artist, profiting from his essays in a Cubist manner starting in 1914, interjects an effective discontinuity in the visual image. He ruptures the nominal linkage among the three parts of the picture, each of which is held in suspense by black, spatially indeterminate areas, and then reestablishes the picture's unity through the geometric echoing of circular and curved forms among the architecture, the fruits and leaves, and the group of praying figures.

This fragmenting of a single decorative surface into three parts in *The Moroccans* is a device which represents Matisse's belated and partial assimilation of Cubist concepts during the years 1914–17. While a number of significant pictures of this period show hardly a trace of this preoccupation, others represent a very direct effort to come to grips with a style that in its early phase, around 1907, was inimical to the organic growth of his personal manner. But by 1914 the heroic days of Cubism were over, and its style (termed Synthetic in its later stage)

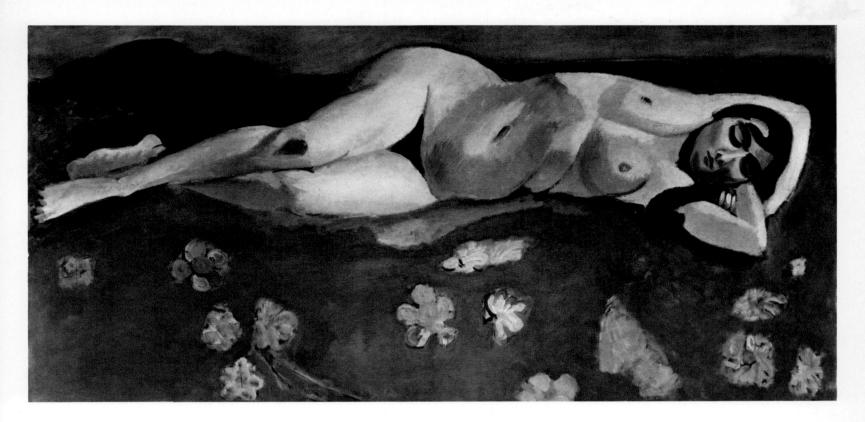

was tending toward decorative flattening and simplification. Moreover, some Cubists were introducing strong colors into their studies of fractured planes and dislocated volumes, in sharp contrast to the more monochromatic tendencies of earlier Cubism. All these developments, seen best perhaps in the works of Juan Gris of around 1914, were leading to a flattened, patterned pictorial surface of vivid, sometimes clashing hues. This development provided a logical opportunity for Matisse to experiment with Cubist devices without breaking with his own idiom. The historical connection was provided by the fact that Matisse and Gris summered together at Collioure in 1914, holding many conversations and, according to Gris, even heated arguments over painting.

Perhaps not enough has been made of this encounter by students of Matisse's work. However, the major works immediately following 1914, together with many of the minor, would be tinged with Cubist devices, culminating in the completion of *Bathers by the River* (1916–17; colorplate 31) in a manner even more architectonic than the originally contemplated layout of 1910. This period, which roughly coincides with the years of World War I, forms a partial rupture with the lyrical and harmonious era centered upon the efforts of 1910–11. It is as if Matisse almost deliberately introduced difficulties into his established style, one that had been enriched by the travels to North Africa of 1911–13, by introducing abrupt paradoxes and even contradictions into his compositions.

above: 29. SLEEPING NUDE. c. 1916. Oil on canvas, 37 3/8 \times 76 3/4". Private collection, New York City

below: 30. THE STUDIO, QUAI SAINT-MICHEL. 1916. Oil on canvas, 57 $1/2 \times 45 3/4''$. The Phillips Collection, Washington, D.C.

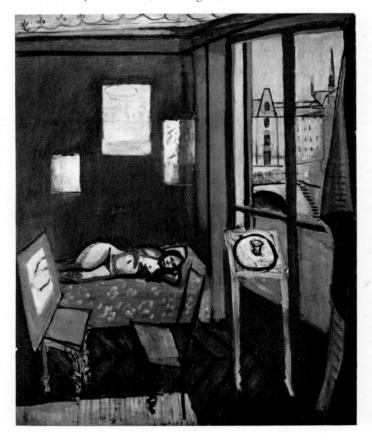

left: 31.
MLLE YVONNE
LANDSBERG. 1914.
Oil on canvas,
58 × 38 1/2".
Philadelphia Museum
of Art. The Louise
and Walter Arensberg
Collection

right: 32.

PORTRAIT OF

A WOMAN. 1916.

Oil on panel,

13 × 9 1/2".

The Harry N. Abrams

Family Collection,

New York City

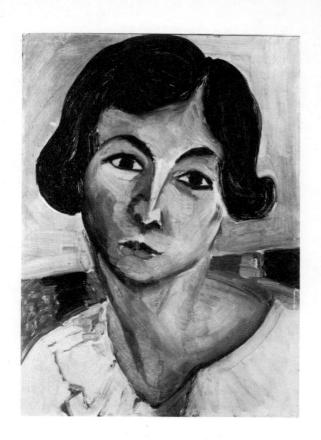

33 a-c. THREE SISTERS. 1916–17. Triptych, oil on canvas, each panel 77 imes 38." \odot The Barnes Foundation, Merion, Pennsylvania

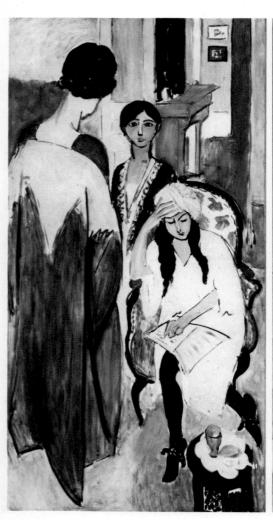

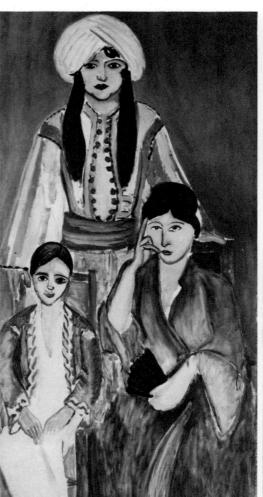

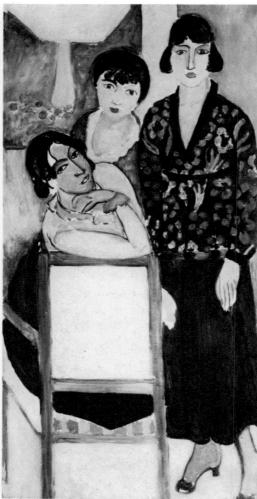

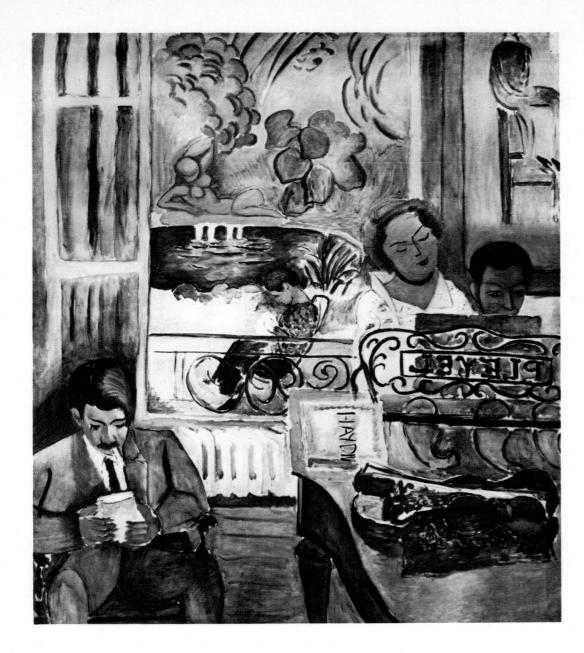

34. THE MUSIC LESSON.
1916 or 1917. Oil on canvas,
96 × 82 1/2".
© The Barnes Foundation,
Merion, Pennsylvania

35. TEA. 1919.
Oil on canvas,
55 × 83". Collection
Mr. and Mrs. David Loew,
Beverly Hills, California

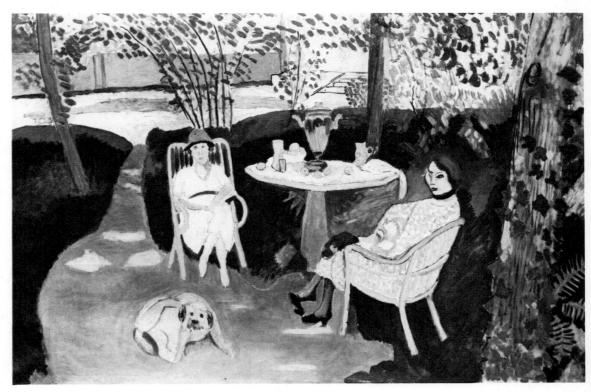

As if to indicate his perplexity and his need to reconsider many basic questions concerning the creative process that he had expounded in the 1908 "Notes of a Painter," he resorted to a device of his pre-1900 student years. In 1893-95 he had made a rather ordinary, if loose, copy of Jan de Heem's The Dessert as one of several studies after Old Masters in the Louvre he did under the tutelage of Gustave Moreau. Interestingly, this would be the title and subject but not the actual source of Matisse's Desserte (1897; fig. 8) and Harmony in Red (1908-9; colorplate 18). In the years 1915–17 he reworked De Heem's image in a canvas of much larger format, employing an almost pedantically Cubist manner (fig. 28). As a Cubist reordering of reality, the final result is not especially consistent or profound, and we must conclude that this picture was, for the artist, a testing ground for the discovery of those elements in Cubism that might be harmoniously combined in his own work. As noted elsewhere, Bathers by the River still exhibits traces of work done much earlier in a different mode, yet it is the later, Cubistinclined overpainting that dominates. However, The

37. Matisse in his apartment in Nice, 1928

Piano Lesson (1916; colorplate 33), with its massing of flat planes outlined by a grid of horizontal, vertical, and diagonal lines, is perhaps Matisse's most consistent assimilation of the Cubist legacy, a picture that is indebted to that movement and is not merely a collection of incompletely borrowed or reinterpreted devices (as had been the case with the Neo-Impressionist Luxe, calme et volupté of 1904, as well as with several of the painter's more superficially Cubistic canvases). Ironically, during or shortly after the execution of The Piano Lesson he painted its pendant, The Music Lesson, in a ripe, softened style, one which nonetheless makes use of the same basic palette of pinks, greens, and grays, as if to say that having conquered the Cubist question, he could turn his back on it. Yet Cubism did have a durable effect on his art later—on the large murals of Dance (colorplate 43, fig. 45) as well as on his late papiers-découpés.

The decade subsequent to the Cubist adventure was outwardly one of retrenchment for Matisse. Not only did he abandon for a considerable period the architecturally scaled, geometric structure of such achievements as *The Piano Lesson*, but he abandoned work in large format altogether. Moreover, the coloristic daring of *Red Studio*

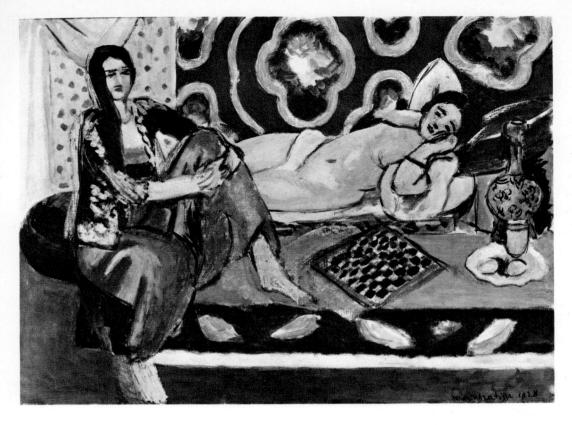

38. ODALISQUES. 1928.
Oil on canvas,
21 1/2 × 29 1/2". Collection
Mr. and Mrs. Ralph F. Colin,
New York City

39. MOORISH WOMAN. 1922. Oil on canvas, 18 1/4 \times 15". © The Barnes Foundation, Merion, Pennsylvania

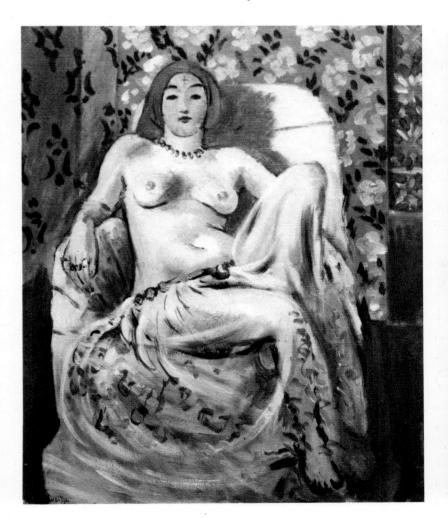

40. ODALISQUE WITH TAMBOURINE. 1926. Oil on canvas, 28 × 21". Collection Mr. and Mrs. William S. Paley, New York City

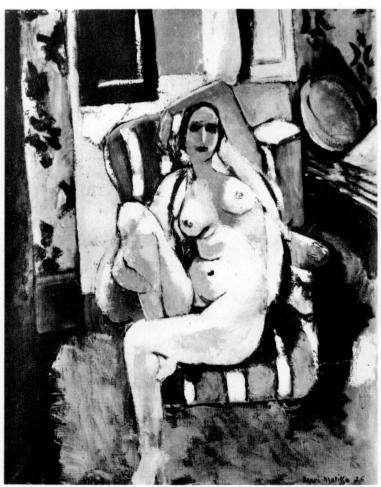

(1911) and the legendary, mythic scope of Joy of Life (1906) are missing from the calm decade of the 1920s, when the artist concerned himself largely with small, Intimist canvases of interiors. These almost invariably reveal improvised studios in hotel rooms or temporary apartments in Nice, which, from 1916 onward, became increasingly the artist's most important working address. Still life and muted landscape also abound during this period, but the interior, normally including the female figure—singly, in pairs, or in trios—is surely the dominant motif. In effect it is a re-creation of the studio theme, now integrated with and enriched by other concepts: the artist's living environment—presented earlier as a single theme in The Painter's Family (1911; colorplate 23) together with the North African motif-exemplified by the frequent inclusion of costumed or partly costumed odalisques. This dovetailing of earlier motifs into single images is paradoxically accomplished in paintings of rather small scale, in muted if often complex color harmonies, and with soft, pliant contours replacing the taut, astringent design of his earlier work.

Because of this softened style, many commentators have concluded that Matisse had now given up the quest for a contemporary art in which he had been engaged for two decades, and was resting on his laurels. Or, at best, this period is seen as a détente, an entr'acte between Matisse's early and late heroic phases. However, this seemingly undemanding manner contains many pictorial subtleties that would not have been possible on a larger scale; furthermore, it presents the artist's favorite motifs in a new synthesis, which, on closer examination, is nothing less than the domestication of Luxe, calme et volupté. One of the most sumptuous of these paintings is Moorish Screen (1922; fig. 36). The vantage point is high, helping to create a tension between the plane of the carpeted floor and that of the wall, whose major ornament is the screen of the title. Almost lost in this sumptuous yet delicately colored and lightly brushed interior are two young women, casually posed in simple white dresses. A mood of indolence is conveyed by this contrast, which in theory ought to be quite abrupt but in fact does not clash at all. Similar unities are to be found in the many and infinitely varied odalisques of the 1920s, in which the play of flesh and fabric is invariably challenging, frequently emphasizing the mutual softness of both, but with the flesh as a more potent reflector of other lights and other colors. Alternatively, as with the Odalisque with Tambourine (1926; fig. 40), the artist becomes impatient with these soft, reflective tones and indulges in a more stringent interplay of painted surfaces, especially between the fig-

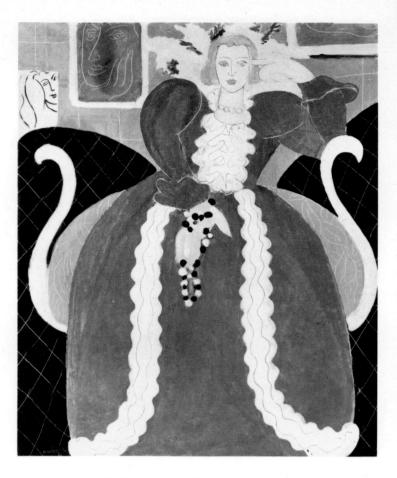

41. LADY IN BLUE. 1937. Oil on canvas, 36 $1/2 \times 29''$. Collection Mrs. John Wintersteen, Philadelphia

ure and its surroundings. The most striking of these souvenirs of North Africa painted in Nice is *Decorative Figure* (1925; colorplate 40), which conveys the paradox of soft texture and a light almost totally absorbed by the nap of the carpets and hangings, contrasted with a strength and clarity of design represented by the forcefully modeled figure and the inventive variations of the flat fabric patterns.

The studio nude, or odalisque, is a motif closely associated with the period of the 1920s, but it should not be forgotten that this normally recumbent figure is a theme that recurs both early and late. Blue Nude (1907; fig. 14) has already been mentioned, together with her much later sister, the rather Ingresque Pink Nude (1935). Larger in dimensions than either of these important works—in fact, lifesize—is the little-known Sleeping Nude (c. 1916; fig. 29), which is shown being painted in Studio, Quai Saint-Michel, of the same year (fig. 30). In some of the paintings of the 1920s the artist's presence is clearly indicated, either by the inclusion of his figure or a fragment thereof, or through the device of the mirror reflection (the mirror

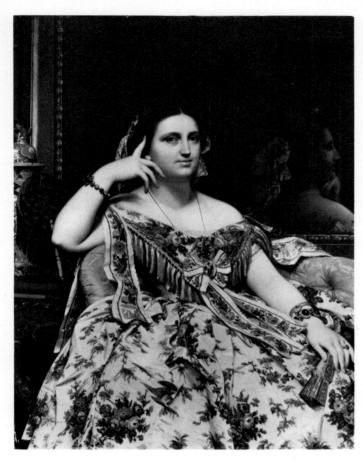

42. J.-A.-D. Ingres. MME INES MOITESSIER SEATED. 1856. Oil on canvas, 47 $1/4 \times 36 1/4''$. The National Gallery, London

being, like the open window, an analogy with the frame and contents of the created picture). One major realization of this motif is in the extensive series of pen-and-ink drawings *Nude in the Studio* (figs. 96, 97) which dominate the period 1935–37. These offer seemingly infinite variations on the nude model, her mirror reflection together with that, frequently, of the artist, whose hand or figure fragment is even occasionally present in the foreground of the sheet. This dialogue between the artist and his model becomes increasingly important in the later mutations of the studio motif, although it had been announced as early as 1903 in *Carmelina* (colorplate 10).

He was occupied throughout the 1920s with the paintings of reconstructed harems along with their passive, accommodating occupants, so comparison with Delacroix, and even more significantly with Ingres, is inescapable. Ingres was, as is well known, rediscovered and newly appreciated by artists of the Cubist generation, and Picasso, as early as 1915, was executing drawings that would seem

to be specific references to the style and presentation of the great French Neoclassicist. It cannot be proved that Matisse was aware of Ingres's Golden Age at the time of Joy of Life or shortly thereafter, but nonetheless there are significant parallels in their work that point to a more serious concern with Ingres on Matisse's part from the late 1920s onward. The Neoclassic component in Matisse's art is, for the most part, subterranean and complex. His work of 1900–1910 is an expansion and refinement of Cézanne's treatment of a favorite classical theme, namely the Bather, largely purged of its specific mythological element. In 1918 he met Renoir, and certainly something of the delicate sensuous touch of Matisse's paintings of the 1920s is indebted to this contact. Renoir's late classicism was lacking in the strong arabesque characteristic of Matisse's work of this mid-period, but toward the end of the 1920s a concern for linear structure reappears, and this seems coincident with a serious study of Ingres more than a decade after Picasso had followed a similar path. This was not a capricious turn in Matisse's development, any more than was his interest in certain stylized aspects of Cubism around 1914-17. Rather, it responded to an inner, organic need in his continual growth as an artist.

The Ingresque aspect of the Pink Nude (1935; fig. 15) has already been mentioned, but the portrait Woman with a Veil (1927; colorplate 42) indicates a much earlier beginning for this preoccupation. The frontal pose, with the chin resting on the cupped hand, the forearm balanced on the knee, is especially typical of the works of the earlier master. Even more striking is the resemblance in pose between Lady in Blue (1937; fig. 41) and Ingres's portrait of Mme Moitessier (1856; fig. 42), where the pose has been reversed and the recumbent hand is holding a string of beads in place of the folded fan. Matisse, of course, maintains a greater simplicity and symmetry of outline, and is even more drastic in his avoidance of interior modeling of the figure. Just as the final results achieved by these respective masters of the nineteenth and twentieth centuries are suggestively parallel, the means by which they achieved their uniquely concentrated images is similar. Both began with relatively informal, naturally posed studies (Matisse's early versions of Lady in Blue were on the canvas itself; they were photographed before being rubbed out or painted over), and from there proceeded to the contrived, hieratic images of the definitive versions. The procedure adopted by Matisse in this and in similar works like Pink Nude or Music (1939; colorplate 45) is not simply the grafting of Ingres's

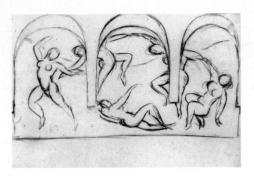

43. Preparatory studies for DANCE. 1930–31. Pencil. Musée Matisse, Nice-Cimiez

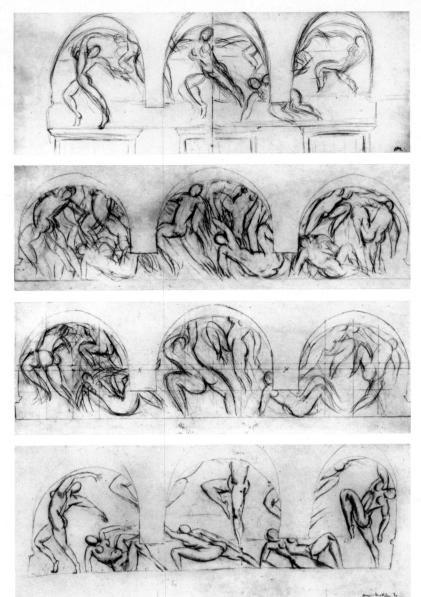

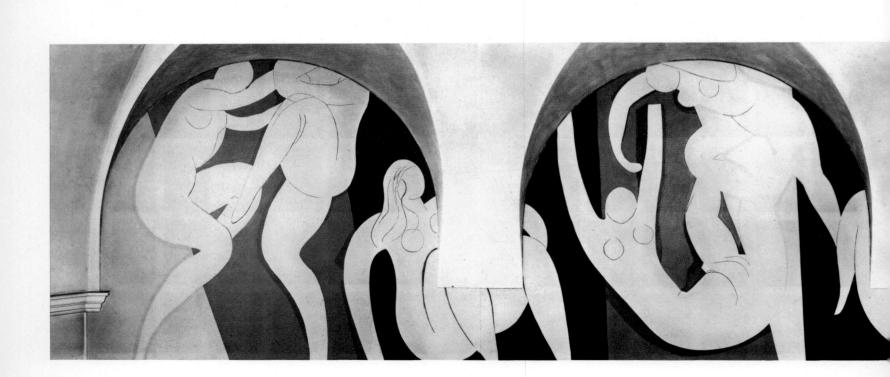

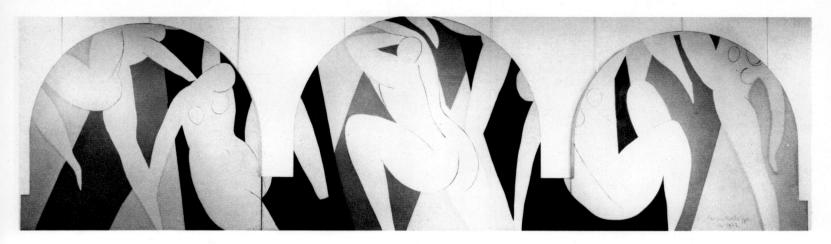

44. DANCE I. 1931-32. Oil on canvas, 11' 8 1/2" × 42' 1". Musée d'Art Moderne de la Ville de Paris

habitual compositional practice onto his own work. Instead, it is the perfection and refinement of his doctrine as presented in "Notes of a Painter" more than a quarter century before. That he could almost coincidentally arrive at a somewhat Ingresque phase in the 1930s is but one more indication of the traditionalistic orientation of his ideals and the thoroughness of his familiarity with the works of earlier masters.

Matisse's art had from time to time, beginning about 1910, shown evidence of leaping the bounds of conventional framed pictures into the area of architectural decoration. This literally took place with the two full-scale versions of *Dance* (1931–33; figs. 44, 45), which, together with the numerous preparatory studies (colorplate 43, fig. 43), are among Matisse's most ambitious. In fact, it was not a new project but the development and adaptation, to a different and arbitrary format, of the dance theme which had begun, possibly as an adaptation

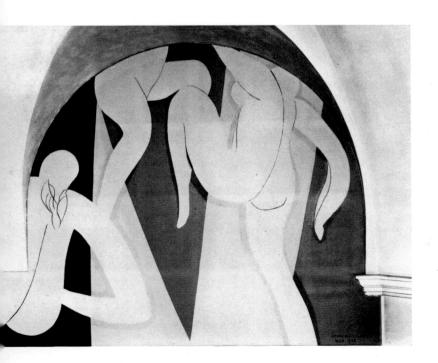

from Ingres or Signac, in the center distance of the Joy of Life twenty-five years earlier. The numerous pencil studies leading up to the two final versions show the gradual mutation of the old theme, the ring of dancers being broken by physical exhaustion and as a consequence of the tripartite arched space into which the mural had to fit (under the vaults of the central hall in the Barnes Foundation, Merion, Pennsylvania). That we are so fortunate as to possess two full-scale versions of this distinctive architectural composition is due to the accident of the artist having received erroneous dimensions in the first instance, and his stubbornness in starting over again with still another variation when this fact became clear. The early pencil sketches as well as the color studies show figures scaled to the contours of the arches, but these figures grow progressively in size until they become enormous, suggestive fragments that overrun the scale of the architecture. Indeed, it is in scale rather than color that Matisse forces the effect of the Barnes Dance and of its mismeasured predecessor. Many commentators have regretted the pale pinks, blues, and grays of these murals, feeling them to be a step down from a previous intensity of expression, but in fact the restrained hues were deliberately designed to blend with the restrained Neoclassic architecture and to avoid competition with other paintings (by Seurat and Cézanne as well as Matisse) that were hung on the lower walls of the same vaulted gallery. Moreover, by grandly enlarging the scale of the figures, the possibilities of decorative flatness in the entire composition were enhanced.

Matisse's own view of the final results in the two

45. DANCE. 1932–33.

Oil on canvas, 11' 8 $1/2'' \times \text{approx. } 47'$.

© The Barnes Foundation, Merion, Pennsylvania

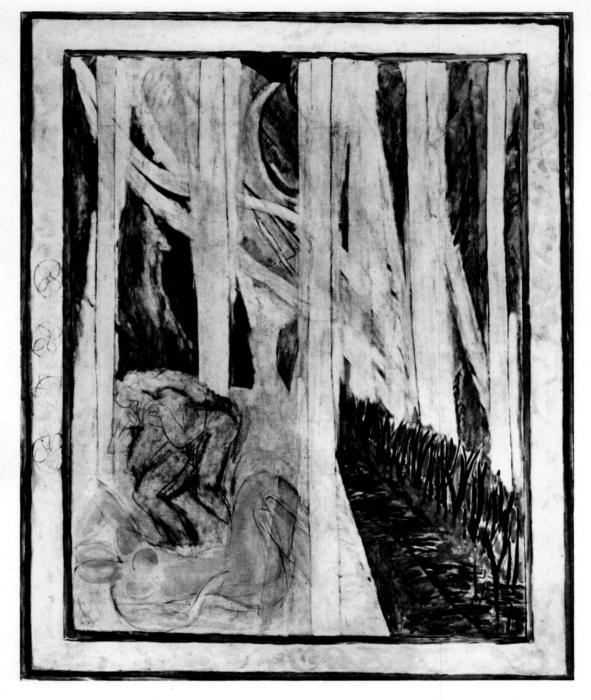

46. NYMPH IN THE FOREST. 1936. Oil on canvas, 96 × 78". Collection Jean Matisse, Paris

monumental completed versions, both of which differ in significant ways from these intermediate studies, is revealing of his aims: "The Merion panel was made especially for the place. Isolated, I don't consider it as anything more than a fragment of architecture." Considering that much later, in the chapel at Vence (1948–51), Matisse was able to carry out an entire architectural ensemble, this attitude is especially important.

Rarely has a twentieth-century artist been offered the opportunity to work at this monumental scale; paradoxically, in the months during which Matisse was at work on the Barnes commission, he was engaged by the publisher Albert Skira to illustrate a deluxe edition of a selection of poems by Mallarmé. Nothing could have been

further removed in size than a project of this genre (it was, in fact, Matisse's first venture into the art of the illustrated book), and yet there is an astounding resemblance between his efforts for each project. Both were the subject of minute study in a multitude of preparatory drawings, though in the case of *Dance* the final result was a vast mural painting, while in the case of the Mallarmé it was a publication featuring twenty-nine full-page etchings. Although the format of the book is not out of the ordinary for luxurious limited editions of this sort (9 3/4 by 13 inches), the illustrated pages possess something of the monumentality of the contemporary murals. Matisse chose to design his plates to equal the full size of the page, dispensing with conventional margins, and to

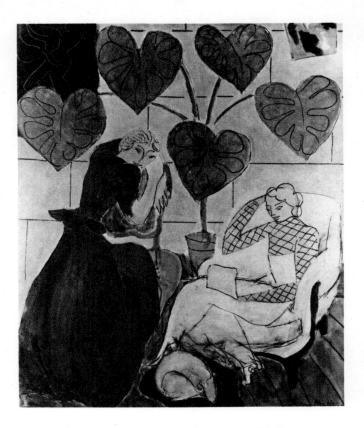

above: 47. THE CONSERVATORY. 1938. Oil on canvas, 29 × 23 7/8". Collection Joseph Pulitzer, Jr., St. Louis

below: 48. THE DREAM. 1935. Oil on canvas, $31.7/8 \times 25.5/8''$. Private collection, New York City

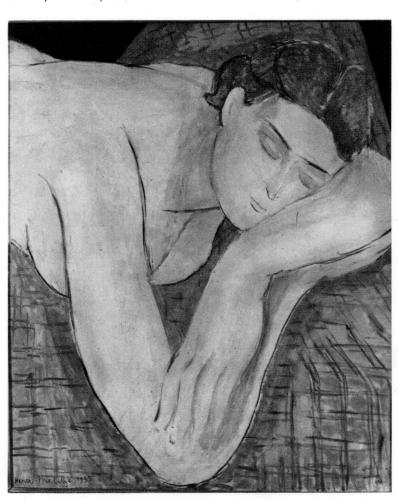

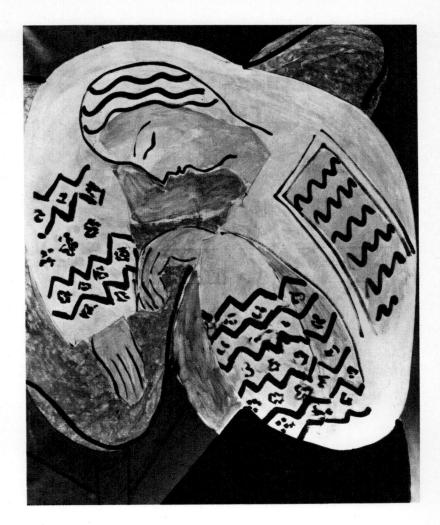

above: 49. THE DREAM (SLEEPING WOMAN). 1940. Oil on canvas, 31 $7/8 \times 25$ 1/2''. Collection M. and Mme Georges Duthuit, Paris

below: 50. LA FRANCE. 1939. Oil on canvas, 18 1/8 × 15". Contemporary Art Establishment, Zurich

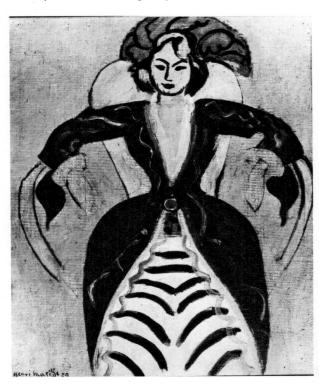

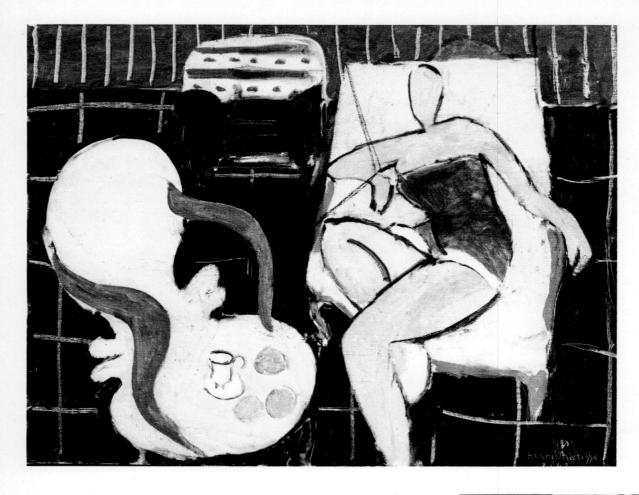

left: 51. DANCER AND ARMCHAIR, BLACK BACKGROUND. 1942. Oil on canvas, 19 3/4 × 25 5/8". Collection Mrs. Marcel Duchamp, New York City

below: 52. ASIA.
1946. Oil on canvas,
45 3/4 × 32". Collection
Mrs. Mollie Parnis
Livingston, New York City

reduce the incidental details of the preparatory sketches to the point where only an etched line of remarkably even weight was used to suggest volume or surrounding space. Consequently, both mural and etched page represent, each according to the nature of its proper material and function, the ultimate condensation of his perception or concept of a given motif. Both seem rendered without effort, with the ease and fluency of experience, and yet both were prepared with minute and painstaking care. Other illustrated books would follow in the two decades and more of life remaining to Matisse, but if he might, in his Ronsard or in Jazz, equal or surpass the originality of concept, he would never duplicate the ethereal refinement or spacious contours of the 1932 Mallarmé.

Now in his sixties, Matisse did not slacken his efforts in the wake of the completion of the Barnes mural in 1933. His efforts continued in several mediums. In 1935 he was commissioned to do a series of etchings for Joyce's *Ulysses*, and instead of illustrating the modern story, he returned to the antique legend to find his subjects for the six plates. In 1935–36 he executed the tapestry cartoon *Window in Tahiti* (colorplate 44), and in the latter year painted the equally monumental *Nymph in the Forest* (fig. 46), which was also probably intended to become a tapestry. Here, reverting to the Nymph and Satyr theme, he develops the figure of the recumbent

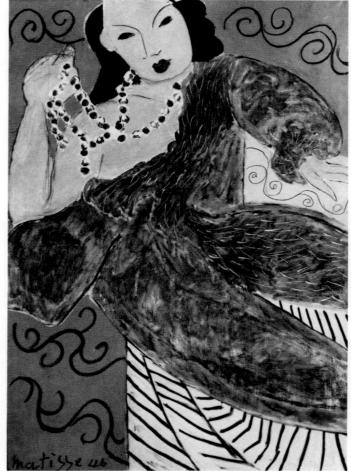

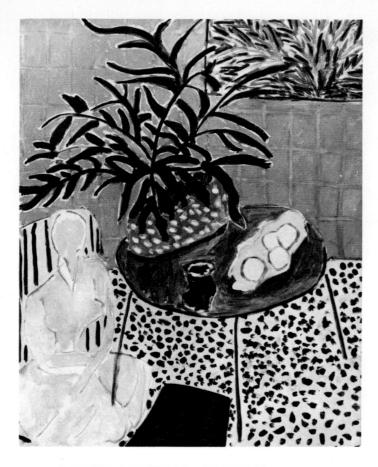

53. INTERIOR WITH BLACK FERN. 1948. Oil on canvas, 45 $1/2 \times 35''$. Collection Mr. and Mrs. Otto Preminger, New York City

nymph from the fallen figure in the center lunette of the Barnes Dance. A monumental drawing of the figures alone, more than five feet in height, was done at this time, but in the early 1940s Matisse drastically revised and simplified it. The subject had been employed for one of the Mallarmé etchings as well, indicating once more the artist's continual reworking of both subjects and poses in a variety of mediums, as well as a variety of scales. Finally, in 1937, he was asked to do a design for Massine's ballet Rouge et Noir. For this project he returned, appropriately enough, to the composition of the Barnes murals, employing that particular architectural form, together with his abstract background, as the basis for the backdrop (the dancing figures being understandably absent from this design, as real dancers would be performing in front of it). And, continuing in an architectural vein, in 1938 Matisse also painted an over-mantel decoration for the Nelson Rockefeller apartment in New York. The painting of four female figures, sitting, reading, and sleeping, quite overwhelms the modest dimensions of the fireplace proper. The painting is over nine feet in height, and is framed by an unusual meandering contour that evokes memories of the Art Nouveau movement which had flourished at the time of the artist's youth.

Of the easel paintings of the period, two of the most splendid are The Conservatory (1938; fig. 47) and The Dream (Sleeping Woman, 1940; fig. 49). The Conservatory develops a theme frequently encountered in the Intimist works of the 1920s but now monumentalized and simplified, even though the picture's actual dimensions are relatively modest. As with the two figures in the 1939 Music (colorplate 45), the problem was one of establishing either a contrapuntal or a parallel pose for the two women: here he opted for the former, while in Music he chose a parallel pose, with the two figures echoing each other. In The Conservatory, the patterns of the two bodies share their importance with the five heart-shaped leaves that provide a virtually heraldic background motif. As for The Dream, it is one of the artist's most remarkable compositions based on the single figure. The subject grows out of an earlier painting (1935) of the head and shoulders of a sleeping model. Now, however, the motif is treated within a boldly fused, all-encompassing circular snail-like motif. One is immediately impelled to see here a variation on a theme dear to Picasso in the late 1920s

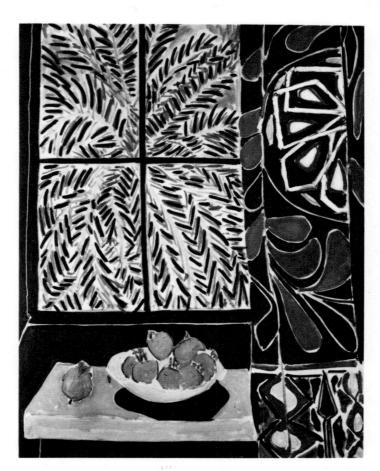

54. INTERIOR WITH EGYPTIAN CURTAIN. 1948. Oil on canvas, 45 $1/2 \times 35''$. The Phillips Collection, Washington, D.C.

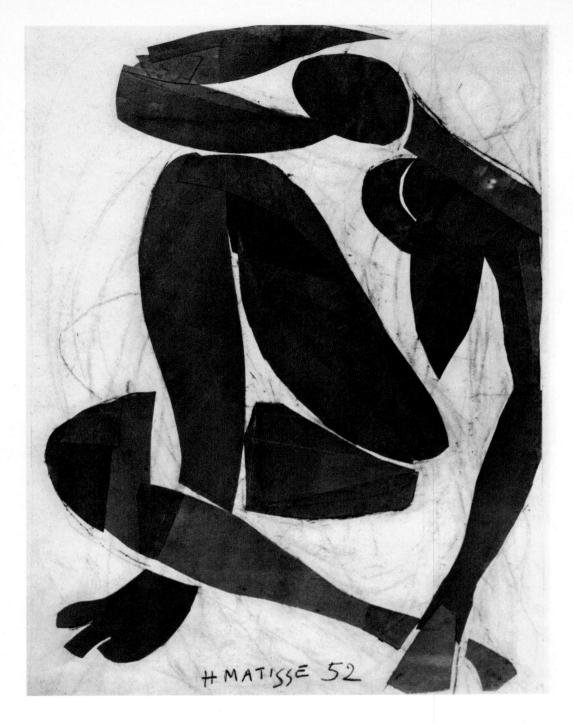

55. BLUE NUDE IV. 1952. Papier découpé, 40 1/2 × 29 1/8". Private collection, Paris

and early 1930s. Indeed, this is only one example (and a rather late one at that) of exchanges of motif or pose between the two painters. Moreover, *The Dream* would seem to be the ultimate outcome of his preoccupation over the past decade with an arbitrary, Ingresque type of arabesque. Just before executing *The Dream*, Matisse painted a bright figure in red and yellow, *La France* (1939; fig. 50), in which the heart-shaped leaves of *The Conservatory* are transformed into the figure itself. Even more remarkable are the two nearly identical drawings (fig. 100) that served as studies for this painting, which

seems to have been carried out in a burst of patriotic enthusiasm during the months immediately following the declaration of war on September 3, 1939.

Matisse at first considered leaving France after the defeat in June, 1940, but changed his mind and left Paris for Bordeaux, finally finding his way back to Nice. Once again, as in 1914–18, the artist's career was partly overshadowed by hostilities. By the fall of 1940 he was having difficulty even in finding colors and canvases. More serious was the onset of an intestinal ailment which necessitated two successive operations in March,

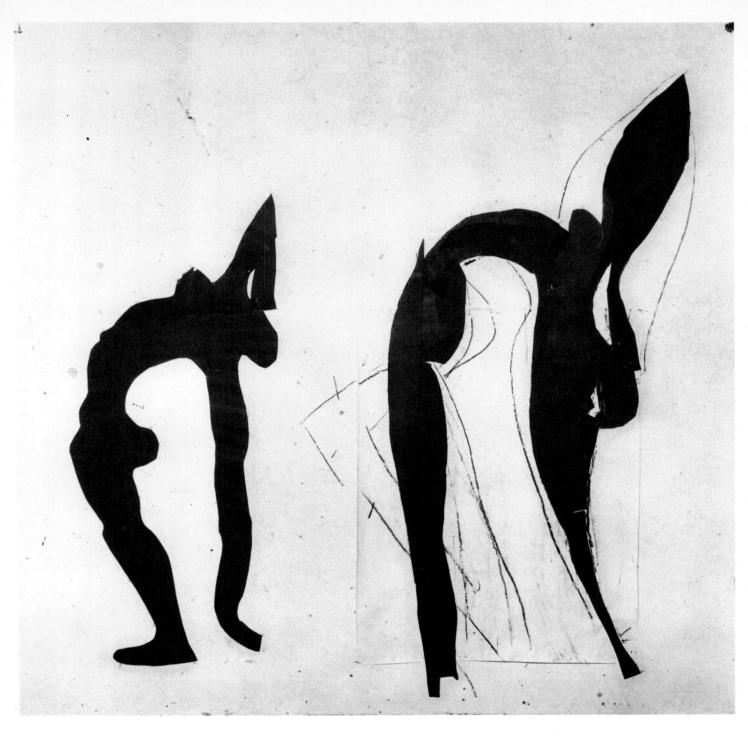

56. ACROBATS. 1952. Gouache and papier découpé, 8' 6" × 8'. Collection Sheldon Solow, New York City

1941, and very nearly proved fatal. From this point on, Matisse was bedridden for many hours of the day, but this physical discomfiture did not slacken his enthusiasm and ability for new work. It is interesting to note that the artist began his professional career in the wake of a slow recovery from an appendicitis operation during his twenty-first year, 1890. A little more than a half century later a similar if more drastic ailment marked the beginning of the last and, for many, the most glorious phase of his career.

Matisse's last paintings, such as Dancer and Armchair,

Black Background (1942; fig. 51), Asia (1946; fig. 52), and Interior with Black Fern (1948; fig. 53), all develop themes that he had been working on in the 1930s or even earlier. One of his very last paintings on canvas, Interior with Egyptian Curtain (1948; fig. 54)—the artist virtually abandoned this medium in 1948—returns to the theme of the open window, carrying us back nearly a half century in his work but with echoes of the interiors of the 1920s. The right margin of the picture is dominated by a curtain of black, with red, green, yellow, and white ornamentation. Beyond the dish of fruit one's view

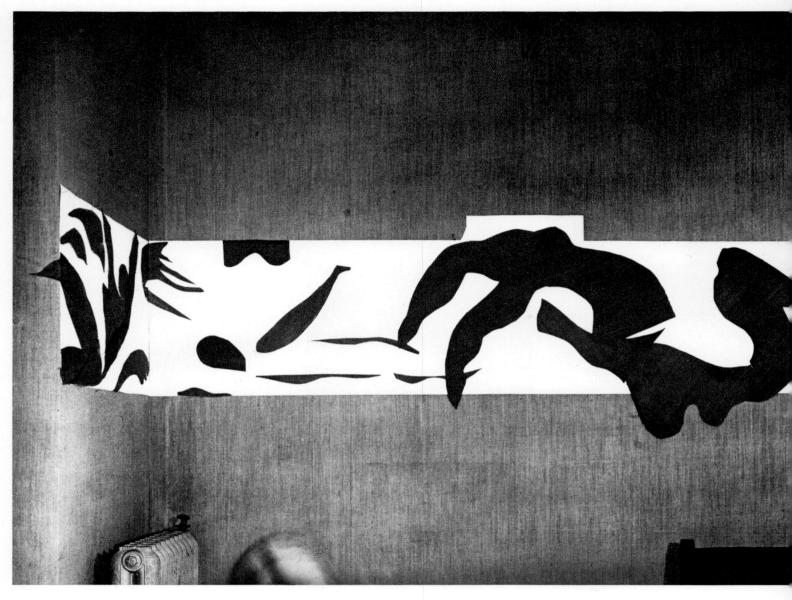

57. THE SWIMMING POOL. 1952. Project for a ceramic mural, gouache and papier découpé on canvas. Half reproduced, size of whole 8' 4 1/2" × 54'. Collection M. and Mme Georges Duthuit, Paris

through the window is completely dominated by the foliage of a palm tree whose curving branches are made to intersect with the rectangular divisions of the window. This landscape fragment is painted in bright blues, greens, and yellows, with accents of black throughout serving to bind together the spaces of the interior and exterior.

Contemporary with these late paintings are some of the artist's most remarkable drawings. An important sequence of these, *Dessins: thèmes et variations*, with a preface by Louis Aragon, was sumptuously published in the midst of the Occupation, in 1943. During this decade Matisse also designed eight luxurious limited editions of various authors, ranging from Ronsard and Charles

d'Orléans to Baudelaire and Montherlant. The most remarkable of these volumes is Jazz (1947), a portfolio of twenty colorplates printed in pochoir after a series of papiers-découpés that date as early as 1943. The plates for Jazz were not composed to a text, but rather Matisse composed a text of meditations on his art to accompany the vivid images. The majority of these are drawn from the theme of the circus, a subject that the artist had never before touched (though of course it figures in a major way in the early works of Picasso). Supplementing the circus themes are a single classical subject, The Fall of Icarus; ornamental landscapes, one titled The Lagoon; and, finally, two mysterious subjects, The Toboggan and Destiny. In the informal, conversational text he speaks of

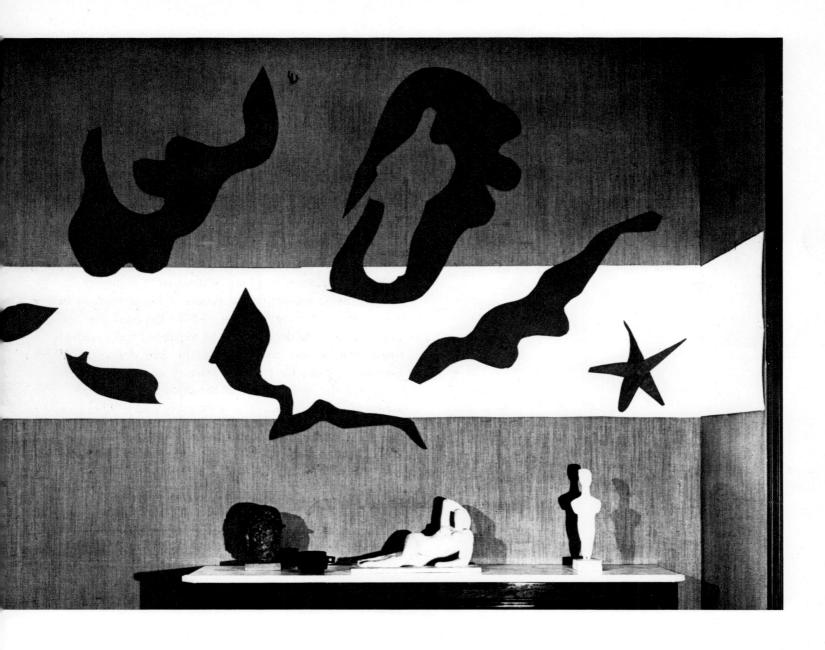

"drawing with scissors," adding: "To cut to the quick in color reminds me of direct cutting in sculpture. This book has been conceived in that spirit."

Matisse's method of papier-découpé is rather different from the collage technique exploited by the Cubists and Dadaists several decades earlier. His procedure was to cover sheets of paper with a uniform color in gouache; then, with one or several colors at hand, he would proceed to cut out the forms and paste them (or have them pasted) on the picture's surface. He had first made use of this technique, though only for purposes of trying out certain hues, while painting the Barnes versions of Dance in 1931–33. However, from 1948 until his death in 1954 this would be Matisse's preferred medium. While the

illustrations for Jazz were, naturally, of rather small format, Matisse quickly realized the possibilities for employing papier-découpé on a grandiose scale—a discovery that led to the great monumental works of the last five years of his life.

The Chapel of the Rosary at Vence (colorplate 46) occupied much of his time during 1948–51. As an artist he successively and simultaneously mastered the arts of painting, drawing, and sculpture, as well as the making of prints in various mediums; there is every reason to think that with sympathetic technical and professional collaboration Matisse could have reached equal heights in architectural design, especially in the realm of creating total interiors.

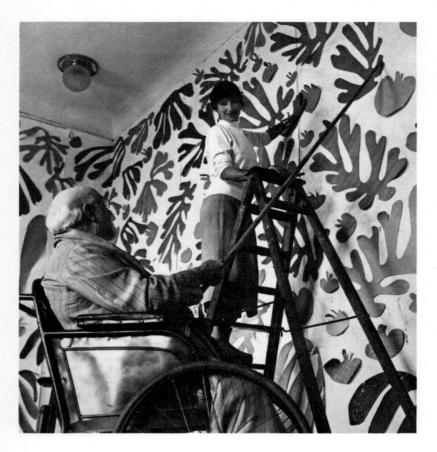

above: 58. Matisse in his studio, 1953

Working with architectural models and with papierdécoupé studies for windows as well as for the priests' chasubles, drawing at large scale for the painted and glazed tiles, and modeling in clay for the bronze altar crucifix must have taxed Matisse's strength. However, upon the chapel's completion he set to work on the surprisingly large number of designs that he was yet to accomplish in papier-découpé. Some of these projects are largely decorative or architectural in purpose, vast ornamental schemes, certain of which were subsequently executed in glazed tile. Others were for stained-glass windows, and still others were figure studies or thematic compositions—as, for example, The Sorrows of the King (1952; colorplate 47). Many of these were pinned to the wall of his studio and other rooms of his apartment in Nice, thus becoming a living, constantly changing and growing series of decorations, an expanded and modified realization of the program that he had described to Estienne in 1909 for the decoration of an artist's studio.

Among the most austere of the papiers-découpés are the series of seated Blue Nudes (1952; fig. 55). The pose should be compared to the 1925 Decorative Figure (color-

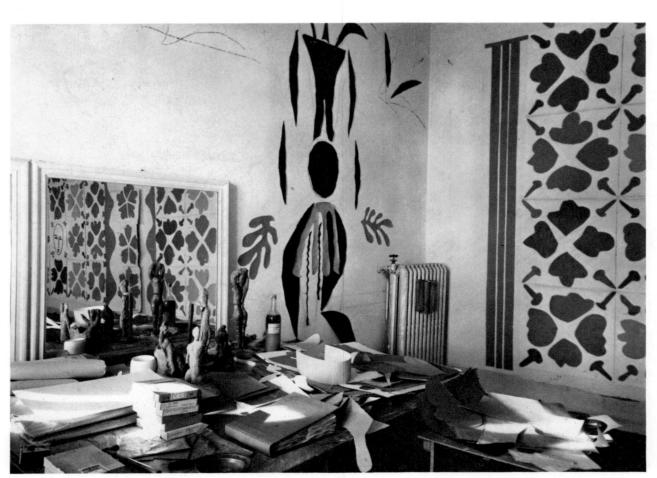

right: 59. A corner of the studio, 1953

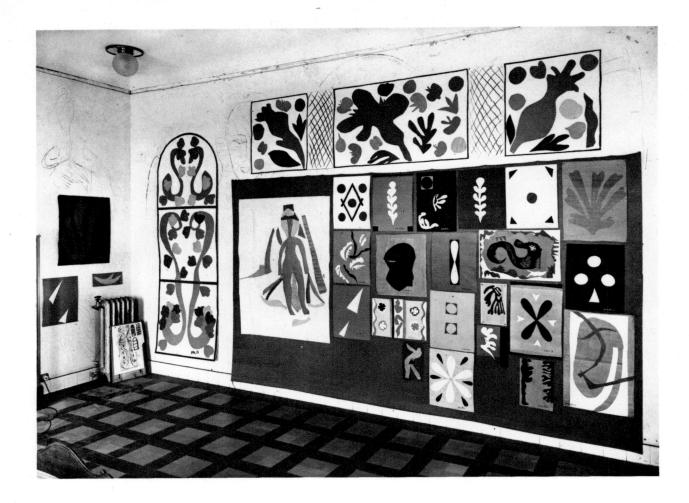

60. A wall in the studio, 1953

plate 40) and may also be related to Picasso's bonelike Seated Bather (1930), while the flattened, stylized rendering represents still another step toward the ornamental, beyond the degree found in Pink Nude (1935). Significantly, Matisse wished that these late works be reproduced without any indications of the slight variations in color intensity, and without the pencil marks on the white paper behind. Hence the present reproduction violates the artist's wishes, but serves to indicate the painstaking, deliberate care that he took to achieve the effect of spontaneity. In fact, the improvised quality of so much of his late work was arrived at only after much consideration and reflection, and only rarely does accident serve to control the final product. The Acrobats (1952; fig. 56) are over-lifesize figures that, in their elastic posturing, seem to grow out of the later versions of Dance, while their subject is reminiscent of the circus theme that runs through Jazz. The most ambitious of the figurative papiers-découpés of this year is The Swimming Pool (fig. 57), fifty-four feet in total length (only half is shown in the reproduction). Here the blue figures are once again set against a white ground, but this time their leapings and cavortings carry them well beyond the upper

and even the lower margins of the paper. The ambitions that had been fired two decades earlier while working on the Dance murals had not been quieted by age or physical infirmity. Here the figures are distorted in a way that must have been suggested by the appearance of objects seen through a surface of water: it is not clear whether we are looking down into the pool or are viewing it in imaginary cross section. In fact, some of the figures seem to be leaping, dolphin-like, from the surface upward, others seem to be diving into the water from above, and still others seem to be merely floating passively on its surface. There is nothing quite like this near-abstract concentration of fluent energy in his previous figurative works save for the various versions of Dance, and the inescapable conclusion is that with The Swimming Pool we are being treated to a water ballet.

Inexhaustibly, Matisse created several more or less "conventional" pictures in papier-découpé at this juncture, notably The Sorrows of the King (1952; colorplate 47) and The Snail (1953; colorplate 48). Beyond these, several photographs (figs. 58–60) of the artist's studio, taken in 1953, show us many of the works of the last full year of his life. The very nature of the photographs

themselves calls up the painted images of the artist's studio which he had so often created over the years, though less frequently after the late 1920s. Here we see small, intimate studies side by side with immense decorative schemes that overwhelm the relatively modest space of the studio. It would almost seem as if the artist had "directed" the photographer in his work, and that only through this medium can we completely grasp the special personal meaning and sense of fulfillment these works had for Matisse.

Matisse's final legacy is thus extremely personal, the inward realization of concepts that were in his mind for much of his working life. With the most abstract and ornamental of the papiers-découpés he had to a degree separated himself from the other surviving members of the École de Paris (Picasso, Braque, Dufy, Derain, Chagall, to mention only the older generation). This break would, however, insure him a special place among the heroes of much younger artists. American painters of various ages and tendencies have been attracted to Matisse's work, especially since he seemed to offer an antidote to the all-pervasive influence of Cubism. Younger artists like Ellsworth Kelly and Frank Stella have been inspired by him at different points in their careers, and a Pop artist like Tom Wesselman has directly copied paintings by Matisse as accessories in his own

compositions. More recently, Roy Lichtenstein, after having previously adapted images from Picasso and Mondrian, has based the iconography of his still-life and studio paintings of 1973 on the French master's handling of these themes. Published and widely exhibited in the early 1960s, Matisse's final creations served to stimulate the efforts and goals of a new generation of late twentiethcentury artists. Indeed, he was concerned with them and their fate almost to the very end. Writing in 1948 to Henry Clifford (who was then organizing an exhibition of his work at the Philadelphia Museum of Art), he observed: "I have always tried to hide my own efforts and wished my works to have the lightness and joyousness of a springtime which never lets anyone suspect the labors it has cost. So I am afraid that the young, seeing in my work only that apparent facility and negligence in the drawing, will use this as an excuse for dispensing with certain efforts which I believe necessary."

The student of Matisse's work thus has a twofold task: he must maintain a freshness of vision so that the purity and succinctness of the completed picture is properly conveyed and at the same time he must remember that the effects of spontaneity ever present in the artist's mature works were achieved only through severe self-criticism, patient reflection, and persistent revision.

SCULPTURE

At first glance it seems inconsistent that Matisse, whose paintings were so frequently directed toward a chromatic two-dimensional reduction of visual phenomena, would have devoted so much effort to mastering the art of sculpture. Further reflection suggests otherwise. While sculpture was, for Picasso, chiefly a useful tool for extending his irrepressible pictorial and thematic invention, for Matisse the art of modeling was a more urgent matter of expanding his mastery over form, the necessary complement of his explorations of space and surface on the canvas. For Picasso, sculpture was a means of broadening his iconography and underscoring the totemistic nature of his work. For Matisse, sculpture was a medium in which he could continue exploring his nuclear motif—the human figure, chiefly female—with results that were more concentrated if only because sculpture, by its nature, impinges directly upon real space as an object, in contrast to the contained, isolated world of the framed canvas.

A consideration of Matisse's sculpture, especially in regard to figure study, serves to emphasize once more the artist's relationship to the various strains of European classicism. With few exceptions, his sculpture was concerned with single figures or their fragments. Consequently, in this medium the unique, isolated human form emerges stark and self-contained to a degree not possible on the flat surface of a painting, drawing, or print. Although he modeled a number of striking portrait busts, Matisse's primary concern as a sculptor was the creation of tangible metaphors concerning the body's structure, surface, and articulation.

Stylistically as well as thematically, his sculpture forms a relatively compact, unchanging body of work, in contrast to the marked evolution of his painting. It thus serves to link the various periods in his art, which in purely pictorial terms seem to reflect differing and even conflicting techniques and goals. This is not to say, however, that there is no significant evolution in his sculpture. Indeed, he returned to certain subjects, notably *The Back*, several times over a period of decades, on each occasion producing a fresh insight into the possible simplification of the motif, a "condensation of sensations."

Sculpture enters Matisse's art along with his discovery of color. In the last years of the nineteenth century he had become acquainted with a variety of Neo- and Post-Impressionist techniques, most of which tended to dissolve the illusionistic substance of the represented form on the canvas through atmospheric or coloristic means. In 1899 and immediately thereafter, his discovery of Cézanne served as a logical corrective to this aspect in his painting—logical because Matisse, especially in the early phases of his career, often progressed by a dialectical process of working in succession with opposed or contrasting procedures.

Although he had made two bronze portrait medallions in 1894, it was not until five years later that he began to grasp the role that sculpture could play in his development. In 1898 or 1899 he sought a meeting with Rodin, who disappointed the young artist by observing that his drawings exhibited "facility of hand," a comment that Matisse characteristically and justifiably resented. Indeed, in his earliest drawings Matisse seldom hides his creative dilemmas, and the conflict of forces remains clearly expressed in many pre-Fauve and Fauve works.

Sculpture was a medium in which Matisse could exercise his patience in a sustained way; modeling in clay obviously offers a more durable physical resistance than does the manipulation of paints. In 1899, working evenings in a municipal art school, he began a free variation (fig. 61) on Antoine-Louis Barye's Jaguar Devouring a Hare (1852), which it took him two years to complete.

61. JAGUAR DEVOURING A HARE. 1899–1901. Bronze, 9 imes 22 1/2". Private collection

While at work on this study, he even went to the trouble of dissecting a cat in order to gain a more direct knowledge of anatomy. The final result is a powerful transformation of the Romantic work. The articulation of the jaguar's body is more expressive than in Barye's original, partly because Matisse avoided surface verisimilitude, thus focusing attention on the flexing masses of the animal form.

Surprisingly, he was able to impart an extraordinary animalistic life to the somewhat abstracted forms of his jaguar, and this radiant physical vitality also emerges in the more static, ponderous *Slave* (1900–1903; fig. 11). Few figures could seem more firmly rooted to their base: the stocky legs, bulky torso, and massive head fully realize a concept that was only partly carried out in the contemporary painting of the same model (colorplate 5). Adding to the effect of this bronze earthbound giant (which in reality is modeled to only half lifesize) is the suppression of the arms, a convention that is altogether permissible in the sculpture but would seem unconvincing and artificial in the painting. The bronze *Slave* and its

companion painting can exist side by side (indeed, their vertical dimensions are nearly equal) as an eloquent demonstration of the parity of painting and sculpture in Matisse's work during these formative years. Each study of the same motif offers a variety of possibilities, each expresses in overlapping yet complementary ways Matisse's unrelenting investigation of the human form. In the end, each version depends on the other; neither is complete in itself, though each leads in different directions in the subsequent evolution of his art.

From this point onward, the artist was almost completely concerned with the interpretation of the female form, in sculpture as in painting. Madeleine I (1901; fig. 63) and La Serpentine (1909; fig. 64), with their undulating, attenuated masses, contrast with the thick, archaizing proportions of Two Negresses (1908; fig. 65). To this group of standing female figures from the Fauve decade must be added Reclining Nude I (1907; fig. 16), the bronze counterpart to Blue Nude, Souvenir de Biskra (1907; fig. 14), a motif that ultimately derives from one of the reclining figures of Joy of Life (1906; fig. 5). The

almost Mannerist contrapposto of Madeleine I contrasts with the stolid earthbound tectonics of the Slave. The pose is related to a painting of 1900, Nude Study in Blue (1900; fig. 62), and once again the arms would appear to have been suppressed in the bronze. However, in the bronze Matisse capitalizes on the fact that the figure is shaped in actual space, and the undulating movement of the legs now carries effectively through the torso and to the inclination of the head. La Serpentine, eight years later, employs a different pose, with the model's left elbow resting on a stand. But though the pose is different. the expressive theme of Madeleine I is here developed and further attenuated. More sinuous, thanks to the reduction of the sculptural masses to tubular arabesques, La Serpentine echoes the linear rhythms of a painting such as Le Luxe II (1907; fig. 20). In this respect we can see how toward the end of the decade sculpture and painting were beginning to serve independent though not dissimilar functions in Matisse's art.

Two Negresses, which has been interpreted as overtly primitivistic or even Africanizing, stands in contrast to the mannered poses of the works just considered. Like La Serpentine, the pose was studied from a photograph, as Albert Elsen has demonstrated, but the photograph simply serves as a convenient stand-in for a live model. The two figures seem to be twins, but there are enough subtle differences in their reciprocal poses (position of hands, spread of legs) to keep them from being mirror images of each other. The supposedly primitivistic quality is probably more a function of Matisse's own inner growth than of any external influence, especially of an exotic sort—even though he was acquainted with African carvings at this early date. Perhaps there is some relation between the pose of Two Negresses and works by Picasso of two years earlier, but if so, it is probably of secondary importance. Matisse, who beginning in 1909 was to create a monumental expansion of the classic motif of the Three Graces in the five-figured ring of Dance, here seems to be trying out a contraction of the same theme with only two figures and also clarifying a particular relationship between "front" and "back."

Indeed, one possible germ of the motif for the five variants on *Back* (figs. 67–71), stretching from 1909 until 1930, would seem to reside in the intense "obverse-reverse" nature of *Two Negresses*. Moreover, the extent of this sculptural odyssey is matched in Matisse's work only by the several paintings of *Dance*. Nor is it insignificant that in the 1909–10 conceptions of *Dance* two of the figures present their backs to the viewer, and that in the 1931–33 variations at least one if not more "backs"

are prominently featured. In execution, the Backs are the only examples of Matisse's sculptural works to achieve real as opposed to apparent monumentality; they are the unique lifesize works in his sculptural oeuvre. The ponderous, earthbound, static figure of the Back series contrasts with the extroverted energy of Dance's garland of figures. Although the five versions of Back are preceded by several drawings, lithographs, and at least one painting of the subject in Matisse's work, the most obvious predecessor and possibly the prototype for the pose can be found in the massive nude of Courbet's Bathers (1853; Musée Fabre, Montpellier). Its bulky proportions, fleshy substance, and emphatically creased spinal column make it seem an obvious source, and Matisse's treatment should be interpreted as a reversal and modification of Courbet's. However, figures viewed from the rear occupy a fairly conspicuous place among the landmarks of nineteenth-century painting, beginning with Ingres's Valpinçon Bather (1808; Paris, Louvre) and its numerous successors, to mention but one instance of the motif treated in a way quite unrelated to Matisse's concern in his sculptured reliefs.

Elsen, who recently discovered a photograph (fig. 67) indicating the existence of the earliest version ($Back\ O$), cites several other interesting precedessors. Back O, probably done in 1909, is the most suggestively fleshlike of the series; in the subsequent versions Matisse begins a search for tectonic variations in which the human form gradually becomes more and more embedded in the artist's material and technique. Back I develops and emphasizes certain subsidiary masses and creases that form angles with the main theme of the vertical spine and the two columnar masses it separates. Back II reworks, broadens, and simplifies these shapes and scorings of surface, and Back III, probably of 1916-17, transforms and further simplifies the concept by replacing the spinal indentation with a long fall of hair. This version can well be compared with the lefthand figure of Bathers by the River (1916/17; colorplate 31). Indeed, the transformation that takes place in Back in the years 1909-17 is probably parallel to that of Bathers by the River from its initial inception (fig. 22) to the final version. Both painting and sculptured relief suggest Matisse's involvement with the problems of Cubism over these years and his ultimately successful adaptation of certain of its schematizing devices into his own more decorative style. Finally, in Back IV Matisse drives the tubular forms to even greater simplification; paradoxically, although the fleshlike naturalism of Back O is now totally gone and the columnar structure almost totally vertical, in contrast to the earlier hipshot pose,

the final version marks a return from the somewhat Cubistic agitation of the intervening studies to a more tranquil surface.

With the completion of Back IV in 1930, Matisse's achievement in sculpture virtually ended, though he continued modeling occasional figures almost to the very end. Before that date he had, however, restudied the theme of the reclining nude, originally conceived in 1907; Reclining Nude II (fig. 72) dates from 1927, Reclining Nude III (fig. 19) from 1929. And prior to these he had, in 1923-25, modeled the most ambitious of his works in the round, the Large Seated Nude (fig. 73). This recumbent or semirecumbent pose, with the model's arms folded behind her head or neck, was repeated and varied in several mediums during the Nice period. But the sculpture would seem to be the definitive statement, with its bold anatomy that establishes an expressive equilibrium between flesh and bronze, and the tense balance of the pose, unsupported yet poised between an upright and a recumbent position. It has become customary to note that the probable inspiration for Matisse's Large Seated Nude was Michelangelo's Night, unlikely as the source may seem for Matisse, especially at this juncture in his career. Yet in his methodical, almost professorial fashion, Matisse had previously sketched from a plaster cast of the Medici Chapel's recumbent nude, which he found in the École des Arts Décoratifs in Nice.

It would seem that Matisse would never stop "studying," whether from artists of the past or from his own past works. *Reclining Nudes II* and *III* are reconsiderations of the bronze done twenty years earlier. Once more we are back to a figurative pose supported on a single

elbow, with one arm raised behind the head. Now Matisse chooses to reverse the figures, placing the head at the right. There is a good deal of slimming and attenuating of proportions, along with a smoothing-out of the surface. Though there are some Cubistic details, especially on the back of *II*, there emerges here a blend of Neoclassicism along with the stylization of the contemporary Art Deco mode.

Matisse's final serial sculptures, Venus in a Shell I and II (figs. 74, 75), though derived from a Hellenistic terra cotta seen in the Louvre, are more important as variations on the figure with arms upraised, as already seen in the Large Seated Nude. Here the artist becomes exceptionally free with the scale and proportions of limbs and torso, and the articulation of the shoulders is extremely summary. And in the second version the pinscaled head, with flattened face and barely suggested features, is perhaps derived from some of Picasso's figures and monument projects of the period. From this point onward Matisse's interest in sculpture diminishes sharply. From the 1930s on, the thrust of his painting is more and more toward surface reduction, in which solid form and spatial void are perhaps best defined as positive and negative coefficients of the same substance, painted canvas. Before long he was to supplement his painting with the new medium of papier découpé, in which scissors take the place of the sculptor's blade. This happened in the early 1930s, while Matisse was engaged in studies for the Barnes murals. It would seem to be no coincidence that this period marks the falling-off of his interest in sculpture.

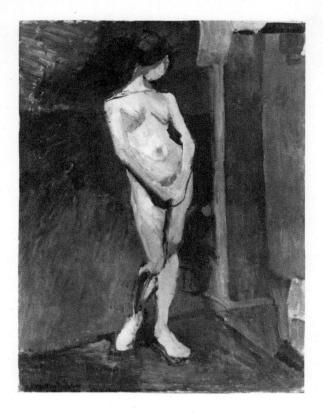

62. NUDE STUDY IN BLUE. 1900. Oil on canvas, 28 $3/4 \times 21 \ 5/8''$. Tate Gallery, London

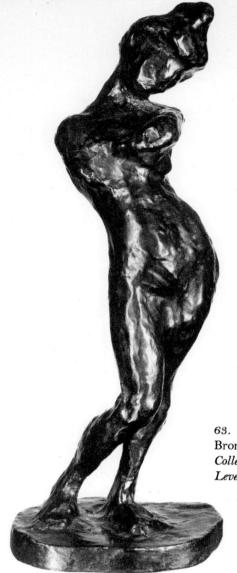

63. MADELEINE I. 1901. Bronze, height 23 3/8". Collection Mrs. M. Victor Leventritt, New York City

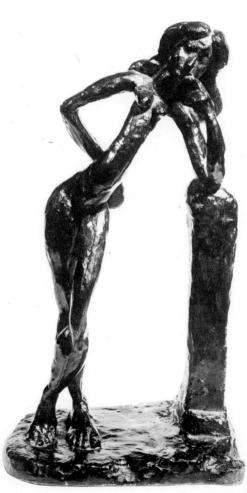

64. LA SERPENTINE.
1909. Bronze,
height 22 1/4".
Museum of Modern Art,
New York City.
Gift of Abby
Aldrich Rockefeller

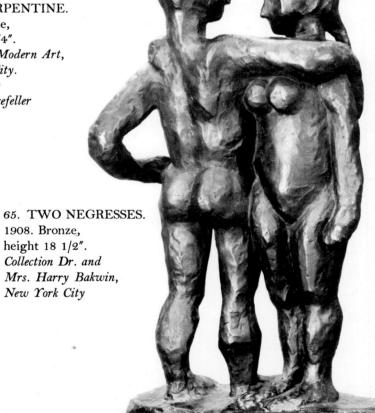

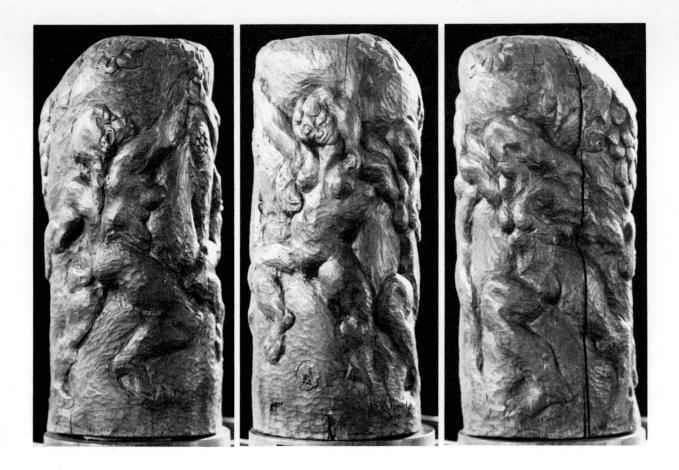

66. DANCE (three views). 1907. Wood, height 17 3/8". Musée Matisse, Nice-Cimiez

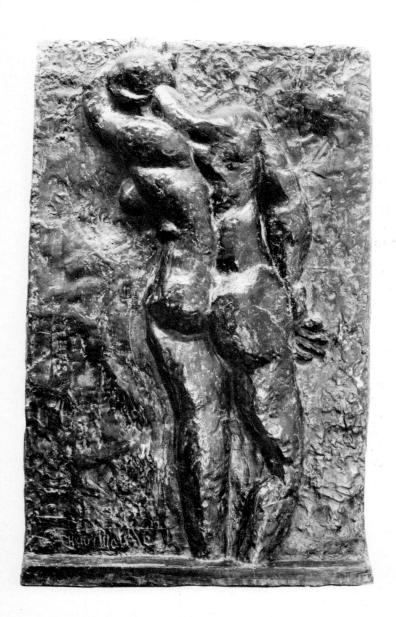

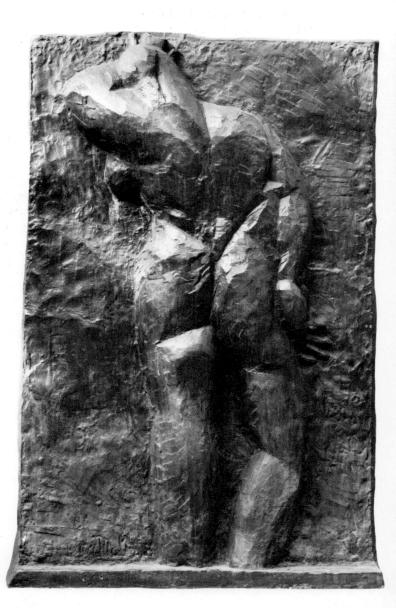

67. BACK O. c. 1909. Clay. Whereabouts unknown

below, left to right:

68. BACK I. 1909. Bronze, 74 3/8 \times 44 1/2 \times 6 1/2"

69. BACK II. 1913. Bronze, 74 1/4 \times 47 5/8 \times 6"

70. BACK III. Probably 1916–17. Bronze, 74 1/2 \times 44 \times 6"

71. BACK IV. 1930. Bronze, 74 \times 44 1/4 \times 6".

Museum of Modern Art, New York City.

Mrs. Simon Guggenheim Fund

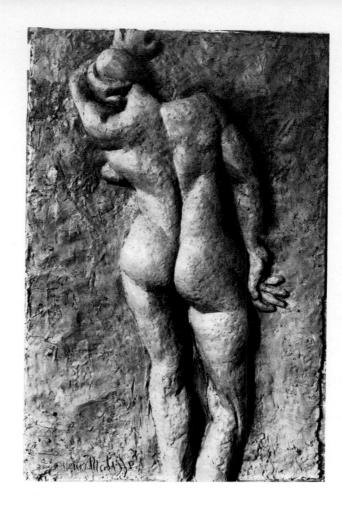

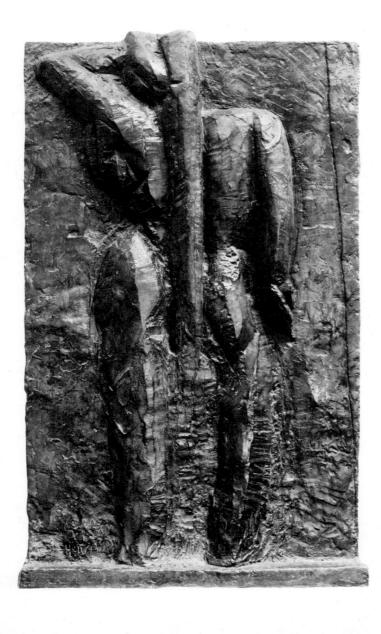

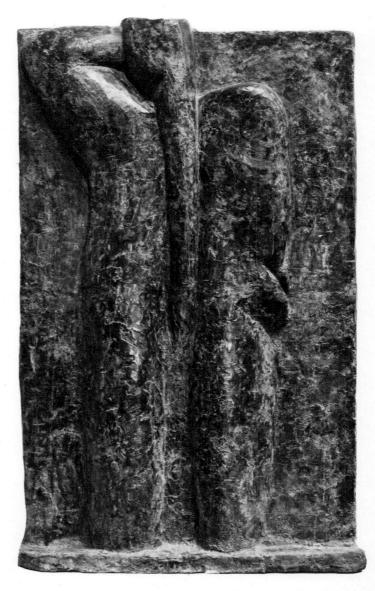

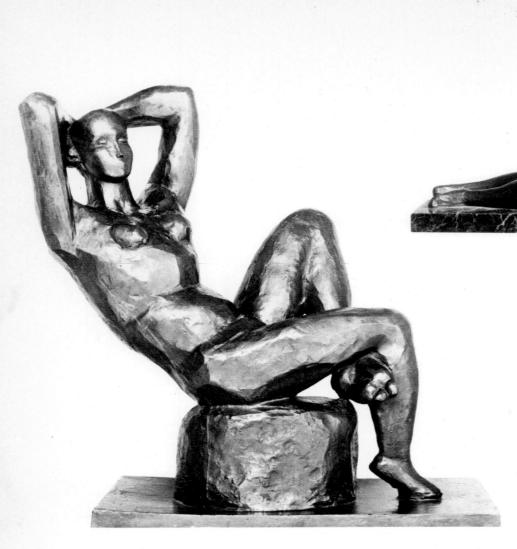

72. RECLINING NUDE II. 1927. Bronze, 11 1/2 × 20 1/4 × 6 1/2". Florene M. Schoenborn-Samuel A. Marx Collection, New York City

73. LARGE SEATED NUDE. 1923–25. Bronze, height 33". Private collection

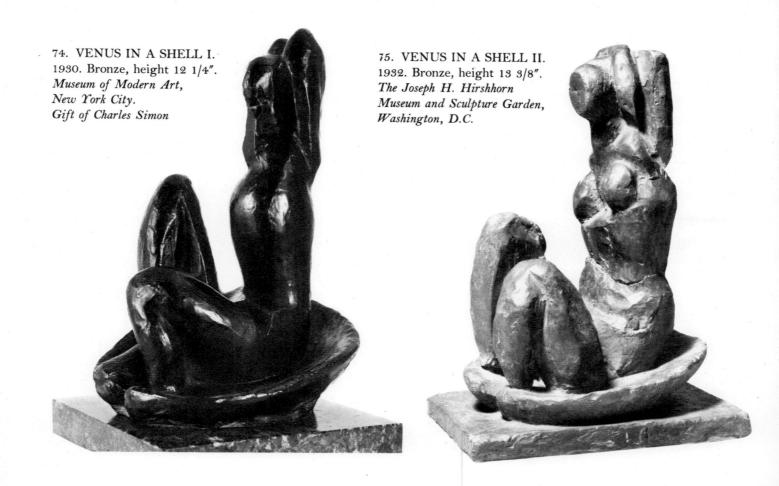

DRAWINGS

Nineteenth-century academic practice virtually decreed that a prospective artist must master the art of drawing before he moved on to painting and sculpture—surely a frustrating situation for certain of the more independent talents of the last one hundred and fifty years. Yet we also have the record of a Degas or Manet, two inventive painters whose entire art profited immeasurably from their astounding efforts at drawing. If such radical innovators of the nineteenth century could employ and transform a timeworn technique, it is not surprising that Matisse could follow a parallel path during the first half of the twentieth century. It does however seem that he is one of the last painters of exceptional stature to make drawing, and especially the intimate study of the human figure, a special and distinct part of his art. Once again, we find that the only reasonable comparison is with Picasso. Other painters of that day, as well as certain of our more recent era, have turned their hand to drawing, but their calligraphy bears little relation to the tradition which Matisse's art-on-paper sums up and, in effect, terminates. It was with his mastery of drawing that Matisse most completely established his relationship with older traditions. In his own teaching, in the Académie Matisse (1908-11), the artist went to great lengths to emphasize the importance of drawing as a foundation. Here he was putting his students through paces similar to those of his own slow beginnings. It is easy to pass over Matisse's early drawings as mere academic exercises made only at the goading of a teacher. This is not justified by the evidence: even after leaving the tutelage of Bouguereau he continued to draw assiduously, and in effect he never stopped for the rest of his life. Drawing was a special kind of nourishment for him, as well as a link to his earlier works and the art of the past; it was even a link between his accomplishments in other medi-

ums—painting, sculpture, and graphics. Nowhere else can his more private side be detected, whether we are considering a preparatory study for a work in some other medium or a drawing made to stand by itself as a completely fulfilled work. Many will consider it strange that one of the outstanding colorists of the early twentieth century was also one of its most consummate draftsmen, but that very paradox, which serves once more to bury the hoary controversy in French art politics between the anciens and the modernes, between the draftsmen and the colorists, also serves to characterize Matisse's unique role as a historic yet contemporary figure.

In his 1908 "Notes of a Painter" he remarked: "What interests me most is neither still life nor landscape but the human figure. It is through this that I best succeed in expressing the nearly religious feeling that I have toward life. I do not insist upon the details of the face. I do not care to repeat them with anatomical exactness." Although Matisse also found time to paint a significant number of fine portraits, and was not uninterested in this mode of expression (in 1954 he composed a book, Portraits par Henri Matisse, Monte Carlo, Éditions du Livre, André Sauret), many of his figure drawings are, to all intents and purposes, featureless, the model's head being indicated by a simple geometric construct. Given the importance of the large figurative compositions in Matisse's oeuvre as a painter (and, for that matter, as a sculptor), the drawings of the figure—the majority being, after the early 1900s, from the female modelprovide a remarkably intimate insight into his art. Certain drawings can be identified as studies for particular pictures; others are champs de manoeuvre in which various poses are tried out, varied, and so forth. Finally, in the work of the latter half of his career, much of the drawing and redrawing is done on the canvas, even with the brush, and the traces of his studies are lost, save for photographs of the work in progress underneath the final painted surface.

Matisse also drew on a large scale: if many sketches and studies are intimate because of their small scale and size, others are monumental because the artist was not content to realize a large composition simply by a process of mechanically enlarging a small sketch. Rather, as in the famous case of the Barnes Dance (1931–33), after making innumerable preparatory sketches in order to engrave the concept in his mind, he chose to redraft the entire composition onto the canvas—addressing this now enormous surface with a piece of charcoal taped to a sixfoot length of bamboo while standing on a bench several feet from the work—so that his bodily as well as his optical reflexes could respond to the entire "happening" in a way that was akin to the spontaneous responses

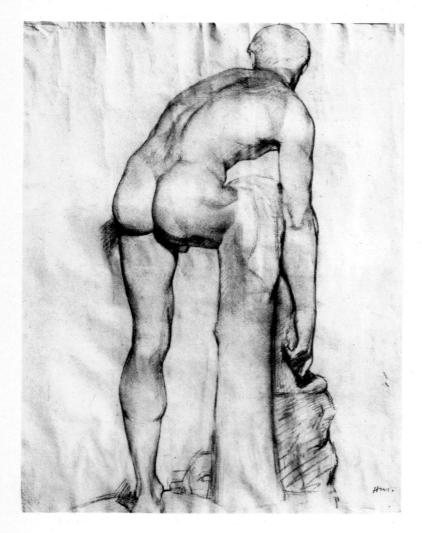

76. CLASSICAL STUDY. 1890–92. Graphite, 24 3/8 × 18 1/2". Musée Matisse, Nice-Cimiez

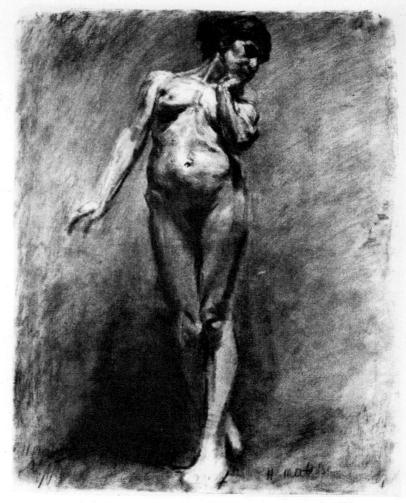

77. STANDING MODEL. 1900. Charcoal, 24 5/8 × 18 5/8". Private collection

possible with a small tablet of paper held in one hand. Matisse's earliest drawings are close to the academic, Neoclassic tradition; as he gradually frees himself in the late 1890s and throughout the subsequent decade, his work becomes expressively more strident, but the touch soon acquires a deftness that could have been achieved only by constant, unremitting application. Then, during this first decade of the century, we become aware of the artist's varied responses to the white sheet of paper, depending on his drafting instruments. This phenomenon carries through the remaining half century of his career, with the quality of the drawings, their relative boldness or delicacy of nuance, depending on the nature of the materials at hand. Matisse's autograph is contained in a lifetime of picture making and related activity, but it is in the ever varied, fluent, form-establishing, space-framing lines of his drawings that we discover the immediate essence of his genius. These works are the necessary complement to the chromatic resonance of his paintings, reminding us that between the various colored areas there lies a boundary, whether indicated by a line or not.

right: 78. CLASSICAL STUDIES IN THE STUDIO. 1890–92. Conté crayon, 22 3/4 × 15". Musée Matisse, Nice-Cimiez

right: 80.

MALE MODEL. c. 1900.
Ink, 12 1/4 × 9".
Solomon R. Guggenheim
Museum, New York City.
Courtesy The
Justin K. Thannhauser
Foundation

below: 81.
SEATED NUDE. 1903.
Pencil, 8 3/4 × 13".
Fogg Art Museum,
Cambridge, Massachusetts.
Bequest of
Marian Harris Phinney

Honer Mahsie

82. NUDE IN ARMCHAIR. c. 1906. Brush and India ink, 25 7/8 \times 18 3/8" Art Institute of Chicago. Gift of Mrs. Potter Palmer

83. THREE STUDIES. c. 1906. Ink, $12 \times 9''$. Dartmouth College Collection, Hanover, New Hampshire

84. EVA MUDOCCI. c. 1915. Black crayon, 36 1/2 imes 27 3/4". Baltimore Museum of Art

85. FEMALE NUDE STUDY. c. 1920. Pencil, 13 $3/4 \times 9 \ 7/8''$. Fogg Art Museum, Cambridge, Massachusetts. Bequest of Grenville L. Winthrop

86. SEATED NUDE WITH RAISED ARMS. c. 1920. Charcoal and estompe, 24×19 1/2". Art Institute of Chicago. The Wirt D. Walker Fund

87. WOMAN LYING DOWN.
c. 1920. Pencil,
14 × 20 1/2". Yale University
Art Gallery, New Haven,
Connecticut. Bequest of
Edith Malvina K. Wetmore

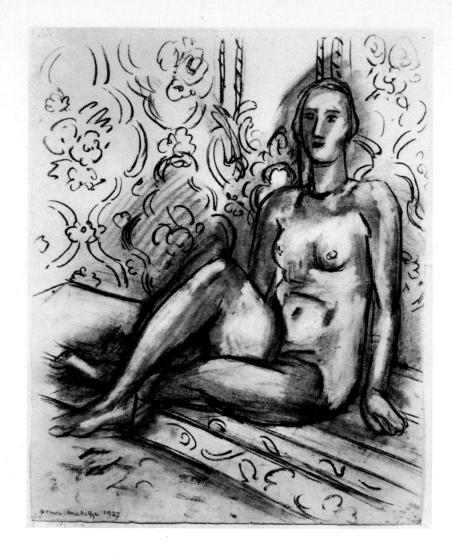

88. SEATED NUDE. (study for *Decorative Figure*). 1925 (signed in 1927). Charcoal, 24 3/4 × 19". *Private collection, Paris*

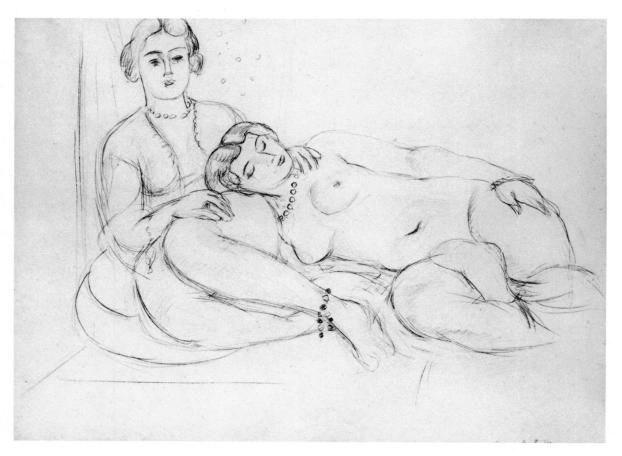

89. TWO ODALISQUES. 1928. Pencil, $14 \ 1/2 \times 19 \ 1/4''$. Private collection

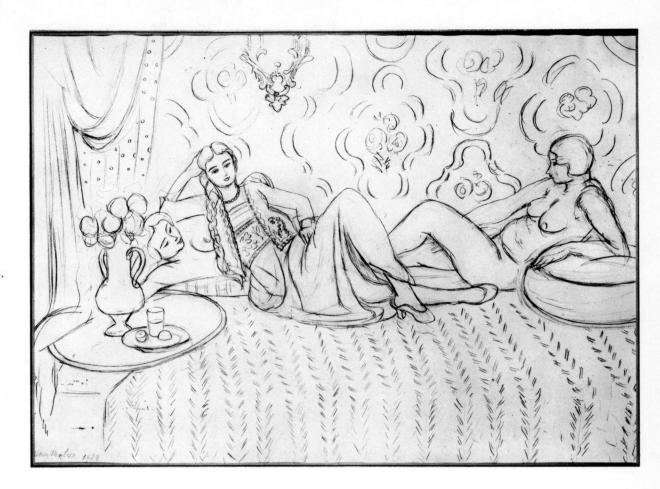

90. THE SIESTA. 1928. Pencil. *Private collection*

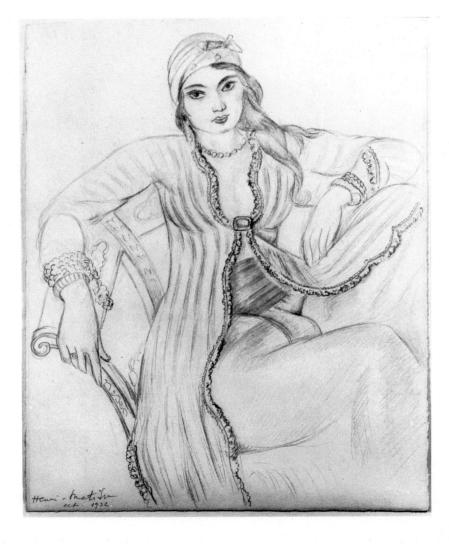

92. Drawing for Mallarmé's *Hérodiade*. 1931–32. Pencil, 13 × 9 3/4". Baltimore Museum of Art. Cone Collection

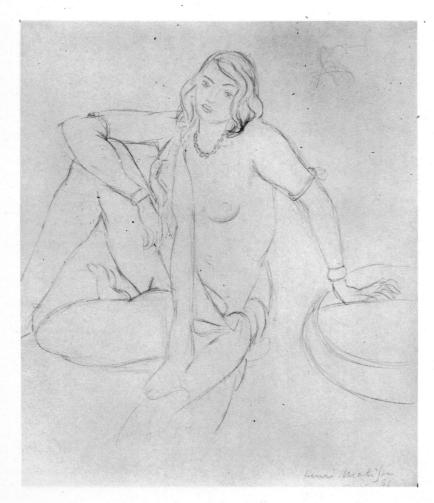

93. SEATED WOMAN. 1931. Pencil, 12 1/4 × 9 7/8". James Goodman Gallery, New York City

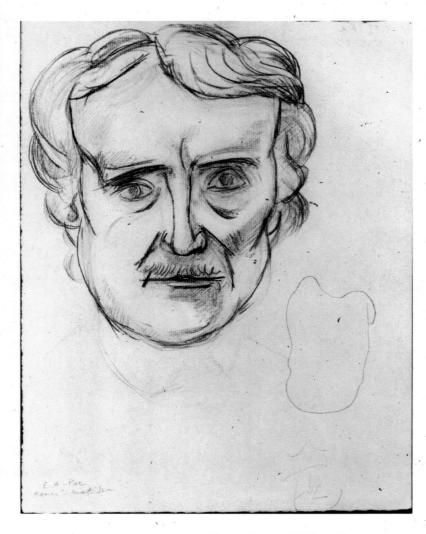

94. Preliminary study for illustration to Mallarmé's Le Tombeau: Edgar Allan Poe. 1932. Pencil, $13\times10~1/8''$. Baltimore Museum of Art. Cone Collection

95. Drawing for illustration to Mallarmé's Le Tombeau: Charles Baudelaire. Pencil, 13×10 1/8". Baltimore Museum of Art. Cone Collection

96. NUDE IN THE STUDIO. 1935. Ink, 17 3/4 \times 22 3/8". Private collection

97. NUDE IN THE STUDIO. 1937. Pen, 20 \times 15". Indiana University Art Museum, Bloomington

98. TWO WOMEN. 1947. India ink, 14 $1/2 \times 19 \ 1/2''$. The Harry N. Abrams Family Collection, New York City

99. DRAWING. 1947. Charcoal, $15 \times 19''$. Collection Samuel A. Berger, New York City

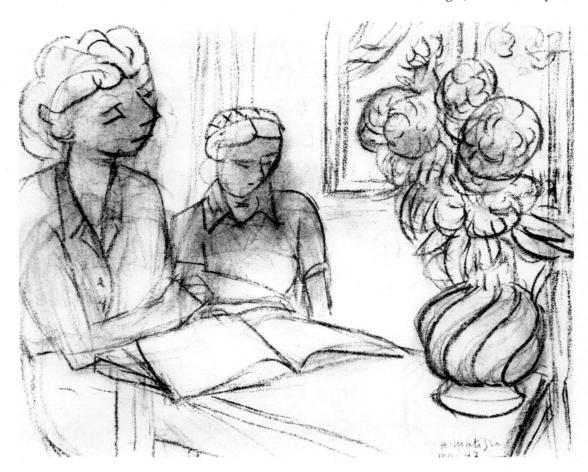

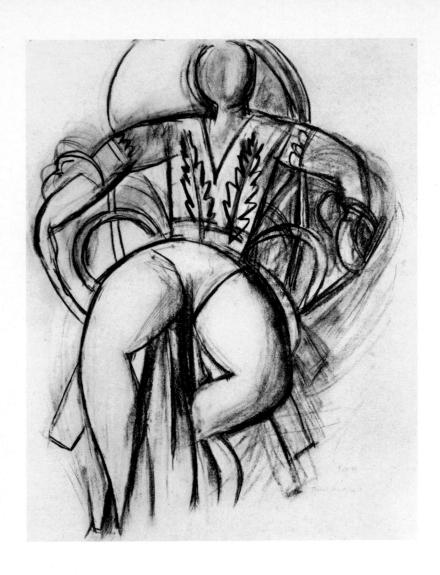

100. DANCER RESTING IN ARMCHAIR (study for La France). 1939. Charcoal, $24\ 3/4\ \times\ 18\ 1/2''$. National Gallery of Canada, Ottawa

101. STUDIO WITH MODEL. 1948. Brush and India ink, $22 \times 29 7/8''$. Art Institute of Chicago. Gift of Curt Valentin

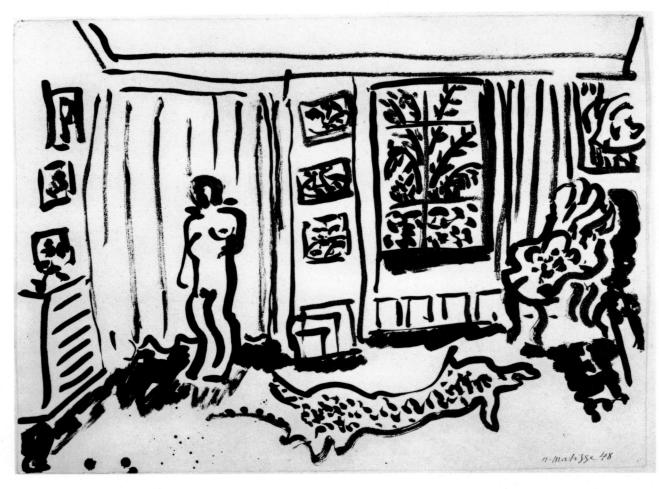

GRAPHICS AND BOOK ILLUSTRATION

Printmaking was a logical extension of Matisse's devotion to drawing. Unlike drawing, however, which he seems to have practiced nearly every day of his working life, printmaking was a sporadic occupation, and his works in the various mediums are concentrated in rather narrowly delimited periods of his career. Just as the artist reacted in various appropriate ways to the medium employed in a given drawing, he responded sensitively to the various expressive possibilities of etching, drypoint, lithography, monotype, and linoleum cut. His rapidly acquired virtuosity in the several techniques could lead alternately to the rich textural effects and luminous devices found in the lithographs of the 1920s, or the deft, laconic lines of the few monotypes done in the previous decade. In both cases his elegant sensuality is vibrantly communicated, though on totally different scales. Hence, if printmaking was an "extension" of drawing, it nonetheless provided him with unique opportunities that charcoal, pencil, or pen could not offer, and he never failed to exploit these possibilities to the further enrichment of his art.

Although he executed important prints in other mediums, Matisse's career as a graphic artist is based largely upon a dialogue between etching and lithography. Line and contour develop a characteristic and distinct lyricism in each medium, and in his lithographs he perfected, in the 1920s, a rich black-and-white equivalent to the opulent coloring and modeling of his paintings of that period. His first etchings and drypoints date from 1903. Though they might be thought of as experiments (since some plates carry several unrelated images), they indicate a spontaneous command of technique. The bold Fauvist modeling and shading of his pen drawings of this

102. STUDIES: FOUR NUDES, TWO HEADS. c. 1903. Etching and drypoint, $4\ 3/4\ \times\ 3\ 1/8''$. Museum of Modern Art, New York City

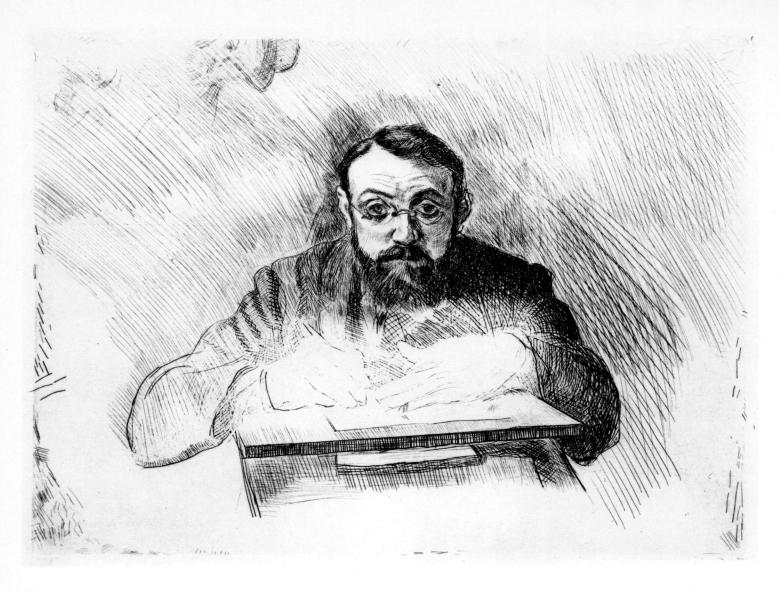

103. PORTRAIT OF THE ARTIST AS AN ETCHER. 1903. Etching, 5 $7/8 \times 7$ 3/4''. The Metropolitan Museum of Art, New York City. Harris Brisbane Dick Fund

period are here modified, the hatched line becoming more delicate and controlled. The plates from this period were printed in very small editions, usually varying between ten and thirty.

In 1906 he turned to other mediums, producing three linoleum cuts and a collection of lithographs. One of the latter, *Nude* (fig. 110), has been variously dated between 1904 and 1907. It stands out from the open linearity of other lithographs of this period by virtue of its sculpturesque modeling and the geometric simplification of the head; its pose represents a reversal of the linoleum cut *Seated Nude*, 1906 (fig. 109), whose contours are of a totally different, even Expressionist nature. Indeed, this motif is an important predecessor to the theme of the nude with arms raised which figures so importantly in the sculpture, painting, and prints of the 1920s, notably the bronze *Large Seated Nude*, 1923–25 (fig. 73), and

the lithograph Seated Nude with Raised Arms, 1924 (fig. 113).

In 1914 Matisse again returned to etching and lithography. The lithographs carry on the series of figure studies of 1906 in the same medium, but with greater authority and control of contour. Study: A Woman's Back (1914; fig. 112) repeats a theme of the earlier series but with greater concentration and effect. Its relation to the same subject in sculpture requires no comment, but the etchings of 1914 are another matter, opening up new possibilities of extremely economical draftsmanship because of the inherent nature of the etching technique and the small size of the copper plate. An extreme and satisfying instance of this distilled linearism is the portrait Loulou in a Flowered Hat (1914; fig. 105), which achieves its eloquence as much by what it omits as by what it includes.

In 1916 Matisse produced a small series of monotypes. These exquisitely crafted miniatures represent the pinnacle of his ability to reduce and simplify without sacrificing expressive effect. In spite of their limited number, they include a variety of subjects: still life, portrait, and figure study.

Beginning in 1922 and continuing to the end of the decade, the artist produced his most famous and widely appreciated lithographs, many of which are closely related in motif and format to the paintings of the period. Odalisques predominate among the subjects, lending a rarefied exoticism to these studies, which are frequently executed with a richness and precision of modeling unequaled elsewhere in his work. Repeating or developing themes that are prevalent in the paintings of the Nice period, certain of these lithographs seem to be even more definitive statements of a given motif than are the corresponding canvases. The possibilities of black, white, and a variety of grays are thoroughly exploited.

In 1929 Matisse returned to etching, and, on a reduced scale and with a contrasting economy of means, continued the motif of the nude figure, either in an exotic studio setting, or occasionally against a generalized background. What he achieved in lithographic textures before is now barely suggested in the summary, electrifying lines of the etching. The contrasts found between these two series once again underscore the artist's unfaltering preoccupation with the materials, tools, and techniques of his craft.

Much of Matisse's subsequent activity in the graphic arts is devoted to the creation of fine, limited-edition books. The etchings for the 1932 edition of Mallarmé (fig. 118) perhaps mark the peak in his efforts in this medium. Their expressive tone is cool and reserved, in contrast to the impetuosity of line to be found in the 1929 etchings. Other mediums were employed for other publications: linoleum cut for Montherlant's Pasiphae (1937-44), lithograph for Poèmes de Charles d'Orleans (1943-50) and Florilège des Amours de Ronsard (1941-48; fig. 119). He continued to produce other prints until the end of his life, but their number and importance in his work begin to pale (as was also the case with his paintings and sculpture) in the face of his growing interest in the synthesizing, unifying technique of papier découpé, which dominated the last decade of his creative activity. In the realm of bookmaking this preoccupation with a new and, for Matisse, all-embracing medium resulted in Jazz, 1944-47 (fig. 120), a collection of twenty color-stencil reproductions published in a limited edition. These illustrations, many of which are devoted to circus themes, were not inspired by a particular literary text. Instead, the pictures were created first, and the artist subsequently wrote an illuminating text to accompany the brilliantly hued plates, thus reversing the normal sequence of an illustrated book. The technique of cutting forms from the colored paper was to be further developed on a large scale in the years following the publication of Jazz.

104. YVONNE LANDSBERG. 1914. Etching, 7 7/8 × 4 1/4".

Museum of Modern Art, New York City.

Gift of Mr. and Mrs. E. Powis Jones

106. HEAD, FINGERS TOUCHING LIPS. 1929. Etching, 5 7/8 × 4 5/8". Reis-Cohen Gallery, New York City

107. FIGURE SEATED WITH CHIN IN HAND. 1929. Etching, 3 $1/4 \times 5 7/8''$. Museum of Modern Art, New York City

105. LOULOU IN A FLOWERED HAT. 1914. Etching, 7 × 5".

Museum of Modern Art, New York City

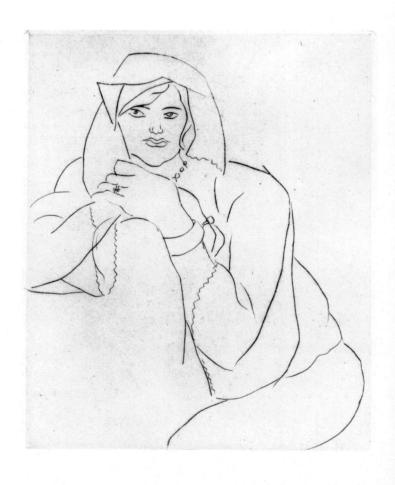

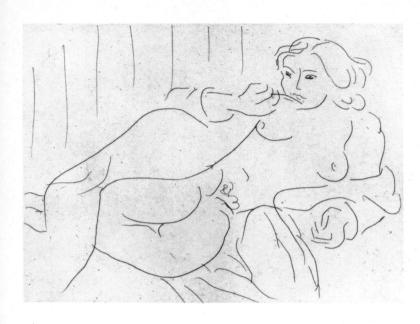

108. NUDE ON COUCH. 1929. Etching, 3 3/4 \times 4 3/4". Museum of Modern Art, New York City

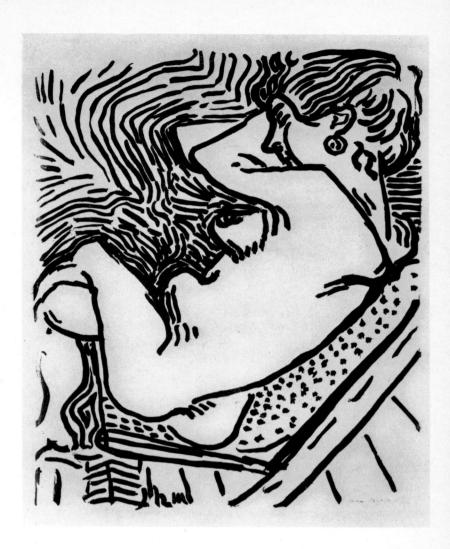

109. SEATED NUDE. 1906. Linoleum cut, 19 $1/4 \times 15 \ 1/2''$. Museum of Modern Art, New York City. Gift of Mr. and Mrs. R. Kirk Askew, Jr.

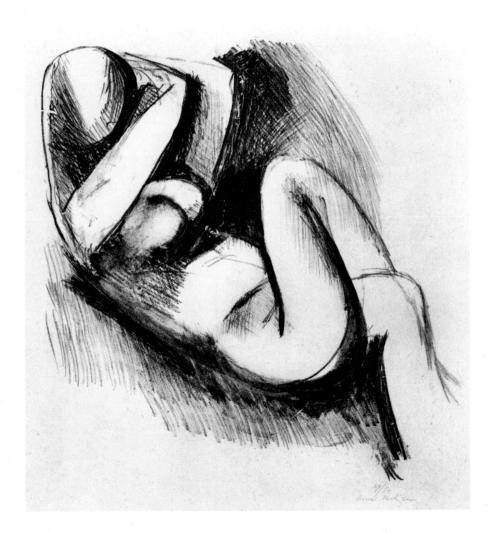

110. NUDE. c. 1904–7. Lithograph, 11 1/4 × 10". Museum of Modern Art, New York City. Gift of Mrs. Abby Aldrich Rockefeller (by exchange)

111. NUDE WITH
CROSSED HANDS. 1906.
Lithograph, 17 × 9 3/4".
Museum of Modern Art,
New York City. Gift of
Victor S. Riesenfeld

112. STUDY: A WOMAN'S BACK. 1914. Lithograph, 16 5/8 × 10 3/8". The Metropolitan Museum of Art, New York City. Rogers Fund, 1921

113. SEATED NUDE WITH RAISED ARMS. 1924. Lithograph, 24 1/4 × 18 3/4". Museum of Modern Art, New York City. Gift of Abby Aldrich Rockefeller (by exchange)

114. RECLINING NUDE. 1925. Lithograph, 8 $5/8 \times 11 \ 7/8''$. Collection John Jacobus, Hanover, New Hampshire

115. THE PERSIAN WOMAN. 1929. Lithograph, 17 $1/2 \times 11$ 3/8''. Dartmouth College Collection, Hanover, New Hampshire

116. APPLES. 1914. Monotype, 2 $1/4 \times 6 1/8''$. Museum of Modern Art, New York City. Abby Aldrich Rockefeller Purchase Fund

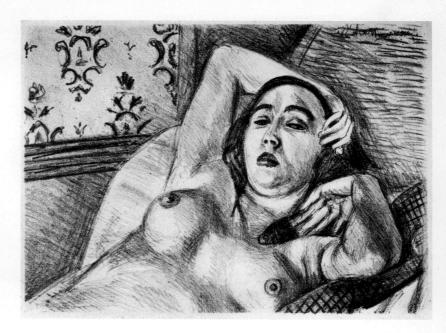

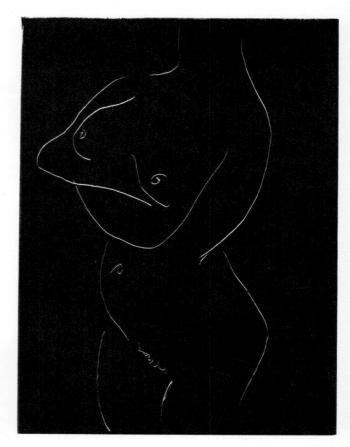

117. TORSO, ARMS FOLDED. 1916–17. Monotype, 7 × 5". Museum of Modern Art, New York City. Frank Crowninshield Fund

118. Etching and partial text of the poem "Hérodiade," Poésies de Stéphane Mallarmé. 1932. Page size 13 × 9 3/4".

Museum of Modern Art, New York City.

Abby Aldrich Rockefeller Fund

119. Lithograph and text of poem from Florilège des Amours de Ronsard.
1941–48. Page size 15 × 11".
Museum of Modern Art, New York City

120. TORSOS, from Jazz. 1944–47. Color stencil, 10 $3/4 \times 16 1/4''$. Stanford University Art Museum, Stanford, California

BIOGRAPHICAL OUTLINE

1869	Henri-Émile-Benoit Matisse born December 31, at Le Cateau-Cambrésis (Nord); family resides nearby at Bohain-en-Vermandois. Studies at the lycée in Saint-Quentin.	1896	Elected an associate member of the Société Nationale des Beaux-Arts after successful exhibition in that Salon; <i>Woman Reading</i> is purchased by the state from that exhibition. Second trip to Brittany.
1887–88 1889	Studies law in Paris. Employed as lawyer's clerk, Saint-Quentin; his first interest in art indicated by participa-	1897	La Desserte a failure at the Salon; meeting with Pissarro and study of Impressionist painting. Third trip to Brittany.
	tion in a drawing class at the École Quentin- Latour.	1898	Marries Amélie-Noémie-Alexandrine Para- yre; most of year spent away from Paris:
1890	Stricken with appendicitis; is given a box of paints by his mother during his recuperation; first paintings.		honeymoon in London (where he studies Turner), then long stays in Corsica and subsequently near Toulouse.
1891	Returns to Paris to study art; receives criticism from Bouguereau at the Académie Julian.	1899	Cormon takes over studio of the late Gustave Moreau; dismisses Matisse shortly after the latter's return to Paris; Matisse frequents the informal Académie Carrière (where he meets
1892	Commences work in the studio of Gustave Moreau; meets Albert Marquet, who is a fellow student in a course at the École des		Derain and Puy); purchases a Cézanne painting, <i>Three Bathers</i> , from Vollard, together with a Gauguin and a plaster bust by Rodin.
1895	Arts Décoratifs. Trip to Brittany with his neighbor, Émile Wery, who also lives at 19 Quai Saint-Michel.	1900	Beginning of period of financial difficulties; wife opens millinery shop; Matisse works on decorations for Grand Palais in the company of Marquet.

1901	First exhibit by Matisse at Salon des In- dépendants; through Derain he meets Vla- minck.	1912	Spends first part of year in Tangier; returns there in December and remains until after the new year.
1902	Exhibits at Berthe Weill's gallery; financial circumstances force him to return to his father's house at Bohain for the winter of 1902–3.	1913	Exhibition of his North African work at Bernheim-Jeune; his works included in the Armory Show, New York (later in Chicago and Boston).
1903	Matisse and other future Fauves exhibit at the first Autumn Salon, which will be the scene of many radical efforts over the next few years. Gauguin retrospective (he died the previous year) at that event.	1914	Exhibits in Berlin; his pictures seized upon outbreak of war; meets Juan Gris at Collioure; their friendship continues and Matisse seeks to organize financial support for Gris. Continues working at Issy and also on the Quai Saint-Michel, where he had once again taken a studio in the autumn of the previous year.
1904	First one-man exhibition at Vollard's, with catalogue introduced by Roger Marx; spends		
	summer at Saint-Tropez, where he is in contact with Signac and Cross.	1916	Exhibition in London; first visit to Nice.
1905	Spring: Exhibits Luxe, calme et volupté at the Salon des Indépendants.	1917	Returns to Nice to recuperate from illness after stay in Marseilles.
	Summer: Works together with Derain at Collioure, where he meets Daniel de Mon-	1918	Meets Renoir; visits him at his villa in Cagnes and shows him his pictures.
	freid, collector of Gauguin paintings. Autumn: Participates with the other Fauves in the "cage" of the Autumn Salon; the term	1920	Creates designs for the Stravinsky-Massine ballet Song of the Nightingale.
	Fauve coined at this manifestation, probably by the critic Louis Vauxcelles.	1921	Spends summer at Étretat on Norman coast; returns to Nice, where he now rents an apart-
			ment: previously he had lived in hotels while
1906	Spring: Exhibits Joy of Life at the Salon des Indépendants. Visits Biskra in Algeria.		ment; previously he had lived in hotels while there.
1906		1922	
	Indépendants. Visits Biskra in Algeria. Meets Picasso (then working on the <i>Demoiselles d'Avignon</i>) through Gertrude Stein; trip to Italy; <i>Le Luxe I</i> exhibited at the Autumn	1922 1924	there. Exhibits his work at Bernheim-Jeune (where he will exhibit several times during this decade), having earlier entered into a contract
1907	Indépendants. Visits Biskra in Algeria. Meets Picasso (then working on the <i>Demoiselles d'Avignon</i>) through Gertrude Stein; trip to Italy; <i>Le Luxe I</i> exhibited at the Autumn Salon. Trip to Germany; publication of "Notes of a		there. Exhibits his work at Bernheim-Jeune (where he will exhibit several times during this decade), having earlier entered into a contract with this dealer. Major retrospective in Copenhagen; again
1907	Indépendants. Visits Biskra in Algeria. Meets Picasso (then working on the <i>Demoiselles d'Avignon</i>) through Gertrude Stein; trip to Italy; <i>Le Luxe I</i> exhibited at the Autumn Salon. Trip to Germany; publication of "Notes of a Painter"; exhibitions in New York, Berlin,	1924	Exhibits his work at Bernheim-Jeune (where he will exhibit several times during this decade), having earlier entered into a contract with this dealer. Major retrospective in Copenhagen; again exhibits in New York.
1907	Indépendants. Visits Biskra in Algeria. Meets Picasso (then working on the Demoiselles d'Avignon) through Gertrude Stein; trip to Italy; Le Luxe I exhibited at the Autumn Salon. Trip to Germany; publication of "Notes of a Painter"; exhibitions in New York, Berlin, and Moscow. Takes up residence in Issy-les-Moulineaux, a suburb on the southern edge of Paris; another trip to Berlin; commission for Dance and	1924 1925	Exhibits his work at Bernheim-Jeune (where he will exhibit several times during this decade), having earlier entered into a contract with this dealer. Major retrospective in Copenhagen; again exhibits in New York. Trip to Italy. Artist's son, Pierre, organizes exhibition of his father's work in New York; Matisse receives first prize in the Carnegie International Exhibition in Pittsburgh. Extensive travel: to United States to serve on Carnegie jury; visits Barnes Collection, Merion, Pennsylvania, and is commissioned to do large mural, Dance; continues on to
1907 1908 1909	Indépendants. Visits Biskra in Algeria. Meets Picasso (then working on the Demoiselles d'Avignon) through Gertrude Stein; trip to Italy; Le Luxe I exhibited at the Autumn Salon. Trip to Germany; publication of "Notes of a Painter"; exhibitions in New York, Berlin, and Moscow. Takes up residence in Issy-les-Moulineaux, a suburb on the southern edge of Paris; another trip to Berlin; commission for Dance and Music comes from Shchukin. Dance and Music exhibited at the Autumn Salon; visits Munich to see exhibition of Muslim art. Visits Spain, principally Andalu-	1924 1925 1927	Exhibits his work at Bernheim-Jeune (where he will exhibit several times during this decade), having earlier entered into a contract with this dealer. Major retrospective in Copenhagen; again exhibits in New York. Trip to Italy. Artist's son, Pierre, organizes exhibition of his father's work in New York; Matisse receives first prize in the Carnegie International Exhibition in Pittsburgh. Extensive travel: to United States to serve on Carnegie jury; visits Barnes Collection, Merion, Pennsylvania, and is commissioned

	York, the latter at the Museum of Modern Art.	1943	Moves into villa at Vence to avoid possible air raids at Nice.
1932	Publication of the Mallarmé etchings; discovery of the mismeasurements of the Barnes mural. Matisse starts over again, rather than alter the finished work.	1945	Special exhibition at the Autumn Salon (Picasso had been similarly honored the previous year); major exhibit together with Picasso at the Victoria and Albert Museum,
1933	Another trip to the United States to attend installation of the Barnes <i>Dance</i> .	1947	London. Publication of <i>Jazz</i> , which had been begun in
1937	Commission for sets of Rouge et Noir,		1943.
	choreography by Massine, to music by Shostakovich. His works shown in a special room in the exhibition "Maîtres d'Art Indépendant" at the Petit Palais, Paris.	1948	Leaves Vence and returns to the Regina, Nice-Cimiez; begins study for the Chapel of the Rosary, Vence; major retrospective at the Philadelphia Museum of Art.
1938	Moves into former Hotel Regina, Nice-Cimiez.	1949	Retrospective exhibition in Lucerne.
1939	Leaves Paris after declaration of war in September and returns to Nice the following	1950	Receives first prize for painting, XXV Biennale, Venice.
	month.	1951	Dedication of chapel at Vence, June 25. Major
1940	Spends spring in Paris, but after the defeat of France he finally returns to Nice after debating possible refuge across the Atlantic.		retrospective at the Museum of Modern Art, New York; the following year it is shown in Cleveland, Chicago, and San Francisco.
1941	Serious abdominal surgery in Lyons; after long convalescence, returns to work in Nice	1952	Matisse Museum is established at his birth- place, Le Cateau-Cambrésis.
	in spite of severe physical handicap.	1954	Dies November 3, and is buried in Nice-
1942	Exchange of pictures with Picasso.		Cimiez.

Painted c. 1894

WOMAN READING (LA LISEUSE)

Oil on canvas, 24 1/4 × 18 7/8"

Musée National d'Art Moderne, Paris

Matisse achieved his first public success (prematurely, as it turned out) when this modest, intimate interior was exhibited in 1896 at the Salon du Champ-de-Mars, an independent but not radical rival of the official Salon, organized by the Société Nationale des Beaux-Arts and presided over by Puvis de Chavannes. Although he was still nominally a student in Moreau's atelier, the success of this work, and three others that accompanied it, merited him an associate member-ship in the Société Nationale that year. It was purchased by the state, and, having been admired by the family of President Félix Faure, it was hung in the apartments of their summer residence at the Château de Rambouillet. It was installed in the Musée National d'Art Moderne only after World War II.

Although Matisse at the time was not yet in complete command of the technical resources of painting, as would become clear in later, more ambitious yet rather laborious works like *La Desserte* (1897; fig. 8), he was already quite capable of realizing a modest effort such as this. Based indirectly upon his appreciation of Chardin and of the Dutch paintings that he would have seen in the museum at Lille before coming to Paris as an art student in 1892, it also suggests his study of Corot. The theme is furthermore prophetic: the subject of a woman reading recurs in his paintings as late as the 1940s, and the interior itself, almost studio-like with its emphasis upon pictures on the wall (unfortunately not identifiable, as would be the case later), is suggestive of a major preoccupation throughout the artist's oeuvre.

At the time of its painting Matisse had little or no knowledge of contemporary trends, and this interior is largely the result of museum study; while it was a reflection of the work that he was doing in Moreau's studio (see, for example, Studio of Gustave Moreau, 1894-95; fig. 7), it owes nothing to his master's manner or subjects. Though occasionally passed over as an imitative or conservative work, it is remarkably independent of any one predominant influence. Even its Intimist qualities, which might suggest an influence from the Nabi quarter and specifically from the work of Vuillard, are misleading, as that painter's work of this epoch was much more schematic and flattened than is the case here, and the qualities of Matisse's present interior appear in Vuillard's work only later. We are left then with a notably independent, if not especially adventurous, small-scale work. It establishes early in his career the fact that while Matisse continued throughout his lifetime to look for inspiration to the works of the past as well as of his contemporaries, he almost never succumbed to direct borrowing of manner or to the adaptation of another artist's composition. An exception to this rule is found in the Signac-inspired Luxe, calme et volupté (1904; colorplate 11) a decade later.

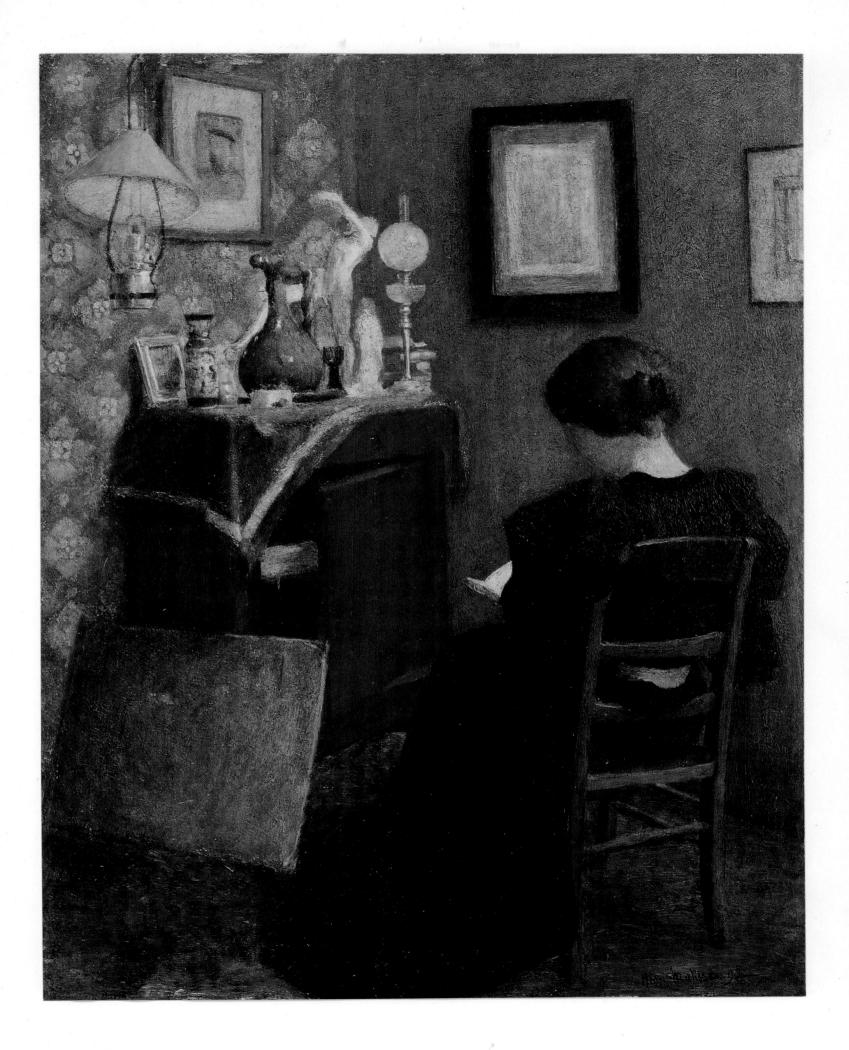

Painted 1898

NUDE IN THE STUDIO (NU DANS L'ATELIER)

Oil on canvas, 25 3/4 × 19 5/8"

Bridgestone Museum, Tokyo

This bright study in orange and green is one of the artist's first major paintings of the female figure. The technique is suggestive of Neo-Impressionism, but is here handled with surprising impetuosity. In fact, this picture, which marks Matisse's first (and temporary) liberation from the somber lights of his early manner, certainly owes its technique and luminosity to the landscape studies done in Brittany during his third successive summer trip in 1897. It was there, under the guidance of such minor painters as Émile Wery and John Russell (who were familiar with Impressionist and Post-Impressionist works), that Matisse's palette lightened for the first time. What is surprising in the present painting is that he converted these lessons of *plein-air* painting to a studio nude with such

The theme of the artist's studio, presented in other contexts in Studio of Gustave Moreau (1894-95; fig. 7) and the Interior with Top Hat (1896; fig. 6)—the latter presumably a corner of Matisse's studio on the Quai Saint-Michel—will ultimately emerge as the most significant in the artist's career. At this early stage, however, he has not yet recognized the full potential of this motif as a vehicle for expressing the human condition of the artist, even though there are indications of other artists at work in the space beyond the model. Very possibly, Matisse did this study in the Moreau atelier, working side by side with Albert Marquet, one of his closest friends of the period. A comparison of the two works produced simultaneously by these two future Fauves is instructive. Marquet models his figure in colors almost as strong as those of Matisse, but the shape of the body is firmer and the light more conventional. Matisse, on the other hand, brushes in the body of the amply proportioned model with greater daring, so that she does not form an abrupt contrast with the Impressionist-inspired background, whereas in the Marquet picture there is a somewhat awkward contrast between the sculptural solidity of the body and the fluttering brushwork of the background. The deftness and lightness of touch exhibited in this picture should be compared with such subsequent nude studies as Male Model (1900; colorplate 5), which were painted at a time when Matisse was digesting the lessons of Cézanne. In the later figure the weight and mass of the brushstroke, as well as the dense patches of strong, related hue, are infinitely more constructive. Subsequently, in the years just after 1900, the artist will feel the need temporarily to abandon a bright or intense color scheme in order to restudy problems of shaping and modeling (see colorplate 10) before returning to saturated colors in later compositions.

This subject offers an interesting comparison with the several versions of Seurat's Les Poseuses, Matisse's work being more impulsive in color and touch. However, the more elaborate studio setting of the Seurat composition, with live models deployed in front of other pictures, suggests subsequent developments in Matisse's work.

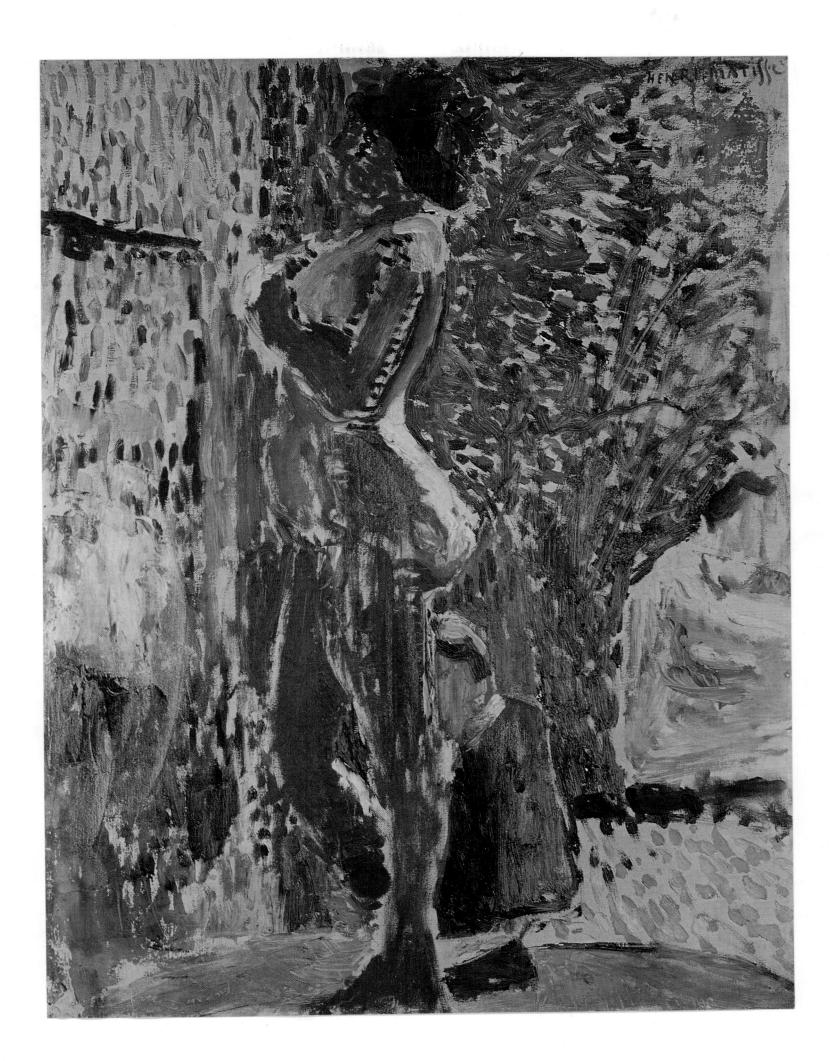

Painted 1899

THE INVALID (LA MALADE)

Oil on canvas, $181/2 \times 15''$

Baltimore Museum of Art. Cone Collection

Painted at the end of Matisse's year-long stay in the south, first in Corsica and then later on in Toulouse, The Invalid is one of his most ambitious and successful interiors of this period. In spite of its small format and sketchlike appearance, its command of a wide range of bright colors, while still somewhat lugubrious, places the picture in the artist's Proto-Fauve stage. Especially commendable is the artist's control of the paint density throughout the composition, supporting the surface tension of the design in a crucial way. The spatial illusion is here thoroughly under control, even though there are patches of bright, advancing colors in the background. A cut-off chair on the left serves as a familiar repoussoir—a compositional device used to expand the illusion of spatial depth. A round table covered with a white cloth dominates both the center of the space and the surface of the design, becoming through its scale and brightness the focal point of the picture. The use of different greens to indicate the shadowy folds of the white tablecloth is perhaps indebted to Impressionist theory, which maintained that shadows are not, in fact, truly black. Significantly, Matisse executes this detail in a bold, un-Impressionistic way. The invalid reposes on the bed in the distance, her features undeveloped but with a bright orange flesh tone that contrasts with the pink of her robe. The various items in the table's still life are painted in a generalized, almost abstract manner, though we can identify bottles, glasses, a bowl, and a tray. In this summary handling of everyday objects the artist clearly moves a step beyond the labored rendering of each object as seen in the earlier La Desserte (1897; fig. 8). It is clear that by working in a smaller, less ambitious format, Matisse is more capable of a unified control of his painted surface, and the vast majority of his paintings of this period, especially the immediately preceding landscapes of 1898, are unusually small in size. Working in almost miniature formats seems to have aided the artist at this particular moment in his early development.

The subject of this picture is unique in Matisse's oeuvre, and while he makes nothing of the potential sorrow or pathos of the theme, it is perplexing, given his celebration of life in all its healthy phases later on. The subject does appear occasionally in Nabi work, but the most famous sickroom pictures of this epoch appear in the tortured deathbed scenes of Edvard Munch, a contemporary whose art was concerned, as Matisse's was not, with laying bare the artist's own deepest anxieties.

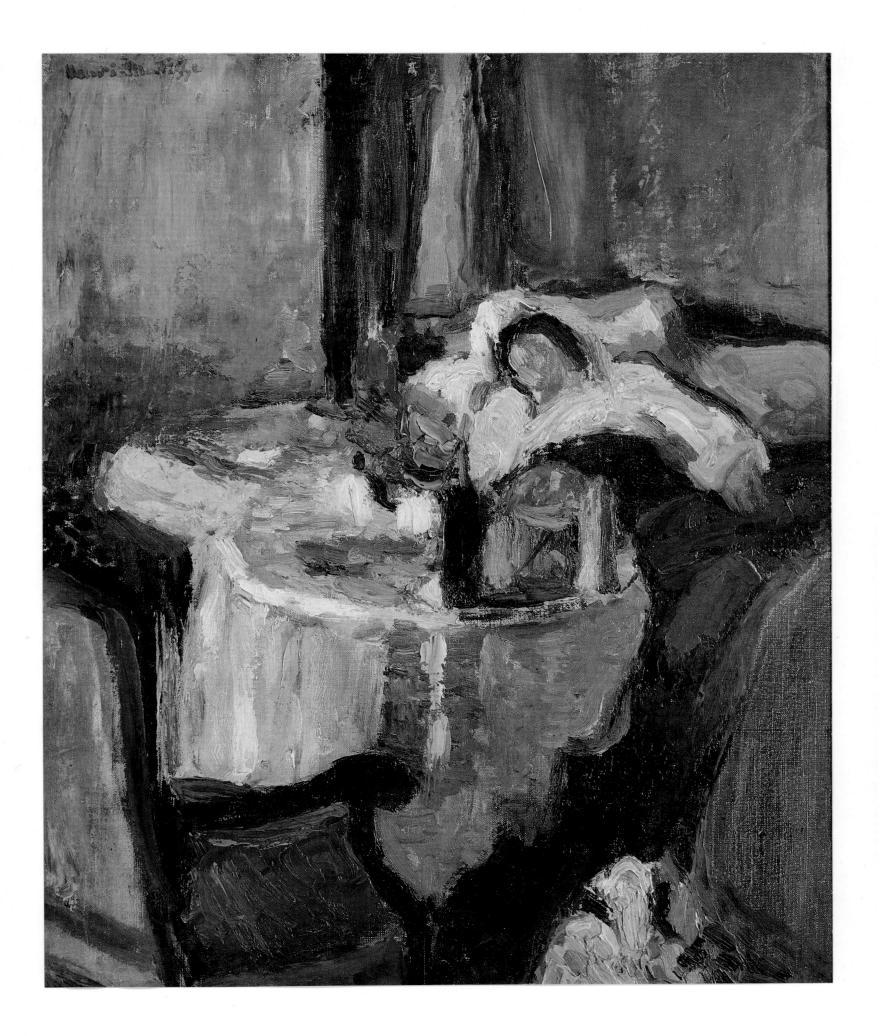

Painted 1900

MALE MODEL (L'HOMME NU, LE SERF)

Oil on canvas, 39 3/4 \times 28 3/4"

Collection Mr. and Mrs. Pierre Matisse, New York City

Considering Matisse's subsequent fame as a figure painter, it is remarkable that through the first decade of his career major nude académies, whether male or female, are few in number in his work. It was not until 1900 that he undertook major figure studies, but then they quickly came to predominate. The especially monumental Male Model, or Serf, is one of the finest of the early works and is intimately related to his early explorations in sculpture, the bronze Slave being a companion work in that genre. There is a certain temptation to label this Matisse's "blue" period, thinking of a superficially similar phase that was shortly to overtake Picasso. However, the two artists' intentions are so radically opposed (nor had they met at the time) that it is misleading to use this label for Matisse's work, except in a very restricted way.

The painted version of the serf seems literally sculpted on the canvas, and the same is almost as true of the heavy swatches of blue, green, and other that form a far from neutral background. The planes of the body are brutal in their generality, as is the abruptness of their intersections in space. A remarkably intense contrast is formed between the high-hued yet somber interior and the highlights bathing most of the model's body. This contrast predicts certain color effects that Matisse would later achieve with pictures like the Shchukin version of Dance (1910; colorplate 19). In this early work such violent coloristic juxtaposition is moderated by the artist's intense concern for an illusion of bodily mass, with its receding and advancing planes of space. It is interesting to reflect that in works like this of about 1900, Matisse seems closer to a kind of Proto-Cubism than Picasso, whose works of the Blue Period were to stress expressive and pathetic arabesques rather than structural masses. Ironically, the two artists were to move in mutually contradictory directions in the evolution of their early careers: Picasso toward an increasingly ponderous figure style leading ultimately to the Demoiselles d'Avignon (1907) and Matisse toward an increasing reduction of the inner modeling of the figure, with a greater reliance on the shaping power of decorative arabesques and ringing color contrasts. Matisse achieved this evolution from boldly modeled to flattened figure structures in such mid-decade works as Joy of Life (1906), where even in the sketch (colorplate 14) one perceives strong coloristic outlines of pale flesh tones that become penumbras, imaginary Fauvist shadows. This device is already detectable around the shoulders and back of Male Model, and is a device that Matisse seems to have invented in a pen-and-ink drawing of 1899 (fig. 10), an unusual study of Delacroix's Abduction of Rebecca (1846), in which the highlighted figures are heavily surrounded by scrawls of black ink, an effect that Matisse superimposed on the Romantic master's original conception. So startling was this effect in the drawing that his fellow students in Moreau's atelier chided him for having made a "negative" (in the photographic sense) copy. However, this discovery would serve him well in the paintings of the next decade as he worked his way into an anti-Cubist style of rendering the figure.

Painted 1900

NOTRE-DAME

Oil on canvas, $18 1/8 \times 14 7/8''$ Tate Gallery, London

As early as 1895 Matisse occupied a studio on the Quai Saint-Michel, overlooking the Cité, the parvis of Notre-Dame, the quais, bridges, and surrounding buildings. He does not seem to have painted the scene from his window for some time, but beginning about 1900 (or perhaps a bit before) he frequently did so, focusing alternately on the facade of Notre-Dame and on the Pont Saint-Michel. These pictures have never been studied as a series, and strictly speaking they are not a series of variations in the same sense as Monet's variants on the facade of Rouen Cathedral (1893–94). Instead, they were painted over a number of years, at a time when the artist's interests were also occupied with other, ultimately more important subjects. However, beginning with this group of cityscapes we are on the threshold of an Indian summer of Impressionism that did not culminate until the Fauve movement burned itself out about 1906 in Matisse's studies for Joy of Life and such parallel works as Derain's studies of the London embankments or his dazzling Coucher de soleil of 1905-6 (Saint-Tropez). Matisse continued to explore the theme of Notre-Dame as late as 1914, when he put aside a fascinating yet aborted effort at an almost entirely blue, constructivist view of the subject (a picture that has been repeatedly exhibited in recent years: Los Angeles, London, Paris), where he remained indecisive concerning the scale of the cathedral within the frame of the picture.

Most of Matisse's views of Notre-Dame date from the early years of the century, and the Tate Gallery version here must be one of the earliest (though a pre-1900 version was included as Number 31 of the 1970 Paris Centennial Retrospective). As in most of these views, the bulk of the cathedral does not loom especially large, and the emphasis is on providing a suggestion of the space formed by the historic monument and its surroundings: indifferent modern edifices, the connecting surfaces of the bridges and quais, the confined channel of the Seine, and sometimes but not invariably a passing barge. It must be as clear to connoisseurs of Gothic architecture as to those of modern painting why the facade of Notre-Dame de Paris, rather dryly restored by Viollet-le-Duc, did not absorb Matisse's interest in the way that that of Notre-Dame de Rouen captivated Monet. Hence, while the colors are often startling in Matisse's Notre-Dame series (as is the case with the present picture, whose execution suggests many of the Corsican and Toulouse landscapes of 1898), the oblique compositional angle, traditional space-forming devices, and atmospheric effect evoke early rather than late Impressionism, in spite of the intense, novel hues.

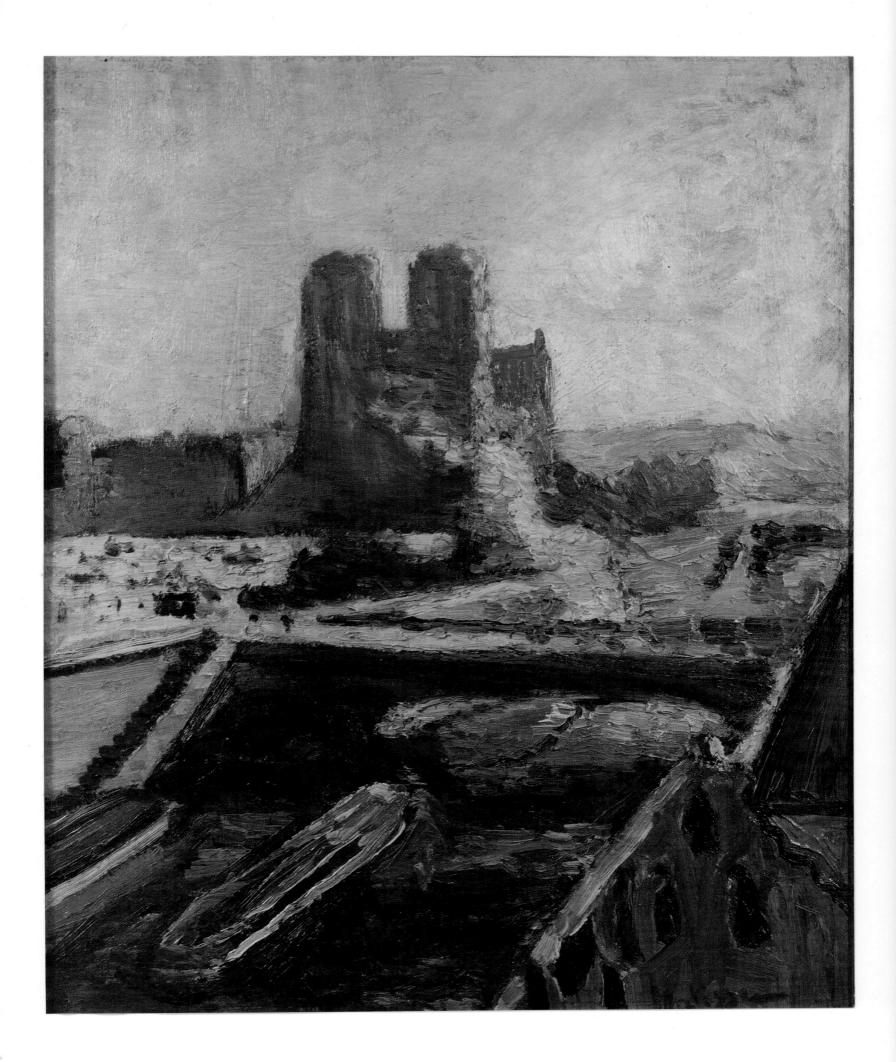

Painted 1902

NOTRE-DAME IN THE LATE AFTERNOON

Oil on canvas, 28 $1/2 \times 21 \ 1/2''$

Albright-Knox Art Gallery, Buffalo, N.Y. Gift of Seymour H. Knox

Clearly this is a more adroit composition than the previous picture, with a control of color areas that tells us something of Matisse's power of self-discipline; there is a condensation of sensations here which leads us to believe that he was pondering the thoughts of Cézanne and applying them to his own rather different circumstances. Most significant, we are now explicitly told that the picture was painted from an open window, for the shutter and jamb form strong verticals on the right margin to give a weighted frame to the view beyond and below. In none of the earlier views taken from the same window did the artist realize the importance of this feature, both as a structural device and as a motif in its own right. This picture was painted before *The Attic Studio* (colorplate 9), where the theme of the open window takes on an added importance.

The rather superficial Impressionistic agitation of the earlier version is now gone; the atmospheric emphasis is changed by the reduction in the area of the sky, and the surfaces consequently take on a more appropriately monumental quality. The barge on the river is absent, and the placement of the figures along the nearer quai more purposeful. The now empty surface of the river is painted with the same imperturbable solidity as the surrounding quais, and the patches of color in this later version begin to carry a structural value of their own. What seems to have occurred here is that the daring concepts of spatial support, first ventured in the backgrounds of such figure studies as Male Model (1900), are now applicable to landscape and topographical painting. What remains conventional is the diagonal repoussoir of the right foreground as a means of leading the eye into the middle distance of the bridge. What is novel is that after the eye moves across that bridge it is not carried in some ordinary fashion to the culminating, terminating facade, but is pictorially arrested by the deep pink tones that unrealistically serve to denote the space in front of the cathedral. In short, in a difficult and complex scene Matisse is now able to structure his pictures with color alone, allowing hues by themselves to establish through their unique character a pictorial center of gravity.

Painted 1902

THE PATH IN THE BOIS DE BOULOGNE (SENTIER, BOIS DE BOULOGNE)

Oil on canvas, 24 3/4 \times 31 1/8"

Pushkin Museum, Moscow

If somewhat overshadowed by the great figure compositions, landscapes occupy an extremely important role at several moments in the artist's career. The present painting, with its dense foliage emphasized by the massive, almost Courbet-like facture, owes much to the study of Cézanne and thus complements Matisse's early efforts at monumental nudes in a Cézannesque manner. In fact, the present composition is closely related to one of the older artist's favorite motifs, the bend in a road leading to a village. Matisse's most notable change in this theme is that he selected a path in a park or garden rather than a simple country lane leading to a humble village, with all its implications of rustic toil (although there are, of course, notable exceptions to this observation: Cézanne's studies of avenues of trees at the Jas de Bouffan, his father's estate near Aix, for example). Given many of Matisse's later landscapes, including those framed by an open window, which are mainly of parks and gardens—that is to say, bits of cultivated, artificial paradise—the early appearance of this motif is particularly impressive. Moreover, this preference of Matisse's for nature in its cultivated state related closely to the evolution of an arcadian paradisial vision throughout his career.

Compared with the important series of small landscapes done by Matisse during his protracted stays in Corsica and Toulouse in 1898, paintings that are aptly denoted as Proto-Fauve, the color here is somber. The purple path and the stream at the right are these major features that hold everything together. Nevertheless, they are overshadowed by the frequently shapeless mass of foliage. Curiously un-Cézannesque is the absence of powerful intertwining limbs and twigs that might otherwise have given a more skeletal organization to the picture. These features are present as subject, but are never capitalized on as a dominant motif. This tentative rejection of one aspect of Cézanne's method of ordering things from a study of nature is, once again, a harbinger of the later landscapes, where foliage is rendered in broad, flat areas surrounded by arbitrary decorative arabesques, with only the barest indication of structural support from the limbs.

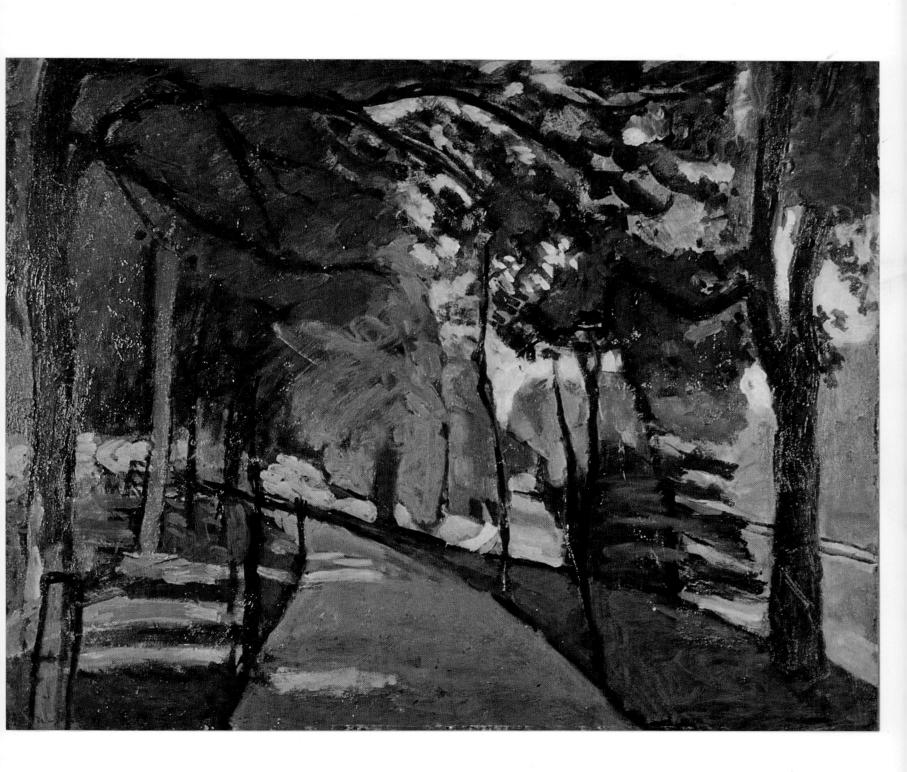

Painted 1903 (formerly dated 1902)

THE ATTIC STUDIO (STUDIO UNDER THE EAVES, L'ATELIER SOUS LES TOITS)

Oil on canvas, 21 $5/8 \times 181/8''$

Fitzwilliam Museum, Cambridge, England

This unusual, somewhat crudely executed interior was painted in the artist's makeshift studio atop his father's house at Bohain-en-Vermandois during a particularly trying period in his career. Economic distress had forced him to abandon Paris for a time. In its somber tones, accentuated rather than relieved by the small, luminous landscape glimpsed through the distant window, it, like other pictures of this epoch, looks back beyond the intense, saturated colors of his work in the late nineties to the earthen palette of his first efforts. On the other hand, its frontal composition, with vast expanses of vacant surface, abandons the diagonal or oblique axes of many earlier paintings, notably *La Desserte* (1897; fig. 8), as well as the self-portrait of 1900 (frontispiece) and the majority of his figure studies of that epoch.

The flattening effect achieved by this spatial arrangement, viewed from a startlingly high vantage point, thus looks forward to the great studio series of 1911 (colorplates 21, 22). Moreover, the theme of the open window, heretofore an accessory in his interiors if it appeared at all, is centralized and exploited for the first time in his work. It was a crucial motif that would occupy the artist until his last paintings on canvas, notably *Interior with Egyptian Curtain* (1948; fig. 54). Here, in fact, the window is made the thematic foil of the canvas which we see suspended from the easel in the middle distance. In the light of his later works, it would seem that the analogy between the picture frame and the frame of the window, each offering a controlled, measured fragment of the artist's world of appearances, finds its beginnings in this modest, unassuming canvas.

The theme of the open window had been thoroughly explored by German Romantic artists like Kaspar David Friedrich in the early nineteenth century, but its appearance in French art of that century was sporadic and incidental. Almost single-handed, Matisse seems to have reinvented the significance if not the actual use of the open, uncurtained window and prepared the way for the exploitation of this theme by his contemporaries and juniors: Bonnard, Gris, Picasso, Delaunay, and even (ironically) Duchamp and Magritte. The play between two spaces, inner and outer, and the crucial analogy with the picture frame serve to define the universe of the artist. Without going to the extreme of tortuous allegories of sight, such as were employed by seventeenth-century Flemish painters like Jan Bruegel, Matisse makes a candid, factual statement concerning the artist's involvement with the subject. While the Impressionist painters, notably Pissarro in his late paintings of Paris done at the time Matisse met him in 1897, frequently painted from the vantage of an apartment window, they never indicated the interior or the frame of the window through which the artist was looking. Since 1900, Matisse had been studying the view of Notre-Dame and the Cité from his studio window on the Quai Saint-Michel, and this picture must be seen as a statement of his new interests.

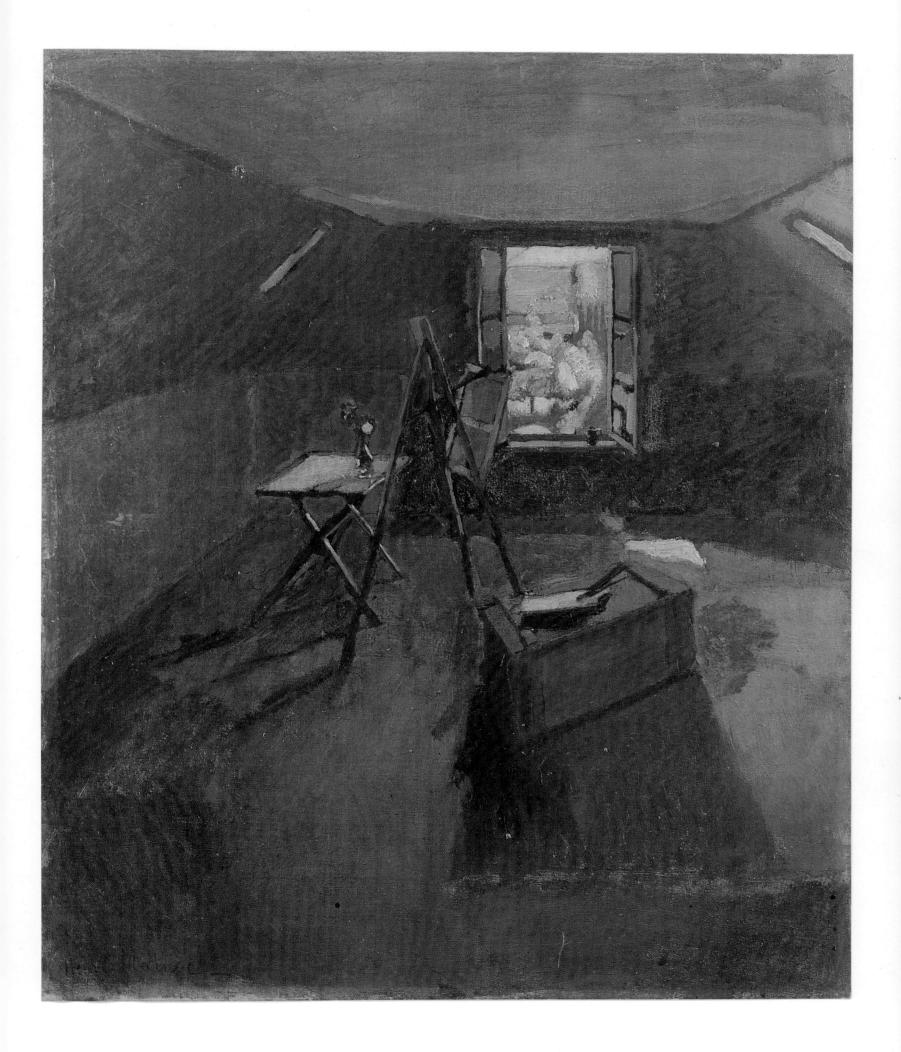

Painted 1903

CARMELINA

Oil on canvas, 31 1/2 \times 25 1/4"

Museum of Fine Arts, Boston. Tompkins Collection, Arthur Gordon Tompkins Residuary Fund

If The Attic Studio, 1903, provides a startling glimpse into the future of Matisse's art during what seems to have been its darkest moment, then Carmelina is the undoubted though thoroughly conventional masterpiece of this somber period, which intervenes between his Proto-Fauve work of about 1897-1900 and his second excursion into Neo-Impressionism in 1904-5. A tightly cemented composition in which the parts mesh like perfectly functioning gears, it sums up the efforts of nineteenth-century realism. Its execution may well have helped Matisse to abandon certain insecurities concerning the styles of the past, which are revealed in his early works after moments of remarkable boldness. Compositionally, it makes an interesting comparison with the series of figure studies, both male and female, that were inaugurated in 1900, and of which Male Model (colorplate 5) is a remarkable example. In those earlier works, which were as dominated by blue as Carmelina is dominated by others, the pictorial ground is handled with brutal abandon, the painted areas themselves creating vital supporting structures of their own. In this subsequent, regressive masterpiece the artist has had recourse to about every studio prop imaginable, and though their enumeration would not be as tedious as with the 1896 Interior with Top Hat (fig. 6), its picturesque inventory stands in marked contrast to the swatches and patches of pure paint in Male Model. Could Matisse have been thinking of a Salon submission in the working out of Carmelina? It is one of his most rhetorical efforts in conventional compositional language. The body of the model merges with the draperies, and the roundness of her body works against the familiar rectangular foils of picture frames, a mirror, and drawings pinned to the wall. Tying the whole together is the startling contrast of lights and darks, particularly as they strike the robust, pliant body of the model, making of her figure something more stark and angular than it must have been in actuality. It is almost as if Corot, Courbet, and Cézanne had collaborated in the creation of a single canvas. Even the abrupt frontality of the pose, with the corresponding parallelism of background wall to picture plane, does not mitigate its conventionality, and for this very reason the picture remains something of a puzzle in the context of Matisse's development in this decade. It suggests little of what was to follow in the next few years. In sum, it must be taken as a concept that the artist held in reserve for more than a decade, since he returned to this subject with frequency and enthusiasm only in the paintings and drawings of the twenties and afterward.

Contrary to its conservative composition, *Carmelina* contains the germinal theme of the reflected mirror images of the artist and his model that would play such an important role in the second half of his career. Its importance for the future is thus iconographic; for the rest it is a profound scholarly summing up of received ideas.

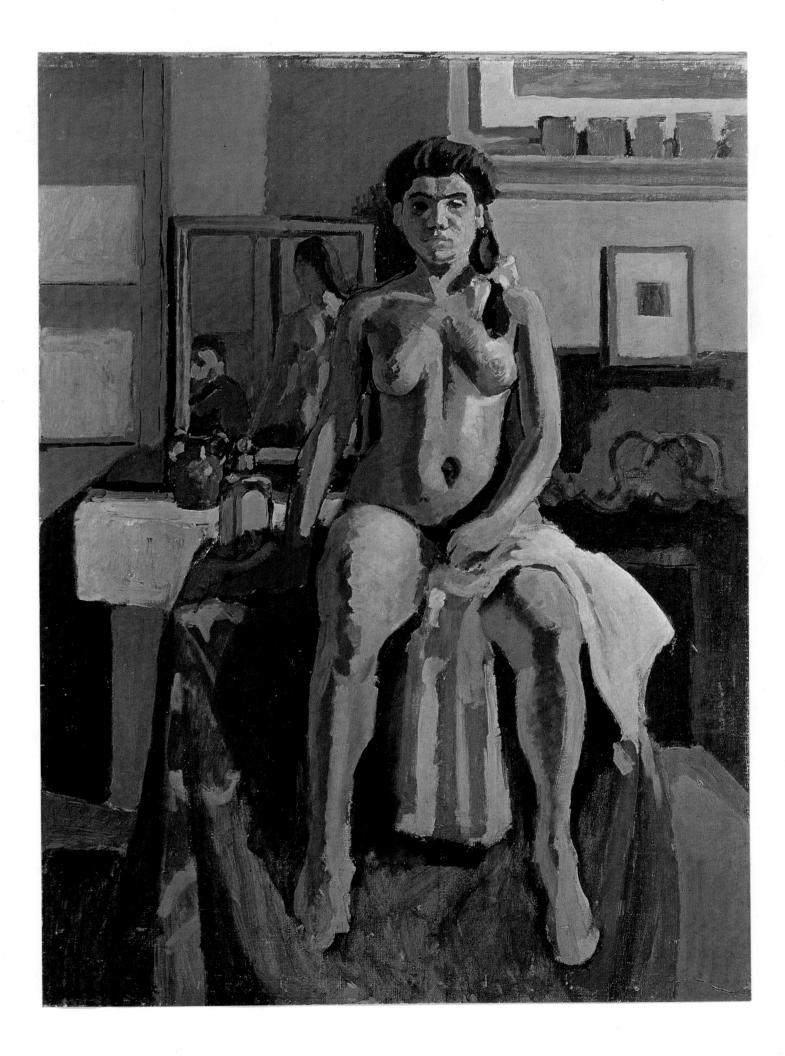

Painted 1904 (sometimes dated 1904-5)

LUXE, CALME ET VOLUPTÉ

Oil on canvas, 37 × 46"

Private collection, Paris

In certain respects this calculating work can be considered an "apprentice" effort; in others it marks the beginning of a sonorous theme that reverberates through the artist's subsequent works almost to the very end. Hence it is a turning point of extraordinary consequence.

Its Neo-Impressionist style is contrived and stiff, and immediately proved uncongenial to Matisse's temperament, even though the palette featured here would continue in his Fauve works. In effect, it may be considered another experiment in the artist's early career—preparatory to his major innovations in Joy of Life.

The academic lifelessness of its manner is due to the influence of Signac and Cross. But if the style was somewhat self-defeating and, in effect, a betrayal of Matisse's freer, more personal and daring efforts of the years just before and after 1900, the subject was an ambitious anticipation of what was to follow in the next five decades.

Là, tout n'est qu'ordre et beauté, Luxe, calme et volupté.

An entire aesthetic is contained within the lines of this thrice-repeated refrain of Baudelaire's L'Invitation au voyage. Matisse did not seek a visual image to subsume the entire poem, but instead created a Cythera-like world out of the literal import and the onomatopoeic suggestiveness of these carefully selected words. In the foreground we discover a beach which recedes to the left, leaving an open bay at the right. That margin of the picture is secured by the trunk of a tree which, through certain spatially ambiguous, almost Cézannesque devices, is linked, in surface design, with the mast and boom of the beached boat in the middle distance. On this sandy shore a group of women are caught in a variety of indolent, relaxed attitudes. At the lower left a cloth is spread with the remains of a picnic, a detail reminiscent of certain early Cézanne compositions which are themselves filled with a tense, erotic suggestiveness. However, Matisse purges his work of these conflicts by maintaining a strictly female grouping, a calmness that he would ambiguously disrupt in the subsequent Joy of Life, with its conspicuous embracing couple in the right foreground.

There is, of course, much in the way of mechanical technique to admire in this stilted composition. The dark shading behind the standing figure nearest the tree at the right and the greenish shadows cast beneath the seated and reclining figures predict a bolder use of the same device in later mythological and pastoral scenes. True, the labored brushwork and forced tensions between spatial illusion and surface design will give way to a greater spontaneity in *Joy of Life*. Nonetheless, Matisse's skill in mastering a style that is, strictly speaking, someone else's commands more than mere respect. He could have remained simply a gifted eclectic and still have found his place in the history of early modern painting. As it was, he had another destiny.

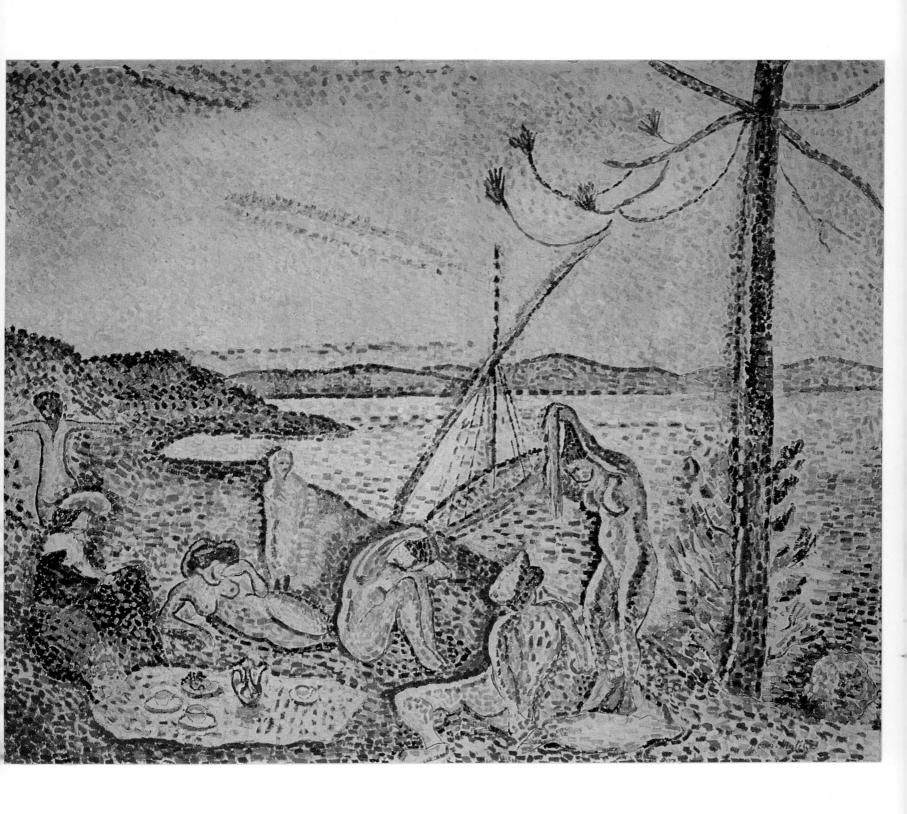

Painted 1905

THE GREEN STRIPE (MADAME MATISSE, PORTRAIT À LA RAIE VERTE)

Oil on canvas, 16 × 12 3/4"

The Royal Museum of Fine Arts, Copenhagen. J. Rump Collection

The modest dimensions of this canvas are surprising, for its impact is monumental, owing to the astute balance of totally saturated colors. The green stripe down the nose is theoretically supported not by the contours of the cheeks but by the blue green of the collar. Yet if this axis, together with the densely painted flesh tones, were the sole support of the blue-black crown of hair, the pictorial structure would collapse. Stubbornly, all these features are kept securely fixed in space through the intense, luminous orange, violet, and green surroundings. Few Fauve canvases are so completely supported by color alone as is this portrait of the artist's wife. Furthermore, the unity of the head and the sustaining color areas (it is almost out of the question to refer to them as a "background") is maintained by a unique crisscross blend in the flesh tones. The left side of the face tends to echo the green of the picture's right, the corresponding being true for the right side, where the more forthrightly pink skin responds to the orange of the left.

In spite of these rarefied, boldly brushed coloristic effects, we nonetheless sense the artist's determination to fashion a likeness. In contrast to Cézanne in many of his late portraits, Matisse is not content with a study of planes and structures, leaving us with a masklike impression. In his contemporary Woman with Hat, the artist employs a similar palette, but as the color still remains somewhat broken in that particular portrait of his wife, the effect is less concise. Similarly, in that painting the immediate presence of the model is less strongly communicated, and thus we are left with the belief that The Green Stripe offers a more accurate and penetrating likeness. However, if Matisse has used color here to the maximum of its expressive and connotative possibilities, he has not produced an image of Expressionistic psychology. The dignified bearing and assured manner of the model are communicated without the slightest ambiguity, and in the end we realize that these abrupt juxtapositions of saturated pigment result from the calculated pictorial decisions of an artist possessed of a unique skill in the balance and contrast of color.

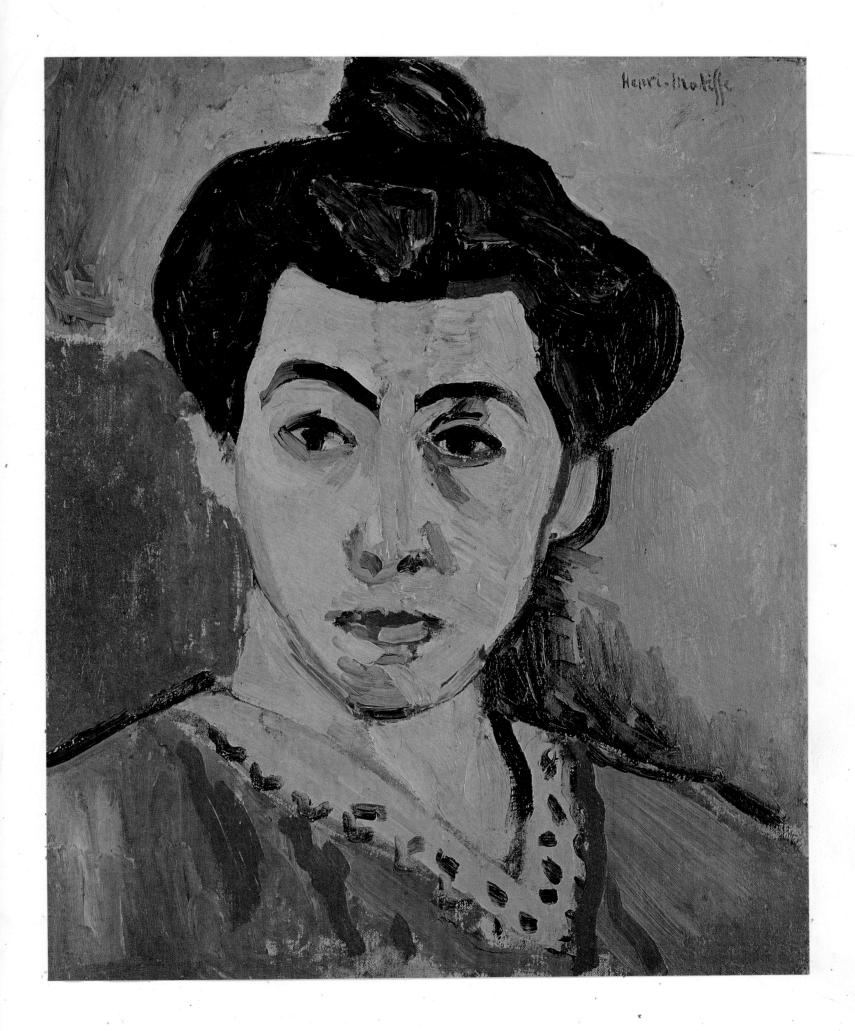

OPEN WINDOW, COLLIOURE (LA FENÊTRE, FENÊTRE OUVERTE)

Oil on canvas, 21 3/4 \times 18 1/8"

Collection Mr. and Mrs. John Hay Whitney, New York City

This is the grand classic statement of the open window as a crucial formal and conceptual theme in Matisse's art, and one of the central masterpieces of the short-lived Fauve movement. This and other pictures of the period mark Matisse's final liberation from the constraints of Neo-Impressionism. Moreover, in this nearly symmetrical picture, with its flanking, framing areas of intense blue green and electrifying pink, the artist had a format in which he could work out the problem of broad, maximized areas of color. The theme of the landscape seen through the open window (here a harbor view), even more emphatically a picture within a picture than in *The Attic Studio* (colorplate 9), carries on in the artist's work, culminating in the remarkable Interior with Egyptian Curtain (1948; fig. 54). One further compositional device must be mentioned: the variously colored rectangular shapes of the individual panes of glass and the supplementary rectangles of the transom must be compared with certain details of the early studio interiors such as Interior with Top Hat (1896; fig. 6) and Carmelina (colorplate 10). Now the artist has emphatically drawn the theme of the picture within a picture to new, virtually symbolic levels. The reflective and translucent panes of glass, vibrantly colored, now supplant the more prosaic pictures and frames on the walls of the earlier interiors. In effect, each of these patches of color, whether pale or intense, can be read as an individual miniature and as a structured part of a coherent whole. Finally, Matisse's lifelong predilection for nature in its cultivated aspects, first hinted at in The Path in the Bois de Boulogne three years earlier (colorplate 8), is underscored in the rectangular garland of ivy clinging to the balcony just beyond the open windows.

The striking color juxtapositions have excited such interest in this picture that the more thoughtful qualities of its palette are often missed. Note the contrasting symmetrical pillars of green and pink, and the tendency of the window panes to reflect chiefly the hue of the opposite side. Alfred Barr has justly commented on the inconsistencies of brushwork between the interior and exterior, finding a certain Impressionistic survival in the conception of the latter (Matisse, p. 72). But this difference is to a degree functional, serving to demarcate two distinct worlds. Moreover, the broken brushstrokes of the exterior serve to thrust emphatically forward and thus render more intense the flat passages serving as framing elements. Indeed, the relatively long strokes of the exterior resemble Impressionist technique less than they resemble many Matisses from the Nice epoch of 1917 and afterward. The one paradox, intentional or not, is that the artist has here produced a picture in which the frame is more important than the view. Looking far ahead, one might compare Open Window, Collioure with certain of Frank Stella's chromatic compositions of the 1960s, where frame and pictorial design have been completely merged into a unified, mutually dependent structural system.

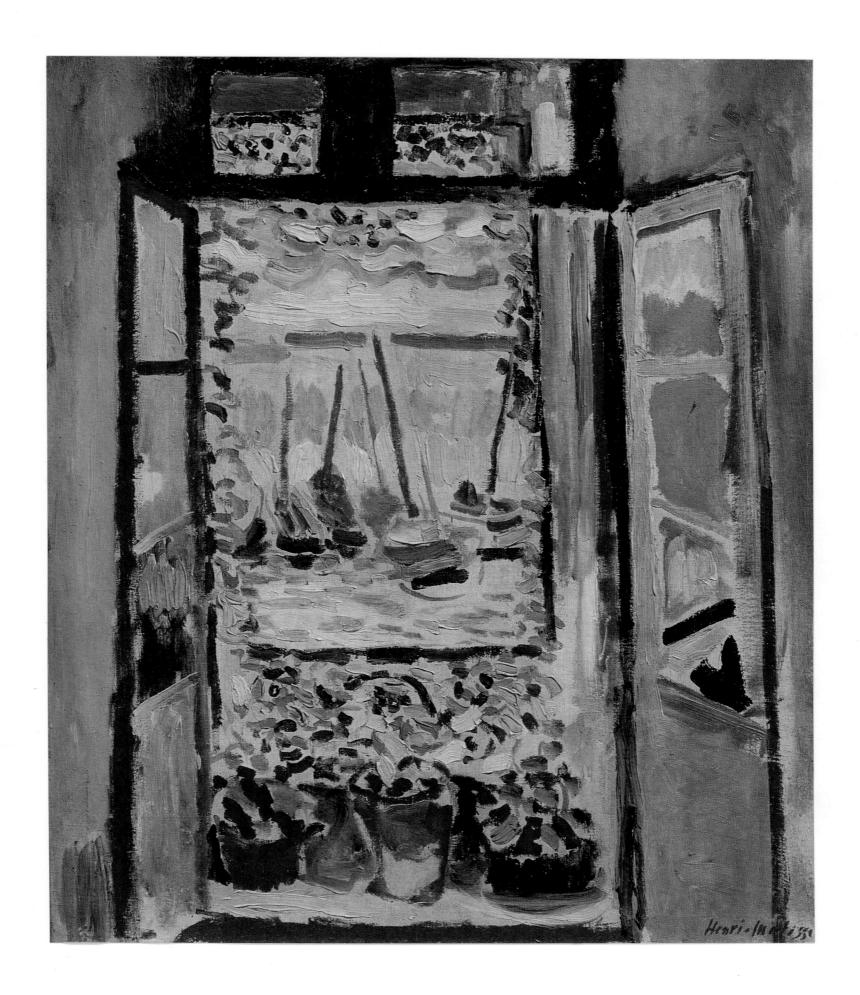

Painted 1906 (sometimes dated 1905)

SKETCH FOR JOY OF LIFE (JOIE DE VIVRE)

Oil on canvas, 16 $1/8 \times 21 5/8$ "

Private collection, San Francisco

The present study is the most developed of three preparatory oils for the monumental final version, almost eight feet wide, in the Barnes Foundation (fig. 5.) This arcadian conception follows directly out of the earlier picture Luxe, calme et volupté (colorplate 11), and is both a reaction and a further creative response to Matisse's preoccupations of the recent past with a variety of new movements. While the study indicates an indebtedness to Neo-Impressionist style in certain of its areas, these references are banished in the broadly brushed final version. While the studies and final version mark the epitome of the artist's work as a Fauve, the final version in particular heralds the development in his subsequent work of large, abruptly juxtaposed flat areas of thinly brushed, high-keyed color, a tendency that was pursued through the monumental works of the teens and thirties and culminates with the last papiers-découpés of the early fifties.

Analogies can profitably be made with some of the great pictures of the sixteenth-century Venetians, notably Titian's Bacchanal. Another and more recent comparison is Ingres's Golden Age, where the circle of dancers is to be found in the foreground. However, historians have tended to relate this picture to a near contemporary, Picasso's Demoiselles d'Avignon, of 1907, and while they occupy parallel stages in the careers of their respective artists, the profound differences in the aims of the two men at this time preclude drawing many conclusions from so abrupt a confrontation. More to the point might be a comparison with Cézanne's Large Bathers (Philadelphia), finished in 1905, which Matisse just possibly could have seen at Vollard's. The dimensions of the two canvases are remarkably similar, and the scale of the figures is also comparable. Matisse's sinuous contours in the sheltering bower of trees in Joy of Life could well be a response to the sternly architectural feature of the bent tree limbs in Cézanne's painting. Iconographically, Matisse's masterpiece perhaps owes something to Signac's 1895 composition Le Temps d'harmonie, a terrestrial paradise in contemporary costume and with a working-class orientation, which nonetheless features a round of dancers under a tree in the distance. Another, more closely associated picture is Derain's Golden Age, dated about 1905, where the theme is strikingly similar but the treatment more violent and the scale of the figures larger. Matisse and Derain worked on these related arcadian subjects simultaneously and could have exchanged ideas. A further revealing juxtaposition can be made with Edvard Munch's figure paintings, dating back as far as 1890, which show a totally different, pessimistic and despairing attitude toward the earthly paradise.

In sum, Matisse's painting represents a fusion of several important trends in late nineteenth-century art, as well as an anticipation of many things to come in his own work.

STANDING NUDE (NU DEBOUT)

Oil on canvas, 36 × 25"

Tate Gallery, London

In the context of Matisse's evolving figure style in these years, this picture, with its firmly modeled, massive, angular contours and squat proportions, emphasized by a rather oversize head, seems something of an anomaly. In spite of its vastly different palette, it almost seems a retrogression to the *académies* of 1900, exemplified by *Male Model* (colorplate 5). Alternatively, we might suppose this figure to be connected with a contemporary project in sculpture, but nothing of this sort is the case, since by now Matisse was already modeling his bronze female figures into arabesques resembling the major figure of *Le Luxe*.

Consequently, we must see this Proto-Cubist figure study as another of Matisse's retrospective glances, although not such a drastic one as Carmelina (colorplate 10). Nor is this a hesitant, insecure look backward. Alfred Barr (Matisse, pp. 86ff) very rightly associates this picture with what he calls "Cézanne and the crisis of 1907-8," a phenomenon that affected not only the Fauves-Matisse, Derain, Dufy, Vlaminck-but also Picasso, a crisis that brought about the defection of Braque from the Fauvist to the Cubist camp. Much of this crisis was worked out in landscape painting. Braque's famous studies at L'Estaque in 1907 are well known, but even an artist like Dufy, who would not follow further into Cubism, painted anti-Fauve, Cézannesque landscapes on the same site in 1908. On the other hand, the great post-Cézanne breakthrough into Cubism dates from Picasso's Demoiselles d'Avignon of 1907, and hence Matisse's Standing Nude takes its place beside the more ambitious work of the Catalan artist. The two had met for the first time the previous fall at the apartment of Leo and Gertrude Stein, but there is no certainty that Matisse knew of the *Demoiselles* when he painted the present figure. On the basis of his earlier preoccupation with Cézanne, we need not look for an outside stimulus for this composition.

It is especially significant that Matisse rarely followed up this line of research in his subsequent figure paintings. He had already digested his lessons from the Aix master earlier in the decade, and after the completion of Joy of Life he had outdistanced not only Fauvism in its narrower sense but also the need to study Cézanne in a quasi-scholarly fashion. By 1907, Matisse was on his way to an anti-Cubist mode of figure design, emphasizing the powerful decorative force of the linear arabesque. Matisse's and Picasso's contrasting routes in these years (1907–10) were equally indebted to the figure compositions of Cézanne's crowning years. The older artist's message was so rich in potential that two diametrically opposed manners could arise from it within the space of less than a decade.

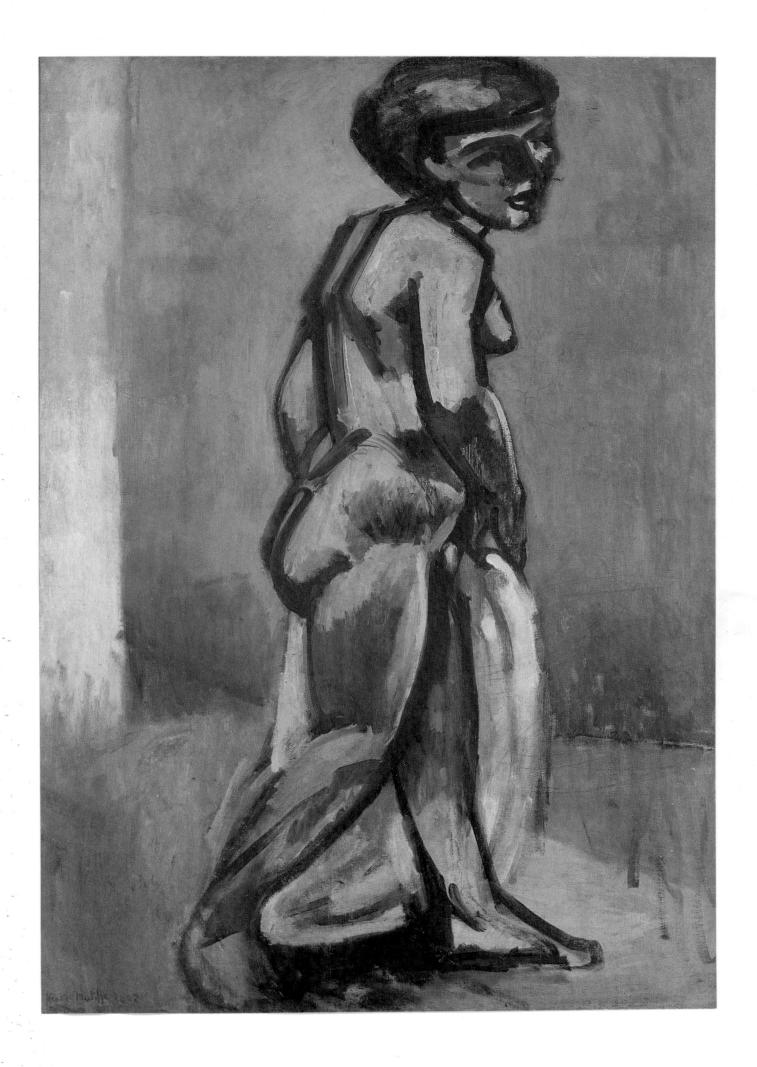

LE LUXE I

Oil on canvas, $823/4 \times 543/8''$

Musée National d'Art Moderne, Paris

This picture, a full-size study for the final version in Copenhagen (fig. 20), is undoubtedly more "interesting" to the critic preoccupied with the evolution of Matisse's art. However, it is infinitely less complete, less "realized" than the more articulate, simplified, and compact statement of Le Luxe II, which remains one of the artist's most serene images. Iconographically a condensation of Luxe, calme et volupté (colorplate 11), its two major figures, the statuesque but hardly sculptural standing figure and the one crouching at her feet, actually derive from the two figures to the left of Joy of Life. The crouching figure has now been reversed, and the standing one here lowers her arms. The image of Lesbos, already present in Matisse's Neo-Impressionist composition and even in Joy of Life, is here made more explicit with the gesture of the bouquet-bearing figure hurrying in from the right. Indeed, Matisse would develop this concept further in the small Music (Sketch) (1907; fig. 21), with the embracing couple, both female, dancing to the music of the solitary male violinist. Parallel themes reappear in numerous drawings and a few paintings of paired odalisques dating from the 1920s and 1930s. Here, in Le Luxe, Baudelaire's verses, especially "Là, tout n'est qu'ordre et beauté," seem more fully realized than before, with the repetition of the theme of a world in which the male figure, with all its implications, is banished. Indeed, from this point onward, the appearance of the male nude is rare in Matisse's work, and except for the final Music (1910; colorplate 20), his role is usually the predatory one of the satyr. In addition to the painting of Nymph and Satyr (1909; Hermitage, Leningrad), a large ceramic mural dated 1907, in effect a triptych with a nymph and satyr flanked by side panels of dancers, has recently been rediscovered by John H. Neff (Burlington Magazine, December 1972, p. 848).

Le Luxe I contains many powerful features that had to be sacrificed in order to reach the expressive heights of the final version. Even the barest survival here and there of a brushstroke suggestive of Impressionism indicates the reluctance with which Matisse was shedding many of the received and learned techniques of his youth. The penumbras surrounding the figures, seen earlier, are virtually gone in the sketch, save for the back of the flower girl, and do not appear at all in the final version. And his most brilliant color concept, the pale copper-oxide blue green of the kneeling figure, had to be ruthlessly omitted from the final version for it to attain its unique serenity. In effect, Matisse here gives us a modern Aphrodite risen from the sea, erotic yet narcissistic, destined only for the eyes, attentions, and supplications of her own sex. It is a developed and expanded fragment of Joy of Life, just as, three years later, Dance (colorplate 19) was destined to be. In Le Luxe the artist offers us more than a hint of his consummate skill as a monumental draftsman, in close conjunction with his adroitly controlled genius in contrasting colors for a maximum of expressive and poetic effect. The stylized arabesques of the figures in Le Luxe and their fluent, graceful, almost lifesize contours map the direction of Matisse's immediate future and point the way to his decorative, architecturally scaled works of the 1930s and later.

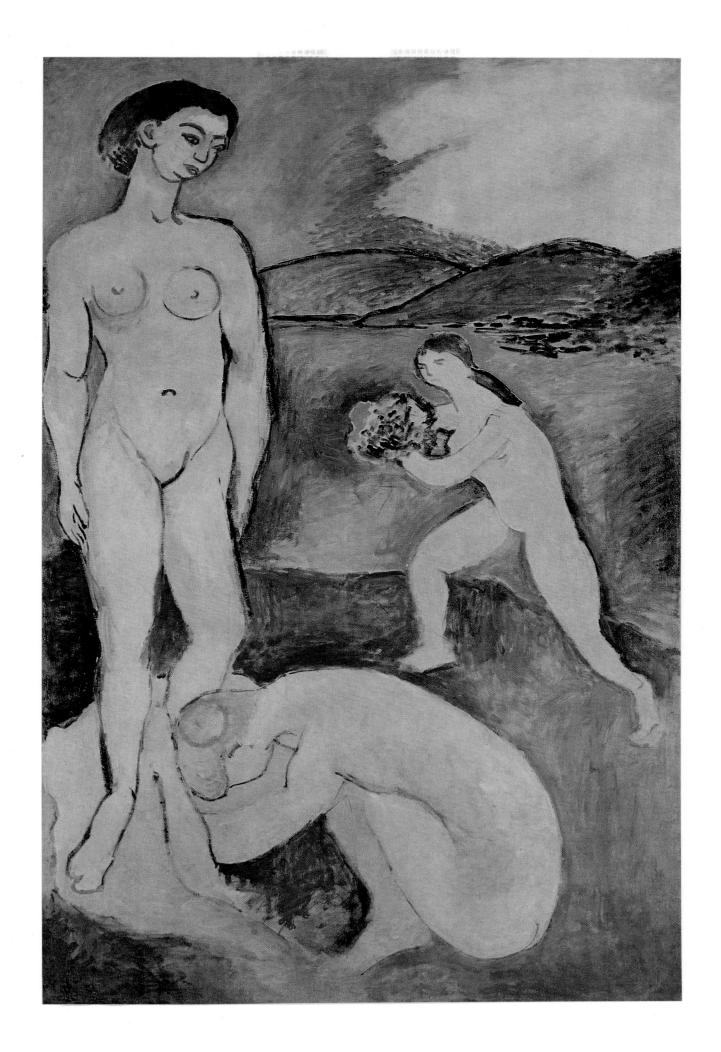

Painted 1907

LANDSCAPE WITH BROOK (BROOK WITH ALOES)

Oil on canvas, 28 3/4 × 23 5/8"

Private collection, U.S.A.

Scenes painted from nature were of extreme importance in Matisse's early evolution, especially as he liberated himself from his earlier dark manner, first in the Breton trips of 1895-97 and then in his year spent in the south in 1898. Subsequently, in Path in the Bois de Boulogne (colorplate 8), he sought to assimilate certain aspects of Cézanne's structure into his then formative style. The present picture, contemporary with the great figure pieces of the period, notably Le Luxe I and II, demonstrates how his newfound compositional design could be applied to the study of landscape. While not yet displaying the lyrical simplicity of the later Tangier scenes (for example, colorplate 25), the artist has already found a personal, unique post-Fauve vision of nature, one that supplements as well as reinforces the major tendencies of his larger, virtually mythological paintings of the period 1906-10. The surface pattern is here the chief structural device, and color is the vehicle whereby it is accomplished. The brook flows across the front of the scene, but does not lead us back into an illusionistic space. The hillside of greens, blues, and ochers offers a soft harmony of hues that is barely disturbed by a few impetuously Fauve touches of red. Furthermore, the high horizon reinforces the picture's lack of depth, leading the eye upward rather than inward. Clearly this is a transitional painting with a few minor and undisturbing inconsistencies, as in the rather heavily painted surface of the water. However, it is an important landmark in the evolution of a motif in Matisse's art that is often overlooked. True, after the twenties, landscapes are rare in his work. But the theme of nature is subsequently transposed in his final designs, emerging in such visions as The Lagoon, one of the most abstract of the plates from Jazz (1947), or the monumental decorative composition Parakeet and Siren (1952), one of his most abstract transformations of nature. In effect, the seeds for those culminating interpretations of foliage were planted as early as the present picture.

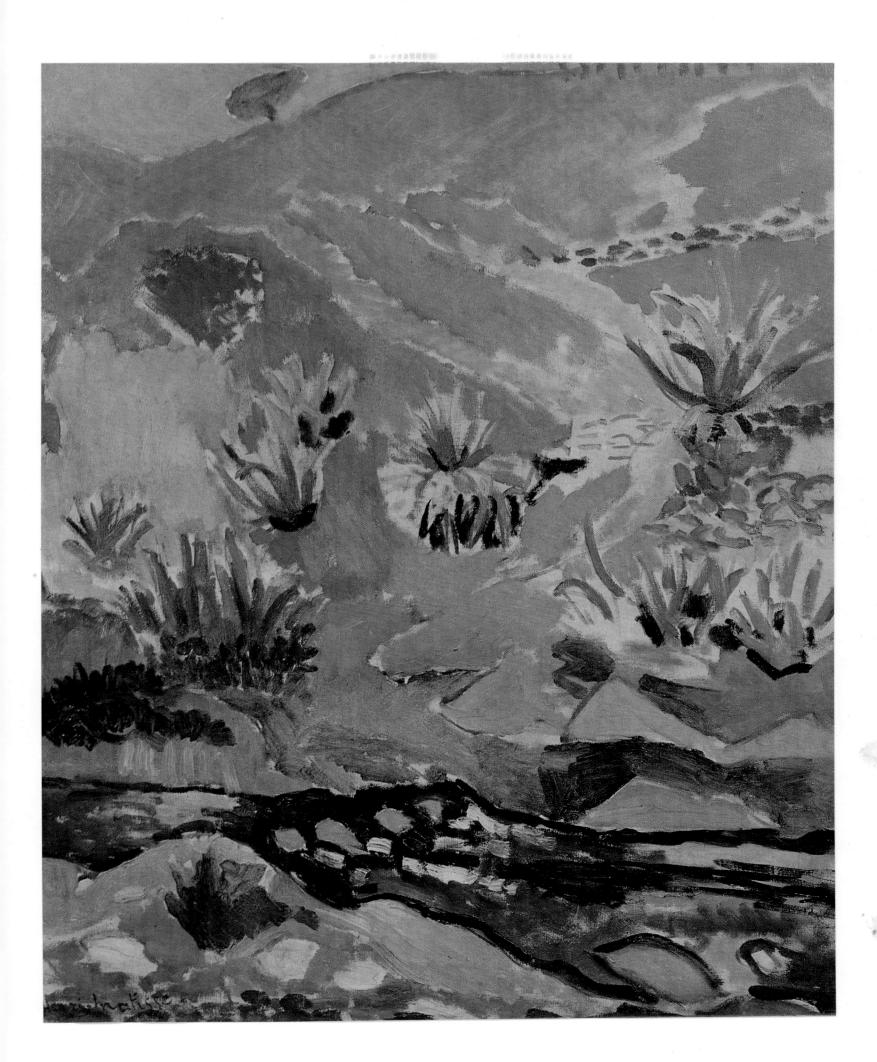

Painted 1908-9

HARMONY IN RED (LA DESSERTE ROUGE, HARMONIE ROUGE)

Oil on canvas, 69 $3/4 \times 85 7/8''$

The Hermitage, Leningrad

The monumentality of this ambitious still life looks backward to La Desserte (1897; fig. 8) and anticipates Still Life with Aubergines (1911; colorplate 24). This series of pictures indicates Matisse's ambition to develop in large format a motif that is customarily treated in a more intimate fashion. At this point in his career, with so much of his effort dedicated to large-scale figure compositions, Matisse clearly felt the need of achieving something equivalent in another, time-honored theme of Western art, one which, a century before, had not been considered worthy of the same attention from artists as large figure paintings or even portraiture. Hence, Harmony in Red is one of the artist's major contributions to the equalization and democratization of hierarchies in subject matter.

The magnetic red of the wall and tablecloth, with the interweaving blue pattern, is one of Matisse's most unusual color creations, and its history is fascinating and complex. The canvas began its life as Harmony in Green (the landscape through the window is almost certainly a survival of this stage), and was then transformed into Harmony in Blue in 1908. It was publicly exhibited in this second state, and sold to Sergei Shchukin, who apparently intended it to be a decorative panel for his dining room. Then, in 1909, Matisse persuaded Shchukin to return the picture to him, and at that time the definitive Harmony in Red emerged. The fact that he was working on a predominantly blue ground rather than on a fresh white canvas very likely influenced him in his choice of this particular red. To judge from photographs of the intermediate stage of the picture, the effect was always flat, the surface of the table and the perpendicular wall behind being treated in a similar, continuous fashion so that the rear surface enjoys a clear unity with the picture plane. The landscape seen through the window at the upper left reinforces the floral arabesques of the interior, setting up a provocative dialogue between nature itself and its decorative transformations found in the interior. Nevertheless, the landscape is itself stylized, providing a premonition of the kind of design that Matisse would employ in his Tangier landscapes four years later. Looking backward, Harmony in Red is a vast advance over La Desserte. The high diagonal view of the earlier picture is here replaced by an approximate frontality. The eye level of the picture, when judged in terms of Renaissance perspective, is just above the sill of the window, hence almost at a median level. In producing one of his most flattened, tapestry-like works of that date, Matisse employed an extraordinarily conventional if almost invisible underpinning of Renaissance perspective, reaching back behind the innovations and distortions employed by artists of the previous century. While we may regret the disappearance of two other paintings beneath the final layer of the finished version, there can be little doubt that what we now see is a vastly more intense composition, one which perhaps could not exist in quite the way it presently does without the sacrifice of the earlier pictures in green and blue.

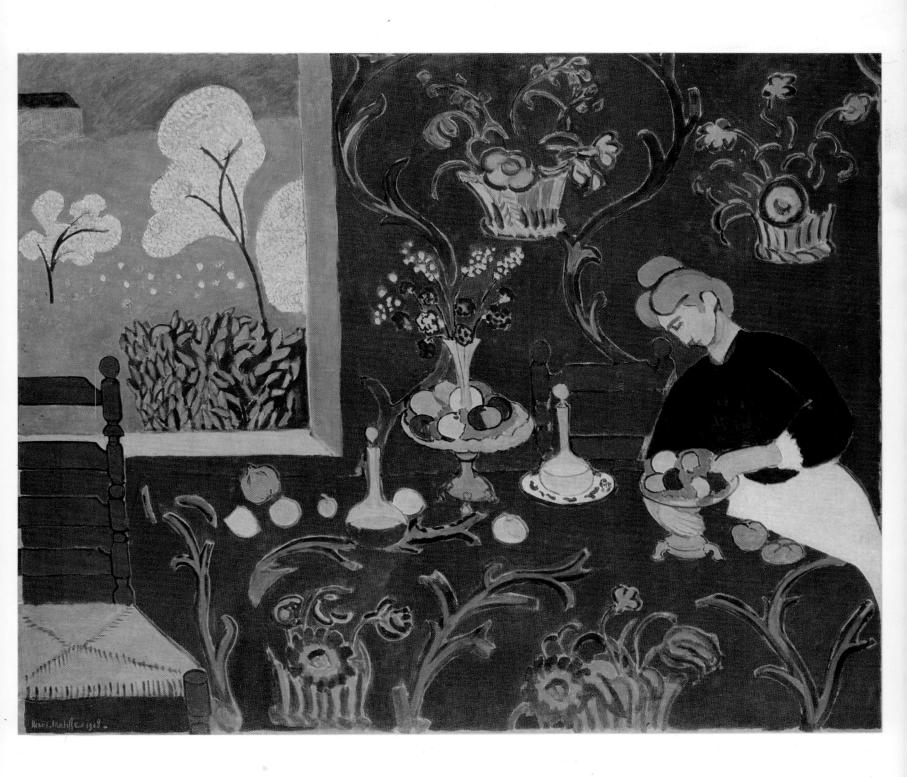

DANCE

Oil on canvas, 8' 5 5/8" \times 12' 9 1/2"

The Hermitage, Leningrad

This painting may be interpreted as an anti-Cubist demonstration of how figures may be linked by means of muscular arabesques and intense color contrasts with the abstracted ground, in contrast to Cubism's evolving device of binding together figures and objects through arbitrary overlaps and planar deformations in an illusionistic space. Its mural-like size was perhaps inevitable, given the expanding scale toward which the artist was then moving, but the happy coincidence of a commission for a series of decorative compositions for the Moscow mansion of the Russian merchant Sergei Shchukin surely goaded the artist along. A full-size study (Museum of Modern Art, New York), whose pale flesh tones did not attempt to reach the saturation point achieved by the terra-cotta ochers of the final version, indicates that the artist was here proceeding in a way analogous to *Le Luxe*.

Dance was conceived as part of a series of three monumental compositions, to be followed by Music (colorplate 20) and Bathers by the River (colorplate 31). But only Dance and Music were completed at the time; a small study of five bathers exists (fig. 22), and in 1917 the artist completed Bathers by the River in a paradoxically Neo-Cubist style.

The sources for *Dance* are multiple, reaching back into antiquity (maenad figures on Greek vases; Graeco-Roman images of the Three Graces). Matisse furthermore told interviewers that he had been stimulated by observing country dancers at Collioure and Parisians dancing at the Moulin de la Galette, an indication that he kept his eye on contemporary life while developing his modern mythologies. The pale, realistic flesh tones of the five women in the full-size sketch of *Dance* give way in the final version to a violent red-ocher suggestive of red-figure Greek vases, with the result that a highly saturated contrast is achieved with the green ground and blue sky. Several crucial lines are strengthened in the definitive canvas, emphasizing the tensions and relaxations of movement. The hands of the figures at the left and in the foreground are brought closer together, creating a tension of contact rivaling Michelangelo's *Creation of Man*.

Among modern prototypes for this celebration of Dionysiac energy, the most notable is Carpeaux's sculpture group on the facade of the Paris Opera. The closest treatment of the theme in terms of time was, however, a large, little-known painting of 1905–6 by his friend Derain. Interestingly, Matisse had already treated this theme separately in the cylindrical wood relief *Dance*, 1907 (fig. 66), which contains only three figures.

Matisse here poses a major aesthetic problem—the relation of the design to the image—in a way that he had never done before with such emphasis. This forceful tension between the image and the design is complemented by the stark contrast of positive figural solid and negative spatial void. Given that at this moment the pioneer Cubists, Picasso and Braque, were developing a style that blurred when it did not disrupt the familiar boundaries between solid and void, Matisse's style here emerges as strikingly anti-Cubist.

Œ

Painted 1910

MUSIC

Oil on canvas, 8' $55/8'' \times 12' 91/2''$ The Hermitage, Leningrad

This last time that Matisse turned his attention to a composition of male figures (their genitalia were subsequently painted out, probably at the insistence of the client) he reduced them to a series of hieroglyphs, but, significantly, musical ones. One of his most challenging inventions, it remains explicable only in terms of the Dancers that preceded and the Bathers that were to follow (but which were not realized until six years later, and in another mode). And yet in the stasis of this present sequence of music makers he has produced a disposition unique even in his own work—the only possible release from the preceding round of dancers. There is no consistent precedent for identifying dance with the female and music with the male; indeed, as the pictures presently stand, the sexual differentiation may be virtually meaningless.

Originally, to judge from two photographs made while the picture was in progress (figs. 23, 24; apparently there were no preliminary versions), the composition was less rigid. In fact, the compositional changes may still be detected today beneath the final painting. A far cry from the muscular, faceted studio models of ten years before, yet coloristically related, these five figures attest once again to Matisse's insistent simplification of a given problem as he worked at it over the years. Thematically, Music is connected with a slightly earlier, more provocative work of the same title of about 1907 (fig. 21), where the violinist at the left presides over a scene in which two embracing women dance while a male figure serves as repoussoir in the right foreground. Hardly a study for the present picture, it nonetheless links the themes of Music and Dance at a slightly earlier stage in the artist's career. The pipe player, second from left in the 1910 Music, evokes a recumbent figure from Joy of Life, but for the rest this is a unique effort. The evolutionary changes which affect chiefly the three figures to the right lead to a bold frontality. In the completed picture they become, as it were, notes on a staff of music (as does the pipe player), with the increasingly rigid violinist doing service as a kind of treble clef.

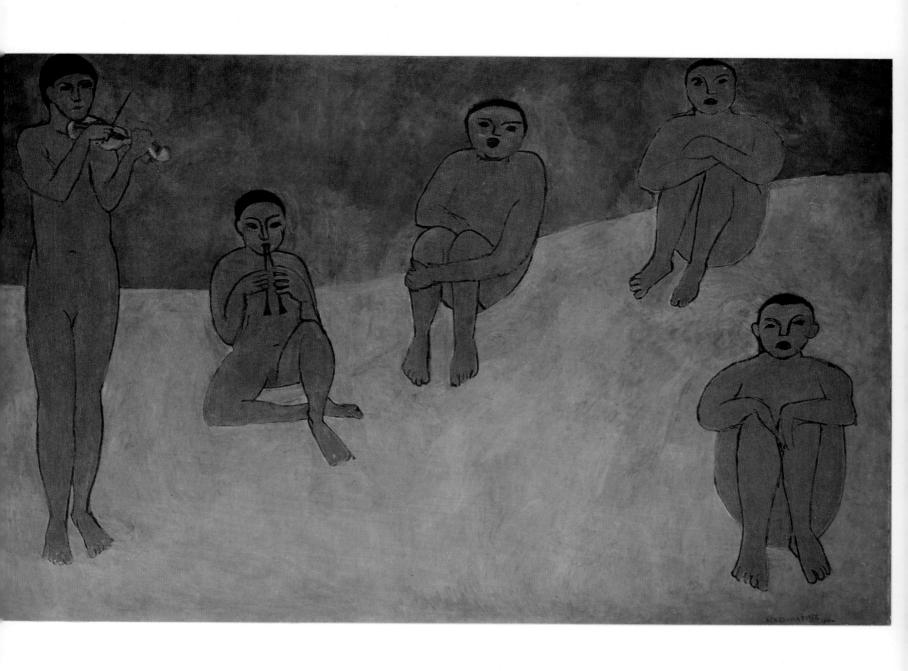

RED STUDIO (L'ATELIER ROUGE, LE PANNEAU ROUGE)

Oil on canvas, 71 $1/4 \times 86 1/4''$

Museum of Modern Art, New York City. Mrs. Simon Guggenheim Fund

The very simplicity of its hue masks one of the artist's most subtle achievements, a composition that remains a paragon of contemporary art even after the passage of time and the achievements of artists like Barnett Newman and Mark Rothko. Here the past of realistic studio interiors by Courbet, Bazille, and others merges with the present of concern for color-field painting or for exploring the threshold of visual perception. The nature of its "redness" is itself magical, utterly without precedent in other paintings by Matisse. The physical surface is mat and dry, the spatial effect is barely suggested, the local colors of individual objects (many themselves paintings) play almost no role in the total effect, and the final impression is both electric and inducive of contemplation. It is an allegory of the senses, both as a pure painted surface and as a representation of a corner of the artist's studio filled with objects of obvious biographic significance. Matisse was uniquely placed in the chronology of recent art to bring all these contradictory concepts together simultaneously, but he was also uniquely equipped in temperament (in terms of where he had started and where he was destined to end) to be the human bridge across which such contacts could be made.

Intensely monochromatic, it seems in retrospect a reflection and perhaps even a criticism of Cubism's similar tendencies at the time, since it employs a high- rather than low-keyed tonality. Spatially, of course, nothing could be further removed from the paradoxes of Cubism than this stenographic tapestry-like study of the artist's working environment, a theme that reaches back to his earliest endeavors. The composition is casual and almost indifferent. Gone are the close interweavings and the tying together of one object to another through either surface or spatial overlapping. Instead, the space opens out into a hitherto unseen infinity, one which always returns us to the surface of the painting proper, providing a unique atmosphere which forms the setting for discrete objects, thus insuring each its own importance and dignity. Once one is past the redness of this picture, its individual elements take on a life of their own, and in a topographic situation that remains realistically convincing.

What is absent from this study of the artist's environment is the artist's model or the artist himself, elements that will appear later in paintings and in countless drawings. The space is empty and uninhabited, except by its special tone, and it is there that we may detect not just an atmosphere but the particular mind and taste of Matisse. Later studio pictures may be more genial, suggestive, and picturesque, but in a grander sense his presence is contained in this image to a greater degree than ever again in a rendering of a similar motif.

Moreover, as a document pure and simple, *Red Studio* contains a summary rendering in the left corner of a lamentably destroyed work, *Large Nude with Necklace*, whose major tonality points to *Red Studio*'s companion piece, *Pink Studio* (colorplate 22).

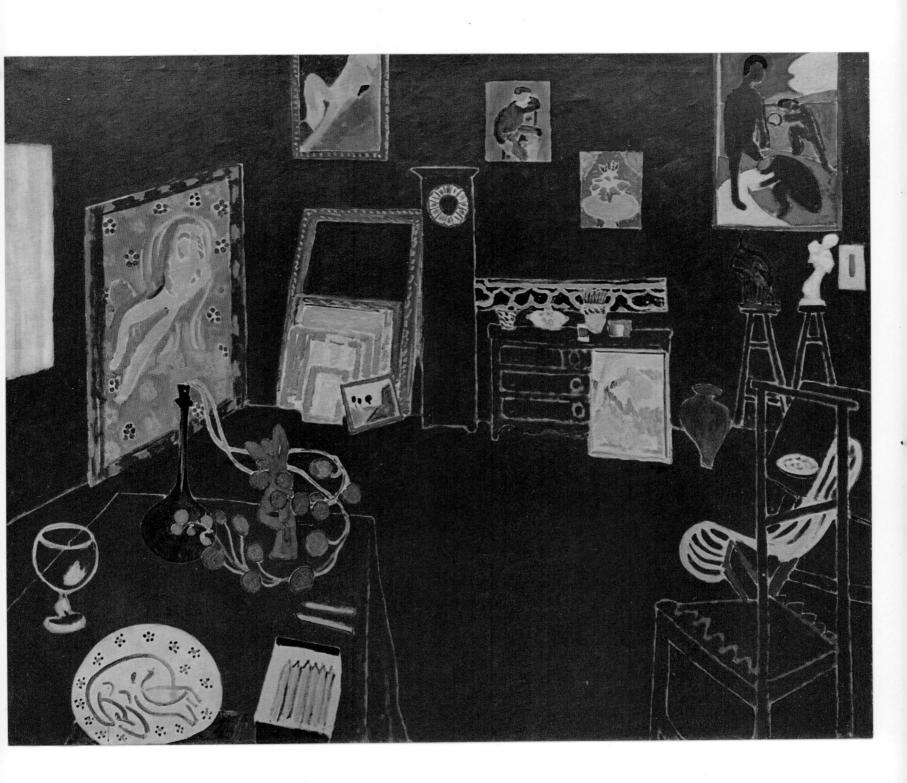

Painted 1911

PINK STUDIO (THE PAINTER'S STUDIO, L'ATELIER ROSE)

Oil on canvas, 69 $3/4 \times 82 1/4''$

Pushkin Museum, Moscow

The first impression received from this picture is as jolting as that of its companion, *Red Studio* (colorplate 21). The unheralded quality of the pink, which is not as all-pervasive as the red of the other, is in no way muted by the differing intensities applied to the floor and the wall, and the prominent areas of green and blue serve to reinforce its sumptuous luminosity, a quality significantly absent from *Red Studio*.

The topography of the studio is here more explicit; the view, with its glimpse through the open window—a motif recaptured from the earlier Attic Studio (colorplate 9)—is conventionally frontal, whereas Red Studio looks more obliquely into a corner. That both of these monumental compositions were painted in the same environment, the artist's studio at Issy-les-Moulineaux, is demonstrated by the correspondence of several works of art, notably the second version of Le Luxe, indicating that the right third of Red Studio is in actuality the left third of Pink Studio. That the artist could sequentially compose two such strikingly contrasting yet equally intense color studies of his actual working environment is astounding, and illustrates the degree to which the reality of the picture's unique being had taken control of his art by 1911. Both are paintings about painting, through their demonstrations of post-Fauve color control, but they further indicate the artist's newfound satisfaction with his immediate surroundings as a motif to create a buoyant world of the imagination as satisfying and idyllic as Joy of Life and subsequent expansions on that theme. One has only to compare these works with earlier studio pictures to realize the degree to which the artist has now rediscovered the nature and pictorial potential of his working environment, finding it no longer necessary to invent a mythological world as the thematic skeleton for the exploration of color and line. The slightly sordid, untidy appearance of the earlier studio pictures is now gone for good.

The sumptuousness of *Pink Studio* offers, on prolonged contemplation, a more mellow air; one becomes accustomed to its haunting atmosphere in a way that contrasts absolutely with the sustained, unrelenting *Red Studio*. A chordal harmony rather than a long-sustained single note is present here, and in spite of its monumentality and the grandeur of its central parts, it prepares us for the small-scaled interiors of the 1920s. The analogy between this painting and Courbet's *Atelier*, 1854–55, is more striking, but once again the artist's presence is not actually seen, but only felt through the wizardry of his color.

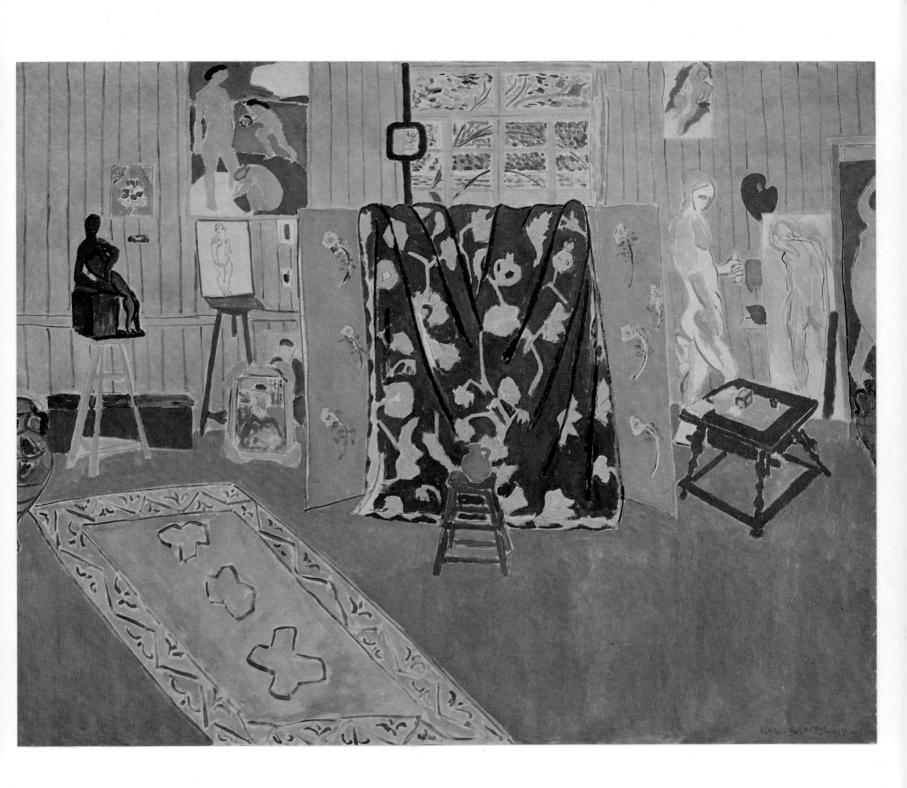

THE PAINTER'S FAMILY

Oil on canvas, 56 $1/4 \times 76 3/8''$

The Hermitage, Leningrad

This is another of the four great "Symphonic Interiors" (to borrow Alfred Barr's apt phrase), perhaps the third of the series to be completed. It was painted in the artist's villa at Issy-les-Moulineaux, whereas *Red Studio* and *Pink Studio* (colorplates 21, 22) were painted in his workrooms constructed in the garden and *Still Life with Aubergines* (1911; colorplate 24) shows us the interior of his villa at Collioure. Hence, these four pictures sum up the artist's life and surroundings of that year, before he temporarily extended his working environment to North Africa.

This is the only one of the four pictures to introduce the figure. His wife is in the left distance, his sons Pierre and Jean are at the checkerboard, and his daughter, Marguerite, stands at the right. The overall flatness of design, relieved and contradicted by certain perspective details, corresponds to the technique of the other three. However, the quality of the color, predominantly red and red brown, lacks the ringing, sonic quality of the others. While not muted, the color is static, a feature helped by Marguerite's black dress. A single work of art, a small bronze figure, stands on the mantel over the central fireplace. Otherwise this is a domestic, bourgeois interior and, despite the picture's large size, remarkably Intimist in quality. Indeed, it suggests comparison with Vuillard's monumental decorative project for the library of Dr. Vaquez, Personnages dans des Intérieurs, 1896, which was publicly exhibited for the first time at the 1905 Autumn Salon, the same which contained the "cage of wild beasts," and it is likely that Matisse saw it at that time. Matisse had met Vuillard much earlier, and had known of his work from about 1897, but curiously was little interested at the time in the efforts of the Nabis, of whom Vuillard was a member. In fact, Matisse's career through its first two decades was moving in a direction counter to that of Vuillard. It is just possible, however, that by 1911 Matisse was prepared to integrate Intimist themes, and even touches of their style, into his work. It is noteworthy that he later became a close friend of the other great Nabi master, Pierre Bonnard. Concerning the checkerboard theme, one should remember that it was employed by Cubist painters at this time, notably by Juan Gris, whose acquaintance Matisse was to make at Collioure in the summer of 1914. Further afield, it is interesting to speculate on the artist's choice of a game of checkers as the central, unifying theme of this domestic interior. Employing a different game played on the same board, namely chess, Marcel Duchamp had already treated the subject pictorially and by 1911 was exploring the metaphysical connotations of chess players in his King and Queen Surrounded by Swift Nudes. This stretched comparison only serves to underscore the materialistic and mythological, as opposed to the metaphysical, sources of Matisse's art. However idealized, spiritualized, and abstract his paintings became, his point of departure was always the real world of immediate sensations, a real world that became increasingly sumptuous as time passed.

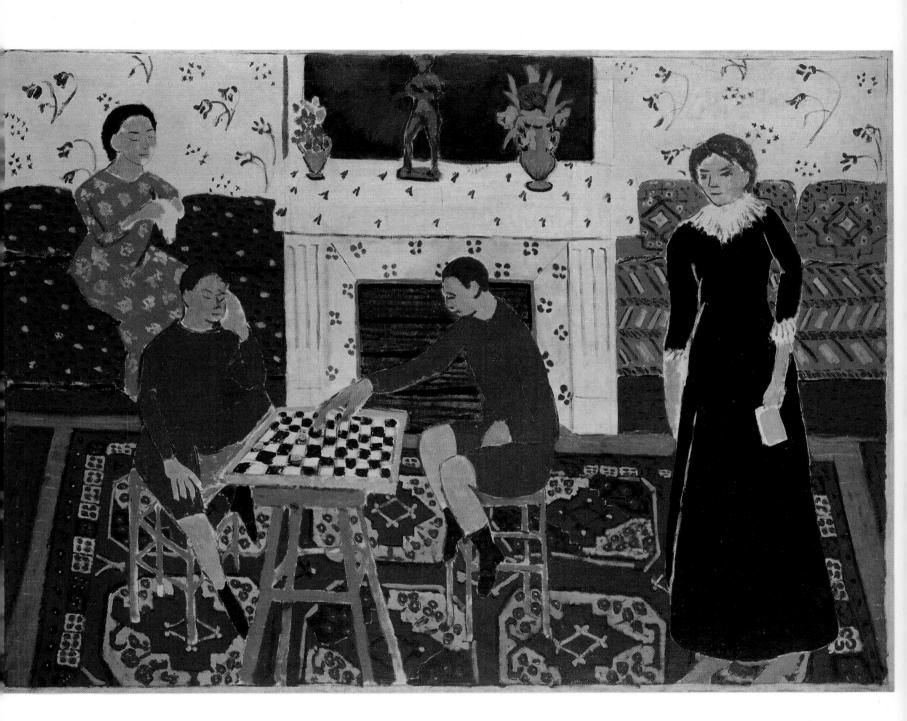

STILL LIFE WITH AUBERGINES

Tempera on canvas, 82 $3/4 \times 96 1/8''$

Musée de Peinture et de Sculpture, Grenoble

The title of this picture is a monumental understatement, and one wonders if the artist used it ironically. It is, in terms of accessories and devices, one of the most complete presentations of his ongoing fundamental theme, the conversion of the artist's own studio into the idyllic world of Joy of Life. This was a personal and artistic quest lasting a lifetime, and it would be unreasonable to expect that one single canvas could sum it all up. Still lacking here is the literal presence of the model and of the artist, but by the time we encounter these phenomena in the smaller-scale, more intimate works of the twenties, the grandeur of this design would be beyond Matisse, at least momentarily, if only because he was concentrating on more delicately nuanced phenomena of vision and subject.

An inventory of this picture is mandatory. Three aubergines are balanced precariously on a table whose red cloth carries an undulating white pattern that reinforces their tuberous shape. A mirror at the left, partly obscured at the bottom by a drawing portfolio, reflects these and other objects on the table in an inconsistent fashion. It is as if Matisse is stating that the artist's mirror image of nature in a painting may take certain licenses with reality in the interests of the picture itself. That it is indeed a mirror, and not another painting within a painting, is demonstrated by the reflection of part of the folding screen with floral pattern that occupies the center of the composition. Behind the screen we glimpse the top of an open door, probably leading to another room, where our eye is arrested by a checkered blue hanging. On the wall to the right is an open window with a real landscape beyond. For the rest, the floor and the wall are covered with abstract five-part floral patterns, all identical; this uniformity of the horizontal and vertical planes sets up a key surface tension with the illusion of spatial depth, a depth that opens both outward and inward (through the mirror reflection) along three separate diagonal axes. Originally the picture carried a painted frame several inches in breadth, with the identical floor-wall pattern, thus heightening the effect of decorative continuity and further reducing the scale of the aubergines themselves; unfortunately, this has been barbarically cut away. The total effect of the picture is one of an imaginary landscape constructed of a studio interior, since the space is as rich in floral abundances as it is in conventional studio props. Thus for the present Matisse completes, at vast scale, his allegory of the artist's world, seen here more emphatically than before as a garden of paradise. His well-known admiration for Persian miniatures, many of which illustrate actual gardens of delight, is here sublimated into a major theme of Western art, one that is central to Matisse's creative odyssey.

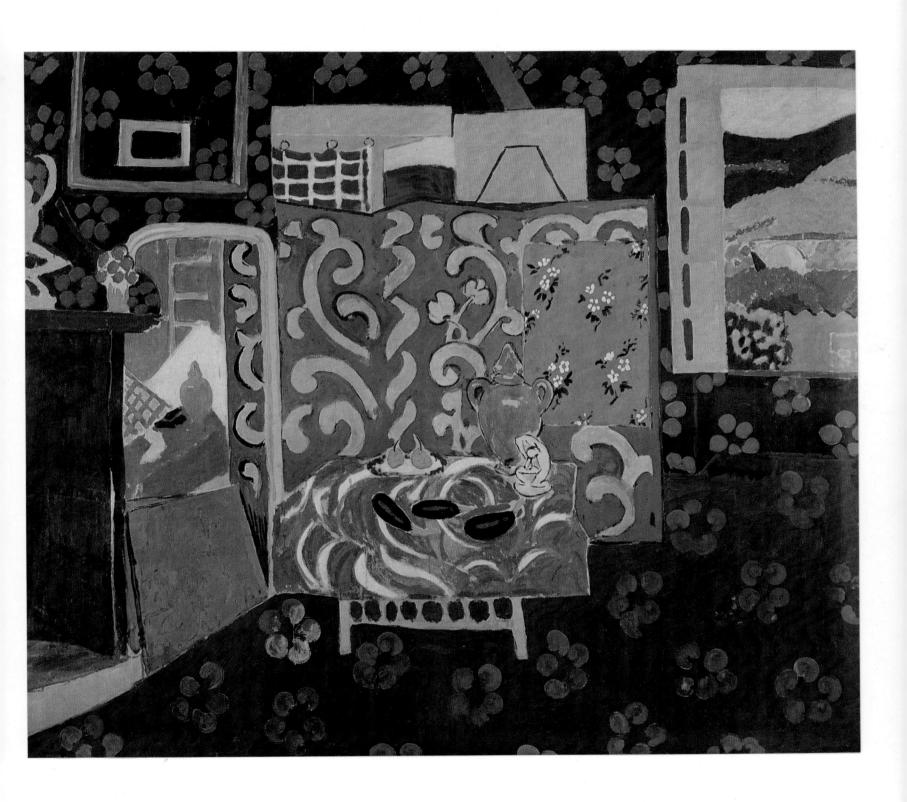

Painted 1912

MOROCCAN GARDEN (PERVENCHES)

Oil on canvas, 46 × 32"

Florene M. Schoenborn-Samuel A. Marx Collection, New York City

Like many nineteenth- and twentieth-century painters, Matisse traveled a great deal: to Germany, Italy, Spain, Russia, the United States, and even to the South Pacific. Yet one would not think of him as an itinerant painter in the same sense as Corot, the Barbizon masters, or even the Impressionists and Post-Impressionists. He certainly observed both art and nature during these trips, but he only infrequently worked on the road. He was not the sort of artist who went searching anywhere and everywhere for motifs to stimulate a restless imagination; he carried most of his themes within him.

An exception to this rule is to be found in his experiences of North Africa during the winters of 1911-12 and 1912-13, and both trips were extraordinarily productive in terms of range and quantity. During the first trip he produced what was in effect a triptych of garden paintings from the park in Tangier. A powerful study in intense pink, blue, purple, and green (Park in Tangier; fig. 26) is one of the companions to the present, more refined composition. While the Stockholm version represents the artist's more immediate response to a new environment, this picture, with its nuances of color contrast and more lyrical design, deserves to be compared with some of his earlier, more abstract work, notably the landscape of Blue Window (1911; fig. 25), or even the glimpse of the outdoors in the upper right of Still Life with Aubergines (colorplate 24). In short, Matisse has quickly integrated his perceptions of a new and unfamiliar environment with his habitual matured manner of structuring a landscape. The rose of the sky is joined to the greens of the foreground through the color and structure of the tree trunk, and the foliage is rendered in large patches held together in the distance by billowing arabesques. These in turn contrast with the few specific, individual leaves that are summarily indicated in the foreground. The distance covered between The Path in the Bois de Boulogne (colorplate 8) and this Moroccan Garden of precisely a decade later is enormous. The route that was traversed can be seen not only in landscape paintings per se but in the many glimpses of exteriors seen through open windows. Moreover, the decorative discipline of these studies of nature is no less than that found in his interiors of the same epoch.

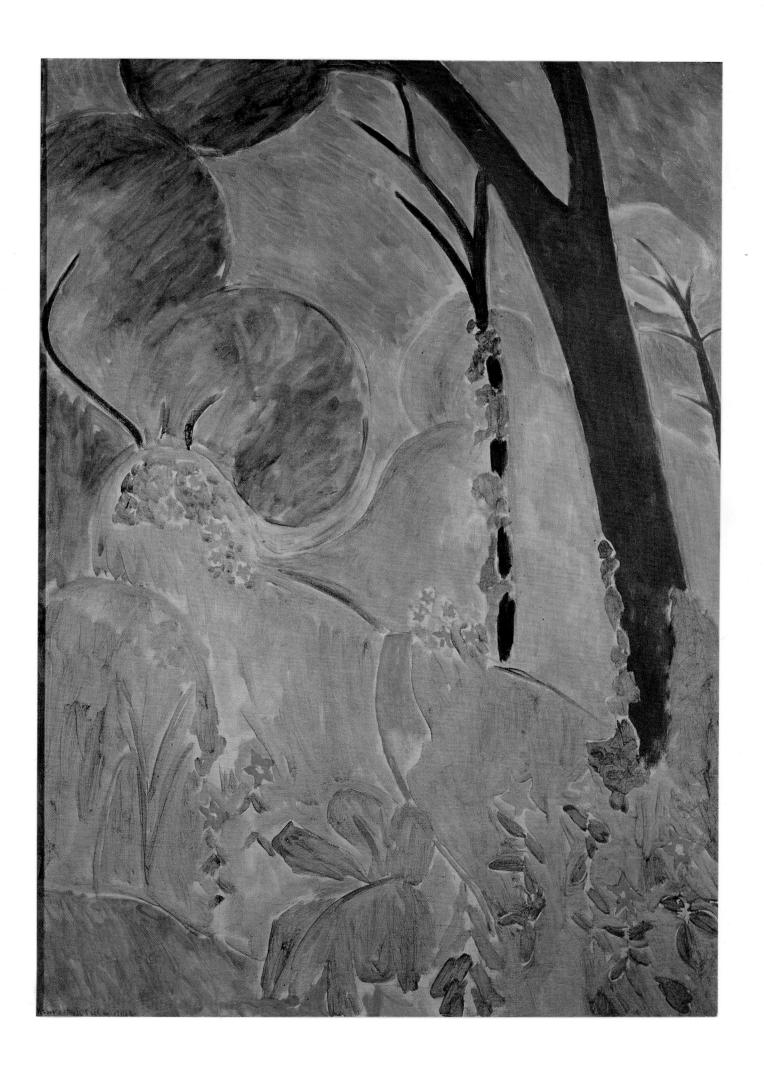

Painted 1912

ZORAH ON THE TERRACE (SUR LA TERRASSE)

Oil on canvas, 45 $5/8 \times 39 3/8$ "

Pushkin Museum, Moscow

It was as if Matisse had at last accepted Baudelaire's Invitation au voyage—the source of Luxe, calme et volupté (colorplate 11)—when he undertook his two working trips to Tangier during 1911–13. Nor can these trips to a Muslim environment be dissociated from his profound appreciation of Persian art. It was as if he were seeking to reinforce artistic experiences through a real confrontation with a nature and a people foreign to normal European experience. At the same time, thanks to the internal development of his own art culminating in Still Life with Aubergines (colorplate 24), he was exactly at the point of being maximally prepared for the experience, so that it reinforced rather than diverted the creative path on which he had embarked during the previous decade. One thinks immediately of Delacroix's parallel experience in 1832 and the long-standing repercussions of that trip on his art.

With this crouching study of the Tangier model, Zorah, whom the artist had rendered standing as the center panel of a triptych the previous winter, Matisse once again creates the centerpiece of a new tripartite composition (the right wing, Entrance to the Kasbah, is reproduced in the next colorplate). The present study of Zorah thrusts us into a world tantalizingly parallel to that of Delacroix's Women of Algiers (1834; Louvre), but with significant differences. Whereas Delacroix conjures up the closed, shadowy world of the harem interior, with opulent surroundings (much as Matisse would suggest with the odalisques of the twenties), Matisse places his model outside, on a rooftop under blazing sunlight, with a minimum of accessories. But the intensity of the light is muted by a pale green shadow that supports this color in Zorah's dress, much as the blue of the carpet functions for the lower part of her dress. The pink patch of sunlight in the upper left is balanced by a matching hue in the goldfish bowl in the lower right. Thus the principle of cross-correspondence of color found in his Fauvist work—notably The Green Stripe (colorplate 12)—recurs in a post-Fauve effort. As for the goldfish bowl, an element curiously out of context here, it is simply a reference to a motif that the artist was currently exploring in many different versions in his studio. In effect, given its placement, we might think of the goldfish as Matisse's monogrammed signature to this picture.

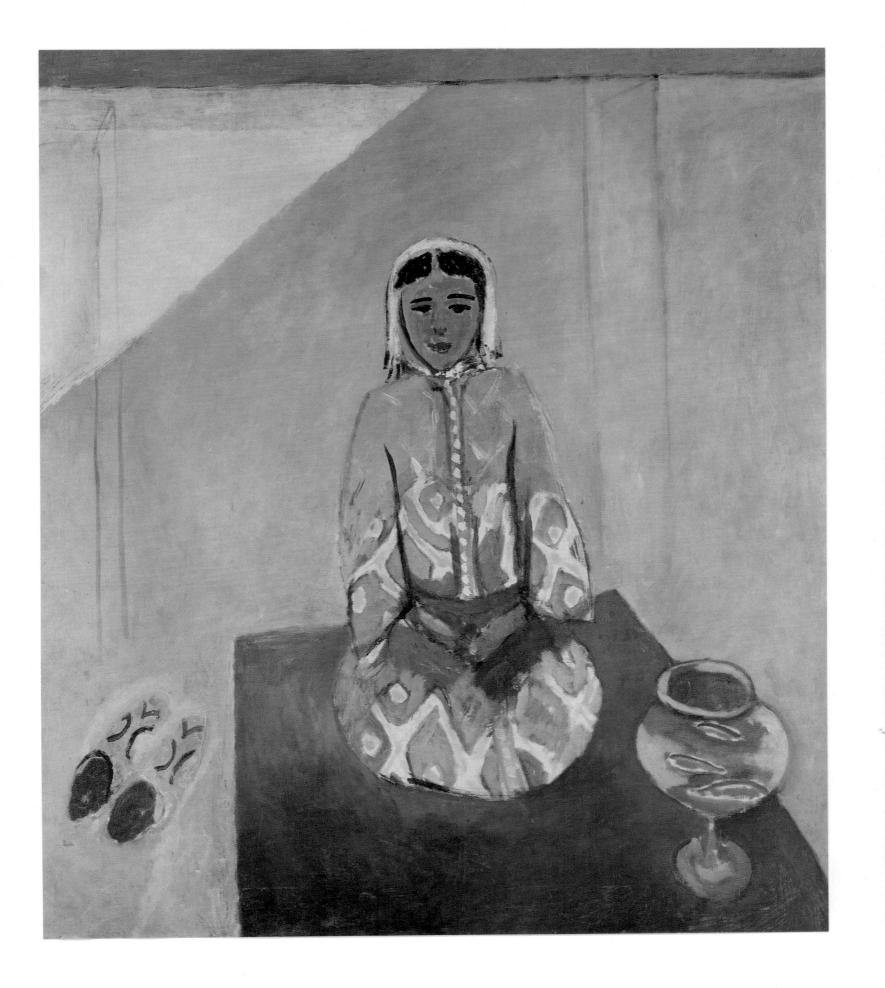

Painted 1912

ENTRANCE TO THE KASBAH (LA PORTE DE LA KASBAH)

Oil on canvas, $455/8 \times 311/2''$

Pushkin Museum, Moscow

This painting is the right wing of the triptych that the artist produced during his second trip to Tangier, one made in the company of his old Fauve comrades, Marquet and Camoin. Although there is a sketchily realized seated figure in the shadow at the left, the picture is almost exclusively concerned with rendering a tightly defined architectural space as seen under the violent contrasts of light and shade typical of North Africa. The colors function accordingly. The blue circle of sky is barely distinguishable from the blue of the arched passage. The blue shadows of the foreground are only slightly more saturated, perhaps chiefly to support the intense pitch of the pink stream of sunlight on the pavement. At first glance this "keyhole" motif seems unique in the artist's work, until we realize that it is a special variant on the idea of the landscape or view seen through a window; this latter theme is actually the subject of Window at Tangier, the left-hand panel of this triptych. In that picture we are offered a broad panorama of the city, perhaps from the artist's hotel room, whereas here the view beyond is constricted with respect to both width and depth. The color relationships between the three pictures are especially interesting. The darker blues of the left panel suggest the murkiness of interior shadows; the green of the central panel behind the model, Zorah, suggests the half-light of a partly shaded exterior; and the intense luminosity of Entrance to the Kasbah, farthest to the right, illustrates the unrelieved power of the tropical sun reflecting on building exteriors. The movement from left to right is one of darkness to light, which in effect becomes the subject of the whole ensemble. Although each painting has its own distinctive coloration, there are subtle points of contact joining the three together in a unified way. Through the decade the idea of the triptych recurs in Matisse's work: in addition to the Amido-Zorah-Fatma series of the previous winter, there is the splendid Three Sisters (1916-17; fig. 33), in which three models are posed in different costume in three varied compositions in each of the panels, resulting in a grand total of nine figures alternately standing or seated.

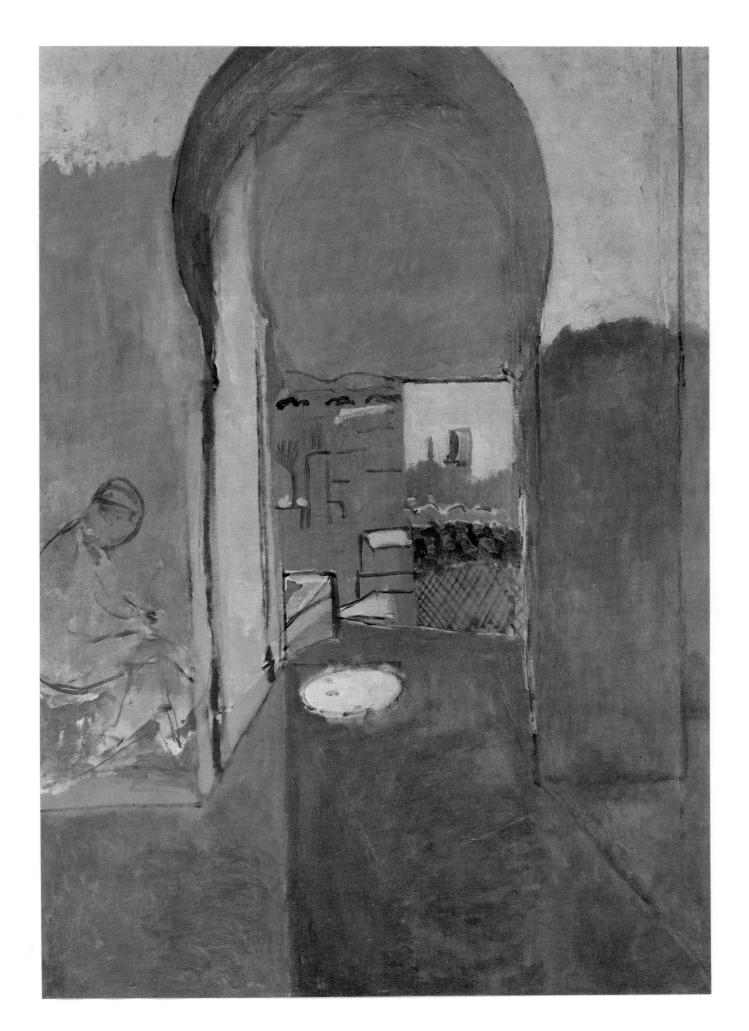

Painted 1913

MADAME MATISSE

Oil on canvas, 57 7/8 \times 38 1/4"

The Hermitage, Leningrad

This likeness stands in stark contrast to the Fauve The Green Stripe (colorplate 12), and so far as hue is concerned illustrates the extremes that are possible in Matisse's art in the space of less than a decade. Its monochromatic insistency is not so great as in the nearly contemporary Blue Window (fig. 25), nor are the blues precisely the same, but both pictures represent a severely restrained decorative impulse, always present with the artist, pushed to an archaistic extreme. The masklike face is modeled in gray, and the features are picked out by a series of curved lines that structurally relate to the general shape of the head. The blue-suited body is flattened, its contours closely related to the green outline of the wicker chair. The play of blue and green, the former dominating, is accented by an orange stole, which likewise relates on the left side to the vertical of the chair and body arm but on the right cuts across it. Its function is largely to prevent the disappearance of the figure in the relatively uniform blue background, which gives no hint as to specific environment. In this respect, the pure painted ground employed to set off the figure resembles in principle the ground of The Green Stripe. In other respects, however, the relationship between figure and surroundings could not be more opposed. The sense of volume that is produced by the contrasting colors of the earlier picture is here largely reversed, in spite of the part played by the orange stole, and the figure and background threaten to merge into a kind of premature field painting.

There are several other portraits of this period to which Madame Matisse should be compared, notably Mlle Yvonne Landsberg (fig. 31) of 1914, in which the heart-shaped motif of the body is reinforced by concentric contours to create a unique decorative effect of illusionary transparent planes bearing at least an accidental relationship to one of Cubism's cardinal constructive devices. Also, in Mlle Yvonne Landsberg the masklike quality of the face is carried a step further. Another significant comparison is with the contemporary portraits of Derain.

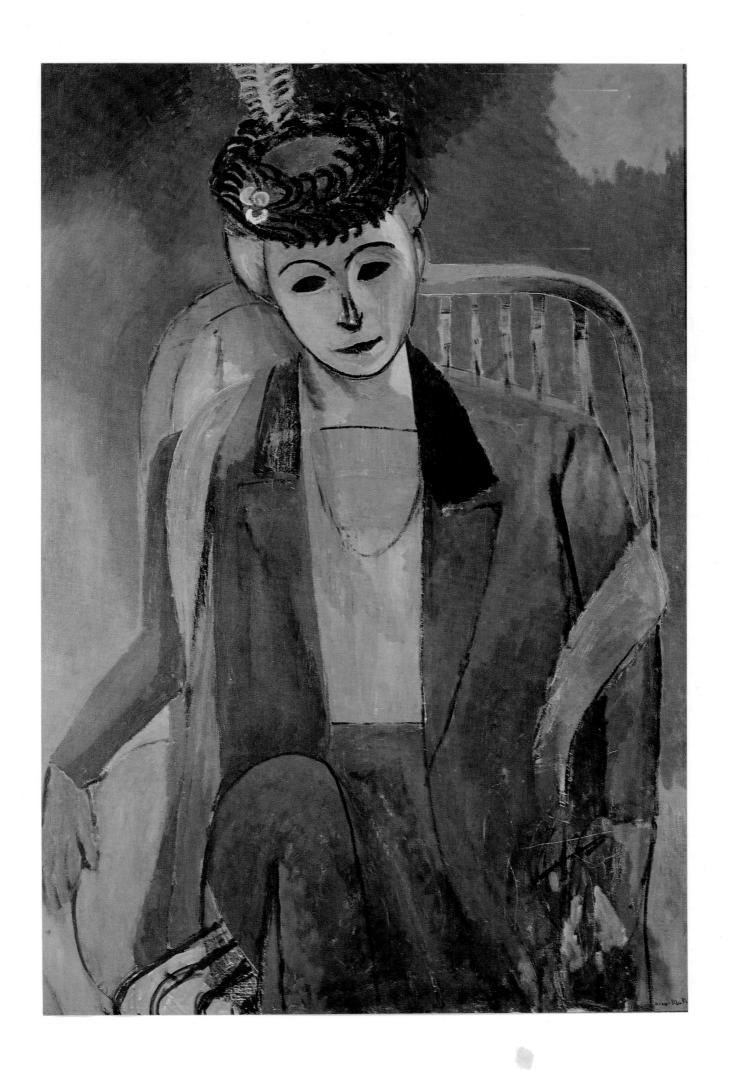

Painted 1914-15

COMPOSITION: THE YELLOW CURTAIN

Oil on canvas, 57 $1/2 \times 38 1/4$ "

Collection Marcel Mabille, Brussels

One of the climactic instances of Matisse's treatment of the view through an open window, the present picture presents a daringly abstract landscape and frame which are contrasted with the relatively realistic handling of the curtain at the left. The green areas of the architectural border are so flatly treated that the landscape beyond is almost literally a picture within a picture and might even be read as a boldly simplified painting hanging on a studio wall. The curtain is actually red with a green floral pattern, and its reverse side, yellow, is seen only in two places where it has fluttered back into the room as the result of a breeze. Its yellow is nearly identical to the yellow-ocher ground of the landscape, a broad, flatly painted area which vibrates against two areas of relatively pale blue, the sky at the top and the elliptical form at the bottom, an area that might also be read as the pool of a small garden. In abstract juxtapositions of flat colors such as these the artist foreshadows at an early date the effects of the papiersdécoupés that will crown his oeuvre in the 1950s. Notable is the freedom with which he treats the rectilinear contours of the window, producing, in effect, an unreal arch at the top. Such minor adjustments and dislocations serve to comment upon the rigidity of the picture frame, which is softened chiefly by the curving folds of the curtain, a feature that is itself held in check by the bold black strip that adjoins the picture frame only at the composition's base. While Matisse, like most of the Cubists, would never pass beyond the rendering of the world of appearances, he here touches a degree of abstraction that will not recur in his art until the monumental Snail (1953; colorplate 48). In creating these masterpieces of representational understatement the artist does not seem to be posing a visual riddle, as is so often the case with Cubism and its aftermath. Rather, his statement is an unambiguous praise of color in its multitude of possible combinations. The viewer is drawn into a state of relaxation and euphoria through the means of the hues themselves, although a tenuous contact is maintained with the world of everyday, secular perception. In contrast with the intellectual challenge and mental tension provoked by such pictures as Goldfish (1915-16; colorplate 30), with their Cubist conundrums, the present picture is a model of decorative and compositional clarity.

Painted 1915-16

GOLDFISH

Oil on canvas, 57 $1/4 \times 44 1/4''$

Florene M. Schoenborn-Samuel A. Marx Collection, New York City

Of Matisse's several still-life subjects, few were more productive than that of goldfish. They occupy a position in his work of the early teens analogous to that of the reclining odalisque in the twenties. The languorous, fluid bodies of these two motifs provoked, however, rather different pictorial results, given the successive stages of his development. This iconographic association is made explicit when the present picture is compared with similar subjects from Copenhagen (1909; fig. 17) and New York (1911; fig. 18), in which the round aquarium world of the goldfish is juxtaposed to a rendering of the bronze Reclining Nude I (1907; fig. 16), itself the sculpted version of Blue Nude, Souvenir de Biskra (fig. 14) of the same year. And on the level of the unconscious, may we not see in this theme—the contrast between an aqueous and an atmospheric world—a marginal development of the motif of the Venus Anadyomene that is obvious in both versions of Le Luxe?

In the present version the fish in their round aquarium are placed on a table in front of a window in a curious, decoratively Cubistic manner, one which probably owes much to the artist's discussions and arguments with Juan Gris dating from the summer of 1914. From the strict Cubist point of view, the composition is not especially profound, and yet certain general tactics of his rivals' art are here rather naturally integrated into Matisse's more decorative approach, with its greater reliance on surface tensions. The space through the open window has been arbitrarily altered—interrupted by an inexplicable dislocation of what might be wall panels or window shutters, which are moved to the center, forming a dark vertical register. (There is a very remote possibility that the artist meant to indicate two windows of equal size, but this device would have no precedent in other works.) This type of composition employing contrasting vertical bands of differing hue or value turns up later in the final Bathers by the River (colorplate 31), and this device, transformed into wedge-shaped areas of contrasting pigment, reappears in the two later versions of Dance (1931–33).

The theme of the view through the open window is an old and ongoing one in Matisse's art, but it is worth noting that it appeared in Juan Gris's Still Life Before an Open Window, contemporary with the present picture. Since it is a rather unusual work in Gris's oeuvre of the period, with an unusual (for him) overall dominance of blue, it seems fair to think that his painting is a reflection of an opposite current. In any case, in this quasi- or Neo-Cubist picture of a view through an open window Matisse has managed to indicate three separate environments, namely, reading from back to front: the sky of the exterior, the water of the aquarium, and the space of the interior.

Painted 1916/17

BATHERS BY THE RIVER

Oil on canvas, 8' 7" × 12' 10"

Art Institute of Chicago

This painting, which began as the possible third decorative panel for Shchukin's Moscow stair, remained in the artist's studio for seven years before being completed in his Neo-Cubist manner. He did not completely paint out the figures that he had commenced in 1910, however, and this phenomenon is most apparent in the figure at the right. What seems clear from the surviving passages is that the figures were originally smaller, and that in the final painting they were enlarged so that they equal the entire height of the picture. Indeed, the figure at the right is so elongated that her feet are cut off by the bottom of the frame. A small project of about 1910 (fig. 22) may reasonably be considered the original scheme for this monumental work. In this lyrical study we discover at least one figure, that farthest to the left, which derives from Joy of Life. The surroundings are relatively picturesque, with a waterfall heightening the effect of the river, which has virtually disappeared in the final version. In the completed work, the number of figures has been reduced from five to four. Matisse would never again model figures and objects in such an emphatically Cubist fashion.

This large composition leads into the much later versions of *Dance* (1931–33) in two important ways. First, it caused him to question the relationship of figure sizes to that of the canvas, with the result that while his early groups are almost never cut off by the frame—in fact, have much color area surrounding them—the ultimate versions of *Dance* permit the figures to stretch beyond the bounds of the arcuated frame in every case. Second, his use of strongly demarcated vertical registers in *Bathers by the River* led to the employment of wedge-shaped and diagonal color contrasts in the later *Dance*.

It seems that Matisse did not simply put Bathers by the River away in 1910, only to redo it entirely in 1916/17. A letter to Camoin of September 15, 1913, tells us that he had been working on his "grand tableau de baigneuses" in the course of that summer (Pierre Schneider, Henri Matisse, exposition de centenaire, p. 86). It is thus reasonable to think that parts of the present picture actually represent work done at that time, shortly after his visits to Tangier. In particular, the foliage of the leftmost register possesses qualities similar to his landscapes of that epoch, while the alternating dark and light vertical bands in the central and right portions suggest his manner of 1915 and later. If this is indeed the case, the artist's "failure" completely to obliterate traces of his earliest (1910) efforts is in effect a highly rational decision. It was his intention to terminate a canvas in which traces of his evolving style over a seven-year period would be manifest in a nonetheless totally unified image.

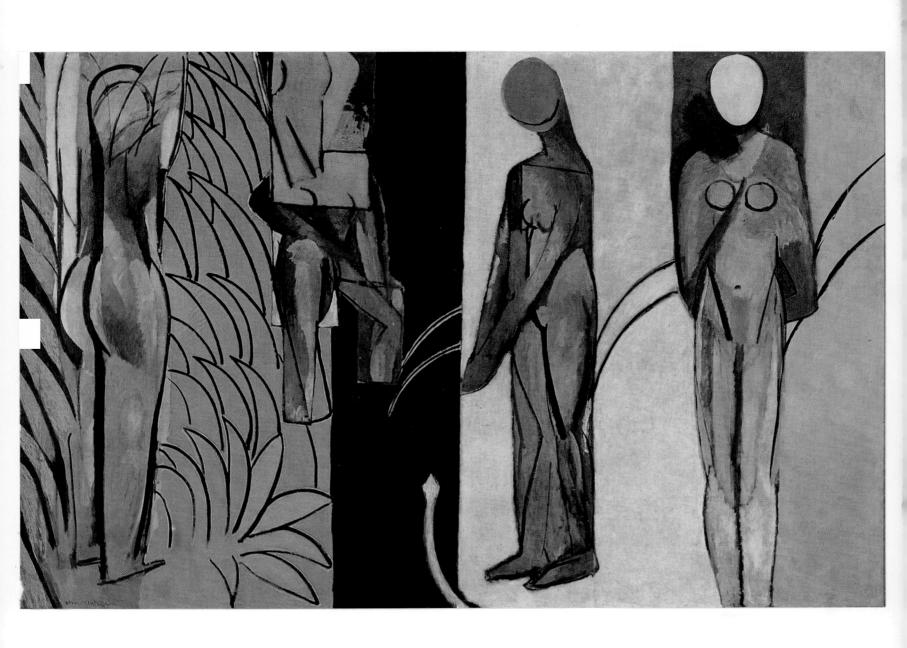

di.

Painted 1916

THE MOROCCANS

Oil on canvas, $70 \times 110 \ 1/2''$

Museum of Modern Art, New York City. Gift of Mr. and Mrs. Samuel A. Marx

Matisse conceived this picture with all the deliberation and patience of a nineteenth-century academic master preparing a machine for some future official Salon. From the same letter to Camoin in which we learn of his efforts of 1913 on Bathers by the River (colorplate 31), we learn that the concept of a definitive effort summing up his North African experiences was in the forefront of Matisse's mind. And despite the fact that his somewhat disruptive encounter with Cubism was occupying him at this period and is in evidence here, this remains one of his most totally satisfying large-scale works. The picture's novel tripartite division seems to break all possible laws of compositional order, and yet for Matisse it works perfectly. It is as if he were deliberately setting himself an impossible task of achieving overall unity, and then proceeding to accomplish it with apparent yet deceptive ease. It would seem that the black ground separating the three distinct parts, and also working itself into various areas of them, is the basis of his success.

The architecture of the upper left evokes Entrance to the Kasbah (colorplate 27), and the display of melons and their leaves on what would seem to be the pavement of a public market is suggestive of the limpid, lyrical designs of Moroccan Garden (colorplate 25), painted on his first trip to Tangier. These elements are situated one above the other on the left side. On the right we find a group of Moroccans at prayer, and this is the most challenging, hard-to-read part of the composition-in contrast to the forthright decorative simplicity of the opposite side. However, their gestures of supplication are somehow clarified by the design of the several melons in the lower left. As Alfred Barr points out (Matisse, p. 173), this area has been mistakenly identified as a group of figures touching their foreheads to the ground. The mistake is understandable because of the expressive abstractness of their design, and it seems quite within the realm of possibility that Matisse intended the ambiguity in order to clarify the more puzzling passages at the right. It is also a structural device that serves to link the otherwise fragmented composition, especially as the worshipers seem to be facing the melons and vice versa. The final unifying device is the repetition of the circular motif throughout the three elements, so that the domes of the architecture, the blue flowers in the pot, the spherical melons, and the rounded bodies of the worshipers all share the same motif. In this picture Matisse provides us with a distillation of his sensations, summing up his North African experiences much as Dance and Music (colorplates 19, 20) concentrate all his efforts from Joy of Life on.

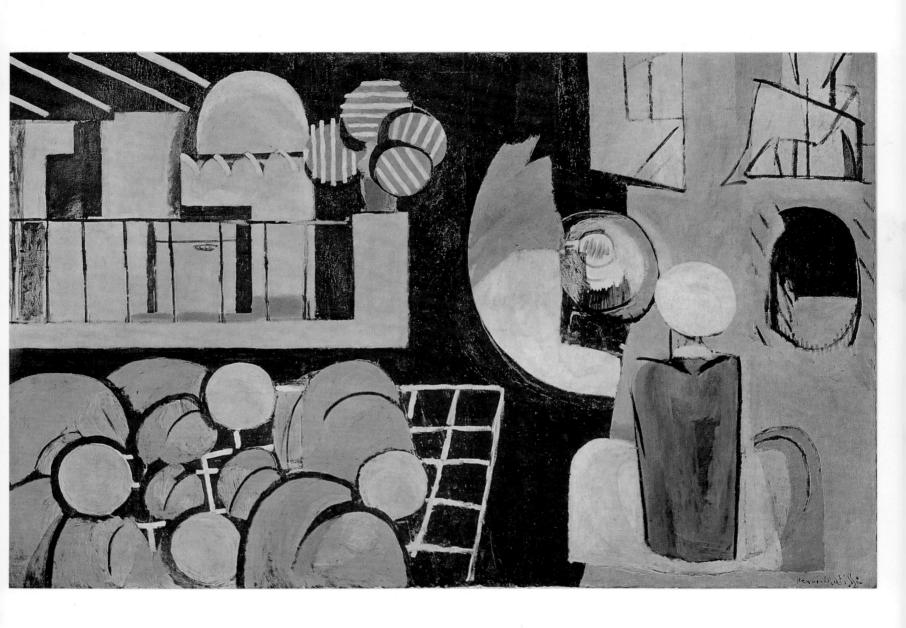

Painted 1916 (sometimes dated 1917)

THE PIANO LESSON

Oil on canvas, 96 $1/2 \times 83 3/4$ "

Museum of Modern Art, New York City. Mrs. Simon Guggenheim Fund

With its large areas of smoothly brushed gray, green, and pink and its severely simple design, The Piano Lesson would seem to be the most abstract of Matisse's monumental canvases. Another version, The Music Lesson (1916 or 1917; fig. 34), is of the same dimensions and palette but is more "realistic," richer in detail, number of figures, and atmospheric sensuousness. In general, experts have tended to place the Barnes painting slightly after the present version (actually the differing titles are a mere matter of convention, the two pictures being in effect variants of the same theme). Unlike the preparatory version of the Shchukin Dance or the earlier stage of Le Luxe, neither of these pictures would seem to be a study for the other. Instead, they are markedly different modes of handling the same subject and must be treated as absolute equals. One of the principal reasons for placing the Barnes version slightly later is the fact that Matisse's immediately succeeding stylistic evolution is toward a fuller, richer modeling and composition. The question is in any case slightly academic; what seems clearest in a confrontation of the two pictures is that the artist realized at a particular moment in his development that he had a choice of directions in which to proceed in his future work. By the end of his life in 1954 he had managed to explore both modes thoroughly, spending most of the 1920s developing a series of richly modeled, relatively illusionistic works, and turning to the more flattened, schematic mode only around 1930. Hence these two pictures sum up much of his work of the previous decade, and through this process of clarification foreshadow the two successive lines of his future development.

In subject as well as in execution, both versions are related to the four "Symphonic Interiors" of 1911, the theme of the studio and the painter's living room now being integrated. But the balance of the mixing is variable. In the severe version here, the emphasis is on art—note the inclusion of the bronze figure at the lower left and the 1913 painting Woman on a High Stool-and on objective and spatial geometry. The diagonal ray of sunlight, unrealistically rendered in green and suggestive of his effects in Sunlight in the Forest (1917; colorplate 34), echoes the pyramidal shape of the metronome in the right foreground. Significantly, this last-mentioned detail is replaced in the Barnes version with the altogether different curved form of the violin seen resting on its open case (this was the instrument Matisse himself played), thus providing an extra reinforcement to the serpentine forms of the music rack, the design of the window balustrade, and the motifs of the garden landscape which are now, in the less severe version, spelled out in picturesque detail. Furthermore, the figure of the artist's son Pierre replaces that of the bronze figure, and Marguerite is now next to Jean at the piano. Hence the Barnes painting is more of a family conversation piece, while the present version with its sole figure is an artist's monologue, thus clearly more suggestive of the earlier studio allegories, where the artist's presence is implied rather than actually seen.

Painted 1917 (previously dated 1912, 1914-16)

SUNLIGHT IN THE FOREST (COUP DE SOLEIL)

Oil on canvas, 36 $1/4 \times 28 3/4$ "

Collection M. and Mme Georges Duthuit, Paris

This perplexing picture has previously been known as Path in the Forest of Trivaux or as Road in the Forest of Clamart and conjecturally dated even as early as 1912. It was retitled, with good reason, for the Paris Centennial Exhibition of 1970, and the new name goes a long way toward clearing up the mystery of the picture's content. It is the most abstract of Matisse's landscapes, in part a Neo-Cubist study in a spirit similar to Goldfish (colorplate 30). It has a remarkably high vantage point, and in this respect it offers certain analogies with a totally different picture, the early Interior with Harmonium (1900; fig. 13), a picture that can reasonably be called Proto-Cubist (together with the predominantly blue académies of the same period) even though Matisse did not subsequently chose to follow that road with Picasso and Braque. The most useful comparison for elucidating the present picture is with The Path in the Bois de Boulogne (colorplate 8), a similar subject treated in a more conventional, post-Cézannesque way.

No detailed explanation of the parts of this picture can be completely satisfactory. Possibly it should be studied as a view seen from a single point in space; possibly, in the Cubist way, as one seen from several. Nor is it clear which parts of the picture are to be read as in sunlight and which are to be taken as in shadow. The path itself is the long, central, pale-hued element, but whether the massive dark diagonal that brutally intersects it should be seen paradoxically as the ray of sunlight filtering through the trees of an otherwise somber forest interior, or whether it is an incidental patch of intense shadow in an otherwise moderately luminous scene, is not clear. Given the unresolved ambiguities of Goldfish (with the remote chance of an alternate interpretation), the possibility that the artist meant the picture to have alternate interpretations cannot be ruled out entirely. In any case, the picture remains unresolved, a kind of battlefield on which contradictory tendencies are fighting against themselves with no decisive result one way or another. In many situations this would be a devastating critique, but in this case it is not. The forceful abstract design provides the picture with many positive qualities, and the unresolved tensions and uncertainties of how to interpret the illusionistic aspect of the picture retain our attention for a protracted period.

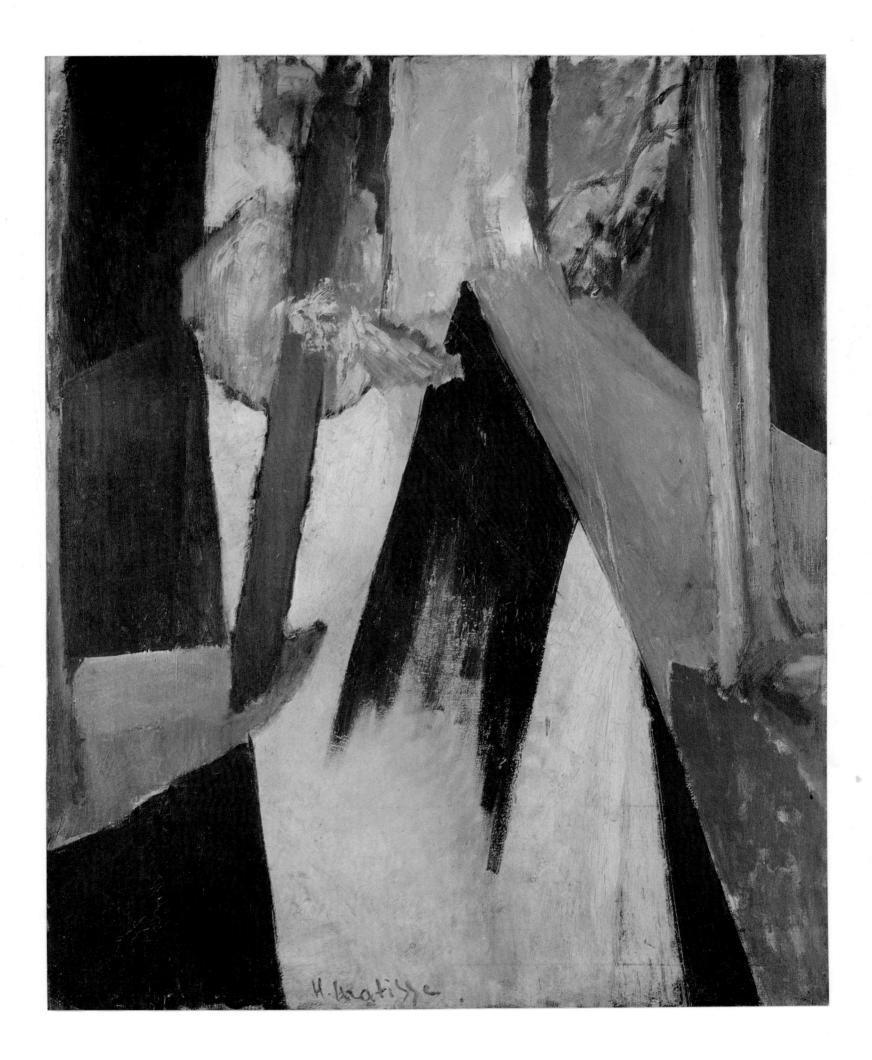

Painted 1917 (previously dated 1916)

THE PAINTER AND HIS MODEL

Oil on canvas, $57.5/8 \times 38.1/4''$

Musée National d'Art Moderne, Paris

This work, of relatively small dimensions when compared with Red Studio or Pink Studio (colorplates 21, 22), was painted not at Issy but in Matisse's old studio on the Quai Saint-Michel. The most immediate reference for the present picture is The Studio, Quai Saint-Michel (1916; fig. 30), where the artist's chair is empty even though, as in The Painter and His Model, the work in progress as well as the model are present. Both pictures offer diagonal views through the window at the right, showing fragments of the Pont Saint-Michel and the buildings beyond, thereby evoking memories of scenes painted from this vantage point (including Notre-Dame) fifteen years earlier. The starkness of the figures and the setting here are in contrast to the luxuriance that is spelled out in the subsequent Artist and His Model (1919; colorplate 36), although one detail, the Moorish mirror frame at the top, will appear later in Decorative Figure (1925; colorplate 40), thus providing an incidental, anecdotal contact between this severe composition and the decorative profuseness of Matisse's subsequent work in the twenties. The green of the model's robe and the purple of the chair are mirrored in the canvas on the easel. These strong accents are almost overwhelmed, however, by the relative absence of color elsewhere.

The design is almost as structurally contrived as the much earlier Carmelina (colorplate 10), where the artist-model relationship is hinted at only through the mirror reflection of Matisse himself. One suspects that this is partly because both pictures were painted in the same locale; certainly it points to the artist's intimate, perceptive reactions to his immediate working surroundings. The pose of the artist is exceptionally rigid, almost that of an Old Kingdom Egyptian pharaoh, in contrast to the more comfortable position of the model. His body and palette are painted in a pale brown-orange; this hue is not meant to suggest a flesh tone but rather to establish a structural continuity between the angularity of body and the vertical of window jamb. The heart-shaped iron grille of the window—a variant of which we have just seen in Goldfish (colorplate 30)—corresponds to the curves of the Moorish frame and relieves the picture's starkness. It is the theme of the picture within a picture, however, now shown with a temporal simultaneity absent in Carmelina, that gives this work its philosophical profundity. Canvas, mirror, and open window are here brought together in a thorough discussion of the art of perceiving and composing a picture.

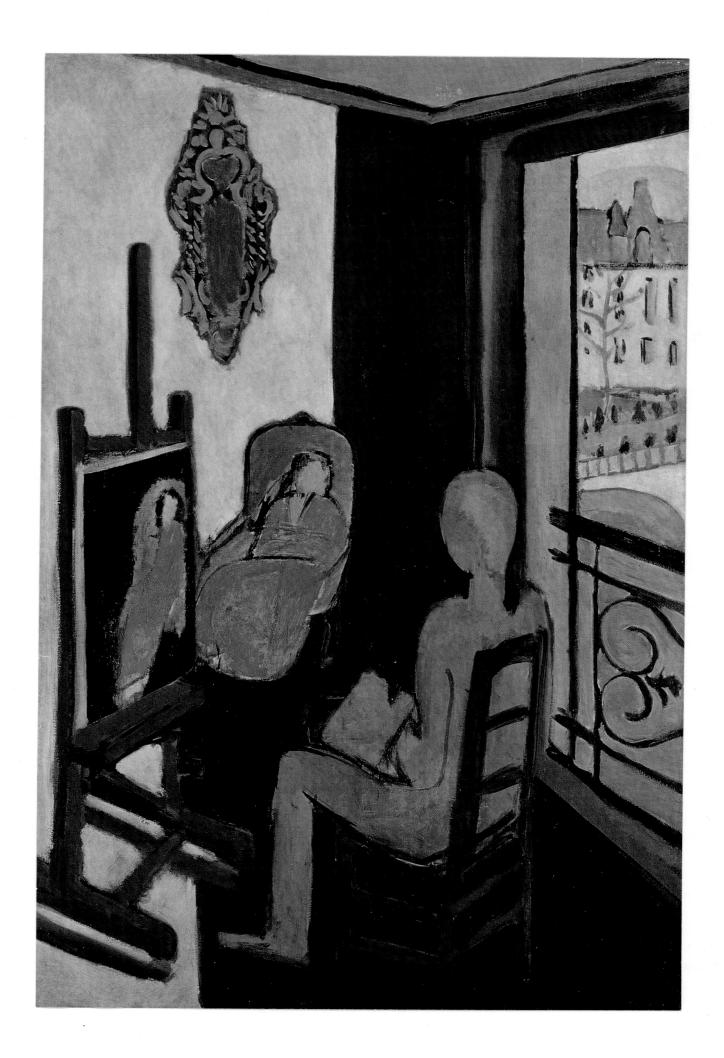

Painted 1919

THE ARTIST AND HIS MODEL

Oil on canvas, 23 5/8 × 28 3/4"

Collection Dr. and Mrs. Harry Bakwin, New York City

Coming in the wake of the 1917 The Painter and His Model (colorplate 35), this gentle study would seem to indicate a slackening of intensity, a détente in which the artist gives himself over to hedonistic self-indulgence. Nothing could be further from the truth. The politics of the avant-garde, especially of the Dadaists, Surrealists, and Abstractionists of the 1920s and later, dictated that Matisse would be one of those painters castigated for having capitulated to a public willing to accept tame modernistic paintings, and for working for this market rather than plunging ahead into more obvious frontiers of visual and metaphysical speculation. But this essentially political criticism takes no account of Matisse's own private growth over the two previous decades (nor could these critics, of course, foresee where he would wind up three decades later). Hence this negative view is fundamentally irrelevant to Matisse's work and the necessity for a modification of his style at this crucial juncture. In terms of the inner coherence of his evolving career, Matisse pushed relentlessly onward all through the twenties.

The design of this picture is complex yet sturdily ordered, and the nuances of color and tone demanded a supple, almost creamy texture to the paint, in opposition to the flat, sometimes indifferently brushed-in areas in some immediately preceding masterpieces. The break with Neo-Cubism, which had stiffened the structure of his large works of the period 1910–17 and which is immediately apparent in the contrasting versions of *The Music Lesson*, was necessary to further growth. The reduced size of his pictures at this period reflects not exhaustion but a change in environmental circumstances. He was working in small improvised studios set up in hotel rooms, rather than in the large permanent establishment at Issy or in his old Paris studio on the Quai Saint-Michel. The seductive outlining of the model here should be compared with that of *Carmelina* (colorplate 10), and indicates a new and more intimate feeling for the natural, spontaneous poses of the female form. Matisse is here in such possession of his painterly faculties that he can do without the arbitrary stiffness of conventional studio poses.

The planar complexities of this composition take us back to some of the pre-1900 work, such as La Desserte (1897; fig. 8) and The Invalid (colorplate 4), but previously the artist had been overextending himself in attempting interior compositions that were, for him, too challenging to bring off in terms of real surface and spatial illusion simultaneously. Here the two potentially conflicting forces are held in delicate equilibrium. The diagonal symmetries of this composition rival in profundity the totally different manner of composition, through parallel vertical registers, of Bathers by the River (colorplate 31). That Matisse had now switched from a monumental format to that of cabinet-sized pictures completes the inexorable logic of his new direction in studying the female form.

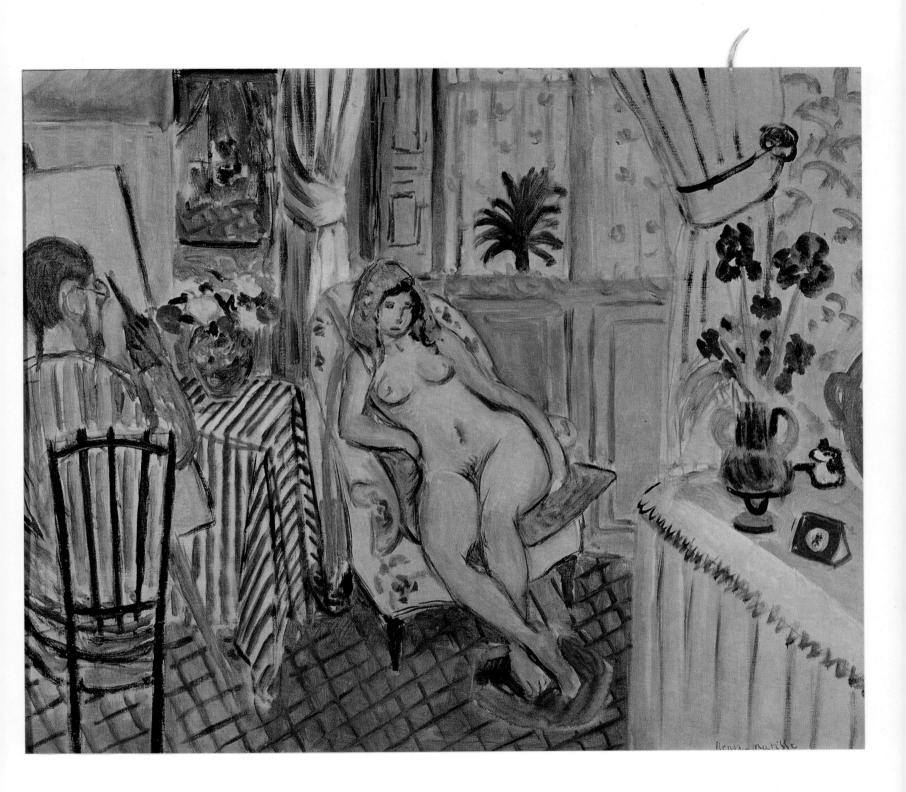

Painted 1921

INTERIOR AT NICE (GRAND INTÉRIEUR, NICE)

Oil on canvas, 52 × 35"

Art Institute of Chicago. Gift of Mrs. Gilbert W. Chapman

To judge from the color and grid of the carpet, this picture was painted in the same hotel in Nice as was The Artist and His Model (colorplate 36). The format and vantage point have been changed, but the soft interior tone and light seem virtually the same. The abrupt, disconcerting changes we can see between Red Studio and Pink Studio a decade previously (colorplates 21, 22)—both having been painted in the same interior—are here absent, and the temptation is to think that Matisse has allowed his imagination to slacken somewhat. In fact, however, he has simply become more subtle in the varying ways in which he converts a familiar space into a unique pictorial event. The window, now open, returns us to the dichotomy between inner and outer space (one must never forget that a perception of the tensions of inside and outside were a central concern of the major Cubist masters). The model, now clothed, is outside on the terrace, beyond the immediate world of the artist, and hence the picture lacks the closed-in, intimate quality of The Artist and His Model. Furthermore, from the variations in furnishings and of the paintings on the wall adjacent to the window, we perceive a passage of time, a phenomenon significantly lacking in the earlier related studio pictures.

In the present picture, the perspective contradiction offers a provocative intellectual challenge, even though we may be familiar with similar devices in French painting from the time of Degas and Cézanne. We look directly down upon the cushion of the chair in front of the mirrored table while simultaneously looking directly out the window, addressing the eye level of the model. Such contradictions in the spectator's point of view had, of course, been more drastically exploited by the Cubists. Quite obviously Matisse had no such idea in mind when he painted this particular dialogue between interior and exterior space, yet it is remarkable that he was able to integrate this basic theme of recent Western art, which contradicts to one degree or another the fundamental Renaissance laws of linear and aerial perspective, with an atmosphere of sensuality and softness of touch reminiscent of Boucher or Chardin.

In the end we may agree that these two pictures fail to stimulate our attention through dramatic shock, as is the case with *Red Studio* and *Pink Studio*, but as imaginary pendants they reveal a degree of refinement and sensibility, a necessary and inevitable progression beyond the earlier stage of events, that shows Matisse's art still in full growth and continued maturation. The very discretion and restraint of their differences in the end piques our curiosity even more profoundly, at least upon reflection. Even more important, these "studios" are populated with actual figures: frequently the artist, almost invariably the model. The theme for his greatest series of drawings of the late twenties and early thirties is here proclaimed. Of his contemporaries, only Picasso would choose to explore this theme so profoundly, though with radically different psychology.

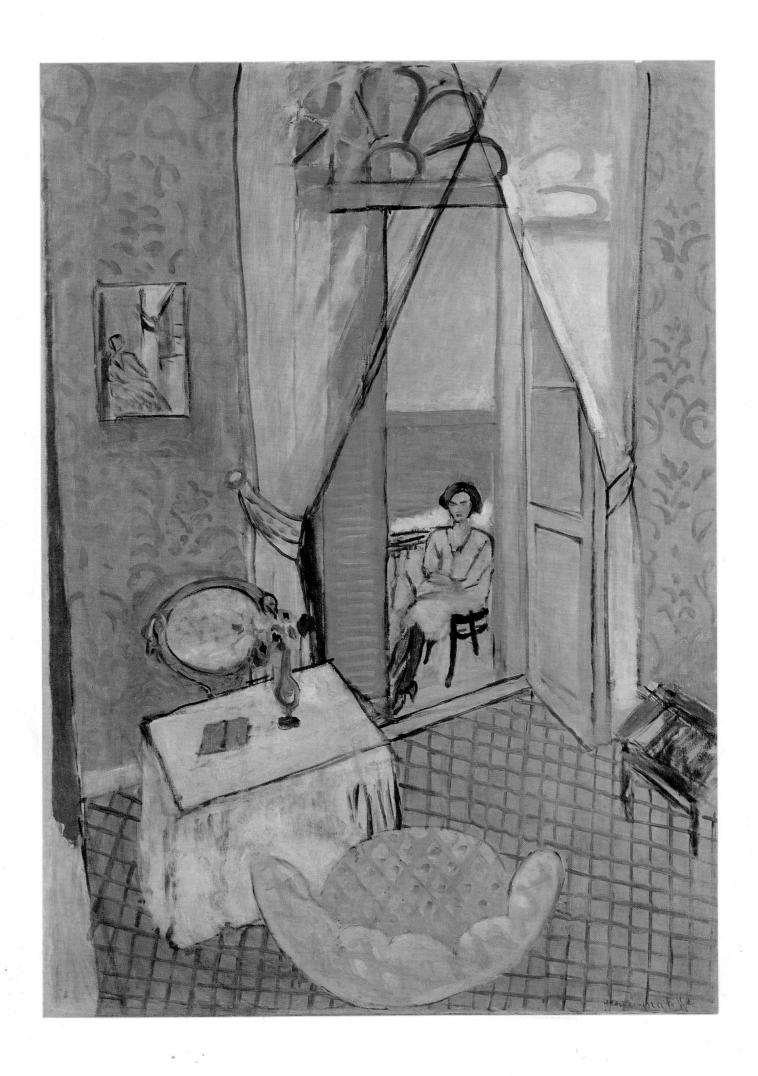

Painted about 1925

STILL LIFE WITH APPLES ON PINK CLOTH

Oil on canvas, 23 3/4 × 28 3/4"

The National Gallery of Art, Washington, D.C. Chester Dale Collection

Matisse's first painting, in 1890, was a still life (Books and Candle), and the theme ran through most of his career, frequently finding itself integrated into the larger interior studio pictures, notably Still Life with Aubergines (colorplate 24) and Interior with Phonograph (colorplate 39). Its ultimate metamorphosis would come in the grand Snail (1953; colorplate 48). However, the painting of rather classical still life frequently enjoyed an existence of its own as a separate genre in his work. This radiantly beautiful study of yellow apples set against a pink cloth which reverberates with the blue of the background hanging is an exceptionally fine instance of the artist in mid-career, halfway between his beginnings and his culmination. Like many of the odalisques of this decade, this is a pivotal work both in style and subject; like the figure and interior studies, this painting shows the artist seeking an intimacy of scale and a compensatory reduction in overpowering architectonic design. The immediate sensuality of the image, the caress of the touch, are in contrast to pictures that come before and after. And yet this stage in Matisse's development is not inconsistent with the unity and the unfolding of his career. Here he seems to be reinvestigating some of the preoccupations of his youth, especially with respect to the Cézannesque disposition of the cloth and the way in which the fruit and pitcher are inserted into this arbitrary topography. Interestingly, there are few precedents for exactly this type of composition, with the angle of the table clearly facing the picture plane. Matisse's earlier still lifes, with the exception of the monumental Desserte (1897), tended toward frontality. Clearly, at this juncture in his career he was seeking a new confrontation with the problem of constructing space in depth, using diverging lines of perspective rather than decorative framing devices and changes of scale. As for the resonant color harmonies, they grow from his long preoccupation with this problem. Here they are used to model forms rather than to create pictorial surface tensions. To a degree this preoccupation is contradictory to his goals as a Fauve and to the decorative, planar tendencies of his final works. But the investigations conducted in pictures of this type were a basic catalyst in the historical chemistry of Matisse's art; their role was to refine his sensibility and his proven accomplishments on a near-architectural scale.

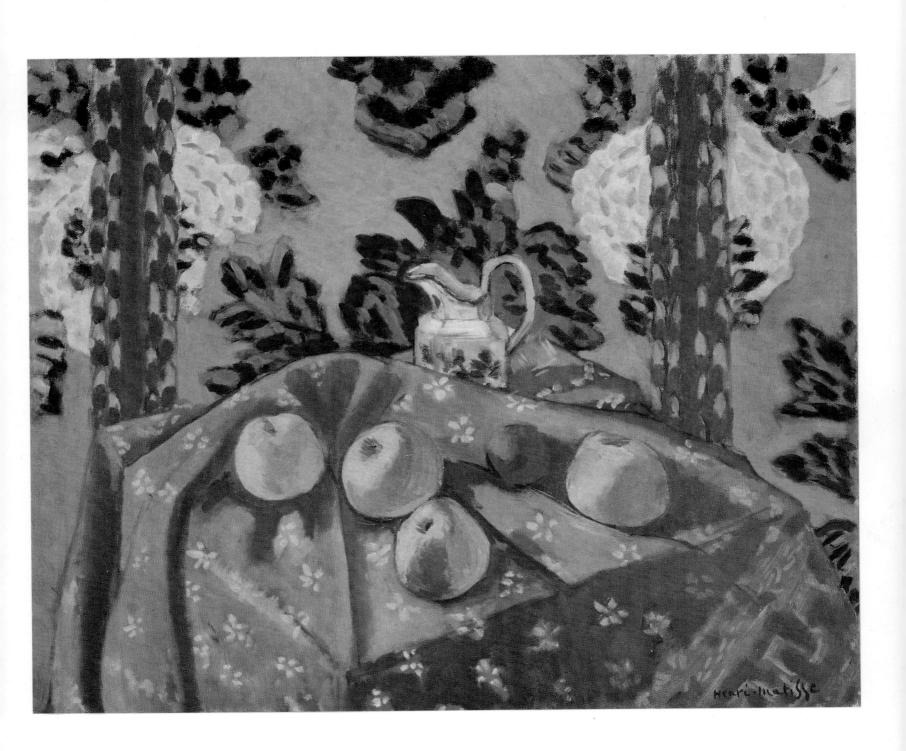

Painted 1924

INTERIOR WITH PHONOGRAPH (INTERIOR AT NICE, INTERIOR WITH MIRROR)

Oil on canvas, 39 $3/4 \times 32''$

Collection Mrs. Albert D. Lasker, New York City

Sometimes titled Still Life with Raised Curtain, certainly a more complete and focused description of the subject, this muted, sunlit interior provides a striking contrast to the monumental studio paintings of 1911. Once again the studio is empty of people, the model(s) dismissed. Only the artist is present, in a slight mirror image in the distance, visible just at the point where the curtain, employed to different effect in *Moorish Screen* (1922; fig. 36), has been gathered up. There the fully spread curtain served as a foil for the two conversing models; here it is employed with a Vermeer-like intent of providing a picture within a picture. The theme, which in Matisse's art dates from the mid-1890s and which, even then, was at least partly derived from his study of the Dutch petits maîtres, has never before been given us with such graceful, nuanced clarity. Diagrammatically the composition is a reversal of Vermeer's Love Letter. However, the light sources are complex: not only is there the light from the implied window at the left (whose panes cast their grid of shadows on the opposite wall at the right), but also the light from the window of the room in the distance, through which is framed still another view. It seems that Matisse never flagged in finding new variants of this key motif, a component of his repeated studio allegory. The still life in the foreground, consisting of a pineapple, some oranges and lemons, a flowered china bottle, and a vase of flowers, is set off by a red-andwhite-striped cloth. Compared with the centerpiece of Still Life with Aubergines (colorplate 24), this is another sort of luxurious opulence. The play of the yellow lemons against the bronze tray and the pale yellow-orange hues of the pineapple is indicative of the artist's refined sensibility in search of ever different adventures in color. The powerful, muscular color contrasts of the Fauve period here give way to a restful adagio of discreetly matched rather than opposed hues. Notable also is the way in which the vase is here outlined in white, whereas in paintings of a more intense palette black was sometimes used to support the structure of objects. There may be an overall sense of nostalgia in this picture, but there is no question of Matisse returning to an earlier style; there is nothing comparable to this painting, though much that is parallel, in the range of his earlier work.

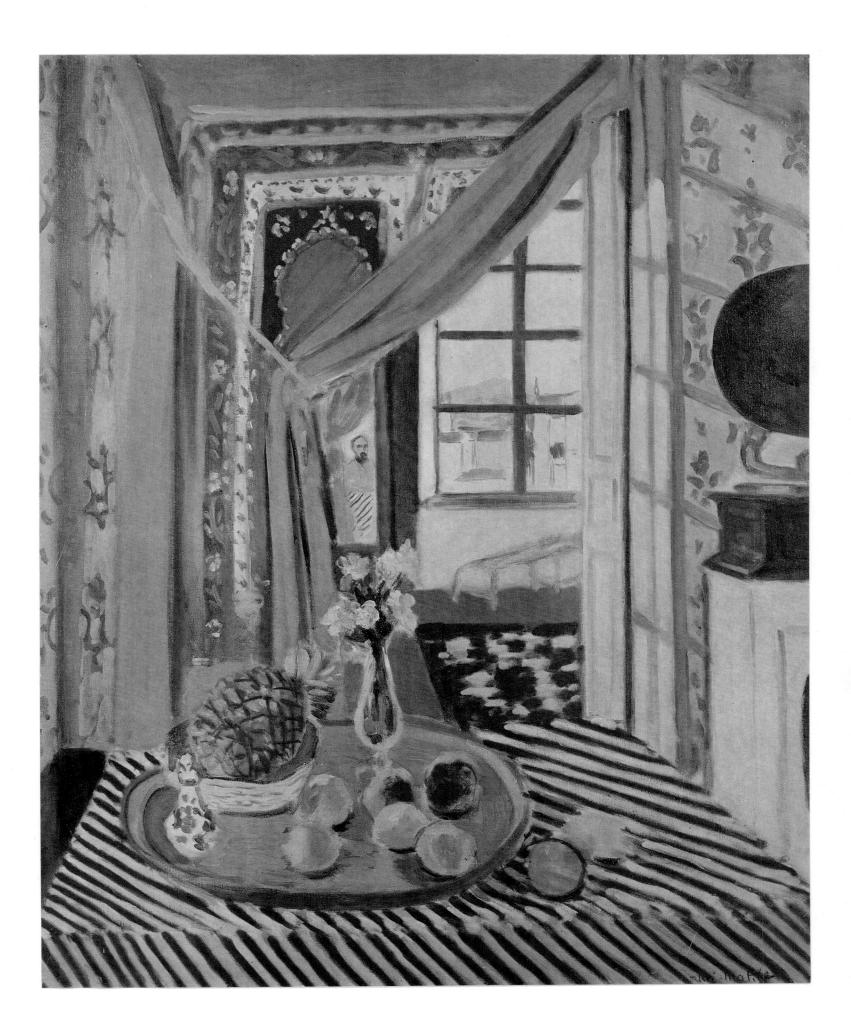

Painted 1925 (formerly dated 1927)

DECORATIVE FIGURE (FIGURE DÉCORATIF SUR FOND ORNAMENTAL)

Oil on canvas, 51 $1/8 \times 38 1/2''$

Musée National d'Art Moderne, Paris

This is traditionally considered the culmination of Matisse's preoccupation with the female nude in an Oriental setting, and, in fact, a kind of turning away from his softer, more sensuous indulgence of the early twenties. But the newly proposed earlier dating suggests a greater complexity (and even contradiction) to his various moves and strategies of the period. A charcoal study for this alternately stark and luxuriant painting exists (signed and dated—but incorrectly—1927) in which the pose is more relaxed, the left arm falling to the floor and the right leg more gracefully extended. Furthermore, the rendering of the form and flesh is more luminously suggestive in the drawing than in the final painting, where the modeling has become almost as schematic and constructive as that found in his work before 1920. The figure is the culmination of Matisse's Doric mode, begun with *Carmelina* (colorplate 10) almost a quarter century earlier. That he could paint so stark a figure at this moment, while also producing others more diaphanous or more erotically fleshlike, demonstrates the control that he exercised during this period.

The background is a remarkable series of variations on a decorative theme, with a nominally repetitive motif that, as painted, never repeats itself in exactly the same fashion. Although the figure sits in stark contrast to the ever varying curves of this backdrop-which contains, nearly lost within its density, the Moorish mirror seen earlier in The Painter and His Model (colorplate 35)—the drapery twined from behind her back across her thigh serves as the crucial link. The model sits within a grayish zone on the floor, which serves to separate the patterns of the carpet from those of the wall hanging. In addition there are a potted plant, a bowl of fruit, and, in the lower right, the suggestion of the corner of a veined-marble-topped table. Yet, in spite of this profusion of objects and motifs, the composition never seems cluttered; everything falls into place, even the abrupt, unnaturally straight line of the model's back. The tightly interlocked seated pose of the final figure suggests the later Figure on the Beach by Picasso (1929), one of his eviscerated, bonelike constructions. Moreover, the complexities of this pose would seem to be the point of departure for Matisse's four papiers-découpés, the seated Blue Nudes of 1952 (fig. 55).

Matisse's own comment on the frequency of this theme in his work of the twenties is revealing: "As for odalisques, I had seen them in Morocco, and so was able to put them in my pictures back in France without playing makebelieve" (Matisse to Tériade in "Matisse Speaks," Art News Annual, XXI, 1952, p. 62). It is especially interesting that he did not study these sheltered houris on the spot, but chose to reconstruct the image using professional models a decade later. The repeated creation of a Moroccan mise en scène in his Nice interiors indicates once again his propensity for constructing in his studio an artificial paradise, a perpetual invitation au voyage.

Painted 1926

YELLOW ODALISQUE

Oil on canvas, 21 $1/4 \times 32''$

National Gallery of Canada, Ottawa

The sumptuously modeled, opulently colored reclining nudes, together with the odalisques in Moorish costume, represent as a group the artist's most revealing theme in the 1920s. They conjure up distant visions of similar paintings ranging from Titian to Delacroix, rather than some fantasized yet minutely topographic view of the harem in the manner of Ingres (or some slightly prurient image out of Gérome). For the most part it is clear that these women are occupants of the artist's own studio space, and in effect their presence serves to eroticize the objects from his own collections: screens, hangings, and so forth. Thus they further expand the theme of earthly paradise stated in the great mythological paintings earlier. But now the paradise has moved into the artist's improvised studio environment, functioning in a way not very different from the aubergines of his great tapestry-like composition of 1911 (colorplate 24).

The present picture (there is a variant in the same hues but from a minutely different perspective in the Barnes Foundation) is one of the most robustly modeled of the odalisques, which partly owe their inspiration to Matisse's several direct contacts with Renoir at Cagnes in 1918. It is notable that he did not pay much attention to this master's art until some two decades after his discovery of Cézanne, even though he may have seen Renoir's work at Vollard's around 1900. Matisse thus arrived at his comprehension of the latter's culminating figure studies after he had long since digested Cézanne's message and integrated it into the long evolution of his own figurative work. Hence, Matisse was maturely equipped, not to borrow from or submit to the influence of Renoir, but rather to clarify and intensify his late, classical-romantic study of the female form. Matisse integrated Renoir's individual mode into the natural course of his own increasing comprehension of the figure and its function in a painting. In particular, there were two paintings in Renoir's studio at the time which could have inspired Matisse: a partly disrobed Odalisque of about 1917 (Barnes Foundation, appropriately enough), and the double-figured nude painting Rest After the Bath, of 1919 (Louvre).

It is noteworthy that there are relatively infrequent treatments of the reclining female figure in Matisse's art before the twenties. The first of these, Blue Nude, Souvenir de Biskra (1907; fig. 14), is a post-Fauve work, a developed variant on one of the two central reclining figures in Joy of Life. The second is the nearly lifesize Sleeping Nude of about 1916 (fig. 29), who with a few modifications could easily inhabit an environment such as that of Still Life with Aubergines—this is, in fact, the picture that Matisse was working on when he painted The Studio, Quai Saint-Michel (fig. 30). The series which the present painting represents thus relates to an earlier theme whose complete realization was postponed more than a decade, and its genealogy once more demonstrates the integrated continuity of Matisse's work and his ability as a mature artist of fifty to find stimulus in one of the great elder painters of the day.

Painted 1927

WOMAN WITH A VEIL (PORTRAIT OF MLLE H.D.)

Oil on canvas, $24 \times 193/4$ "

Collection Mr. and Mrs. William S. Paley, New York City

Portraits figure in large number in Matisse's work, and he was sufficiently attached to them to produce a luxurious album devoted to their reproduction at the end of his life (Portraits par Henri Matisse, published by André Sauret, Éditions du Livre, Monte Carlo, 1954). The book is prefaced by a brief introduction by the artist himself. This ravishing picture is a portrait of the woman who served as the model for Woman with Aquarium (1921; Art Institute of Chicago), and whose features seem recognizable in other paintings of the twenties. The rich, sonorous color of this intense study is an extreme statement of the artist's palette at the time. It is also worthy of comparison with the great Fauve portrait of his wife, The Green Stripe (colorplate 12), where the color harmonies are in a totally different, more dissonant key. The structure of this starkly frontal pose suggests something of the angularity of the model in Decorative Figure (colorplate 40). The woman's body seems enveloped in an enormous stole of a diagonal checkered pattern. The local colors, save for the flesh tones and the gray, diaphanous sleeves, seem to be largely of the artist's invention. The red, green, and yellow are close to the hues Matisse normally employed as a Fauve, but the atmosphere of the picture is transformed into something more luxuriant by the violets and pale blues of the background. The pose of the head, balanced on the model's hand, and the insistent relation of the body to the contour of the chair are suggestive of Ingres. Interestingly enough, in the next few years Matisse's art would offer increasing analogies to the work of this nineteenth-century academic master, notably in Pink Nude (1935; fig. 15) and Lady in Blue (1937; fig. 41). In his nudes and odalisques of the early 1920s, Matisse had already explored Renoir's ways of treating a classical theme. Now he turned, logically and methodically, to a rephrasing in his own manner of elements drawn from Ingres's even purer Neoclassicism. By turning in Ingres's direction at the end of the twenties he was echoing a tendency that had emerged a decade earlier in the work of his greatest rival, Picasso. At the same time, this new influence in Matisse's art was completely consistent with his own inner development, and would shortly be revealed in the murals and the book designs of the early thirties.

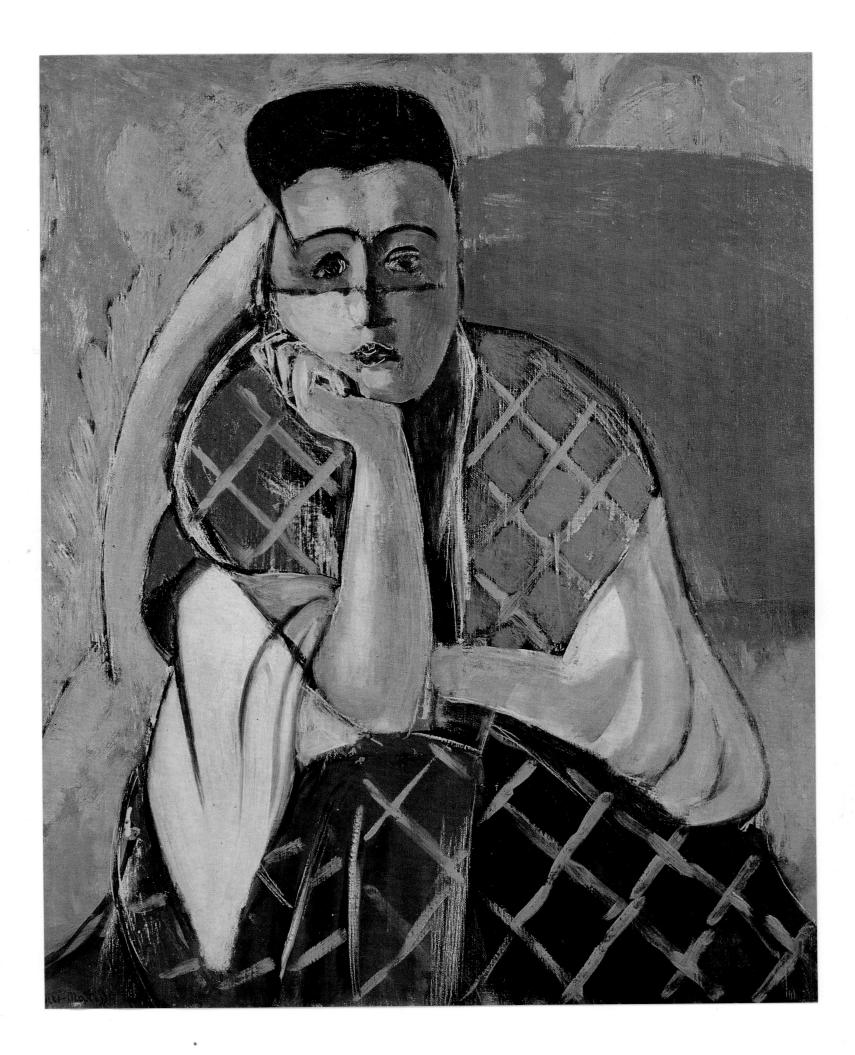

Painted 1930-31

STUDIES FOR DANCE I

Oil on canvas, each panel 12 5/8 × 34"

Musée Matisse, Nice-Cimiez

The metamorphosis of the Shchukin Dance of 1910 (colorplate 19) into the vast, expanded arabesques and athletic eroticism of the two versions of 1931-33 remains one of the most spectacular achievements of recent painting. Composed as a mural to fit an architecturally confining space in Dr. Barnes's main picture gallery, the commission provided Matisse with a new yet not wholly unfamiliar functional problem: Dance and Music of 1910 (colorplate 20) had definite architectural ambitions (though they remained monumental easel paintings) since they were painted for specific locations in Shchukin's house. Moreover, the fact that Matisse was given erroneous dimensions for the lunette-like space they were to occupy offered the artist a second challenge to restudy the Dance motif, since the mistake was not discovered until one full-size version had been completed. He did not simply adapt his first composition to the new dimensions but instead reexplored the whole theme, emerging with an expressively different composition even though painted in the same hue and style. In the present preliminary studies, whose color concepts were rejected for the final versions, we glimpse the remains of the earlier concept of a ring of dancers, their hands held in powerful, linking tension. In fact, there are earlier studies (fig. 43) that show this original motif, which first appeared in Joy of Life, virtually intact though intersected by the lines of the vault. Gradually the artist took this architectural feature into account, until in these present studies the tense circle is broken, some of the dancers having fallen to the ground in exhaustion while others remain erect, triumphant survivors of the bacchic frenzy.

In reaching his final concepts for the color scheme, Matisse had pinned large sheets of colored paper to the canvas until he found the appropriate solution. This was the first instance in the artist's work of the papier-découpé technique, one which he would exploit more openly in the later composition of his book Jazz and in the other, still larger works of the last six years of his life. As for drawing the figures on the canvas itself, he also had recourse to a novel method. In spite of the many earlier studies and sketches, these smaller efforts were not transferred to the final canvas through the time-honored process of enlargement. Instead, he drew on the large canvas with a piece of charcoal fastened to a long bamboo stick, creating truly monumental forms while retaining intact the electric spontaneity of his innate skill as a draftsman in the definitive realizations of the project.

In effect it has taken more than three decades for these murals to find a totally appreciative audience, and the ultimate justification of Matisse's solution has been helped by subsequent achievements. Matisse's art here serves as the historic link between the mellifluous arabesque of a Neoclassic master like Ingres and the geometrically plotted curves of an abstractionist of the 1960s like Frank Stella.

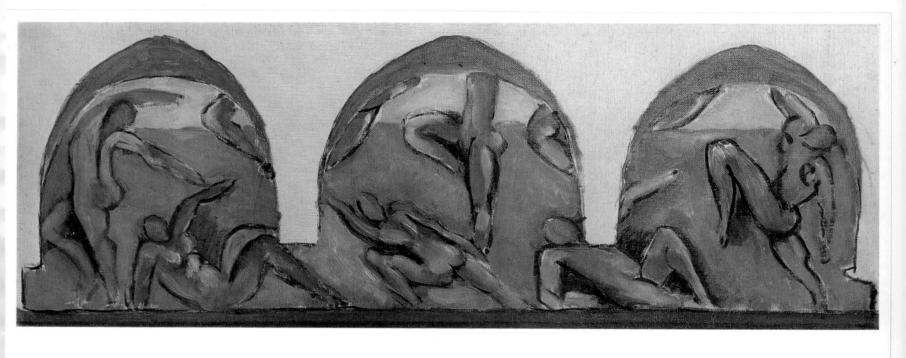

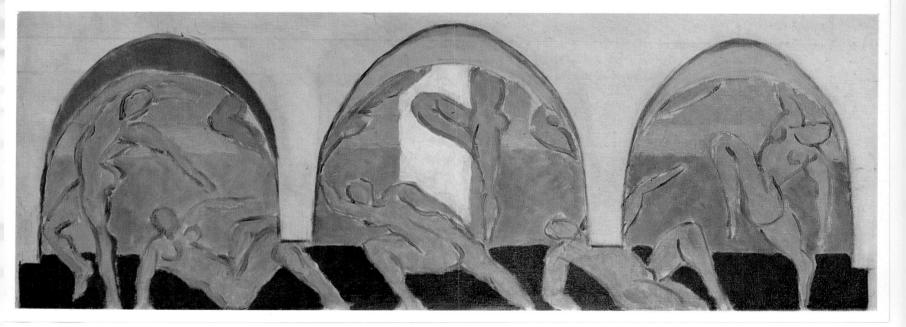

Painted 1935-36

WINDOW IN TAHITI (PAPEETE, VUE DE LA FENÊTRE)

Cartoon for tapestry, approx. 89 × 68"

Musée Matisse, Nice-Cimiez

During his visit to the South Seas, specifically Tahiti, Matisse did several remarkable drawings but no paintings. This was in 1930, just before he began work on the Barnes Dance. Hence it was not until five years after the trip that the artist sought to condense his experiences, relying in part on studies realized on the spot, producing this tapestry cartoon which functions as a monumental souvenir of his voyage. It serves to conclude a major theme in his art that begins with the development of the refrain of Baudelaire's Invitation au voyage in Luxe, calme et volupté (colorplate 11). The several voyages, real and artistic, have now been completed, and for the first time in Matisse's art we can detect a valedictory note. Carrying over from the earlier picture is only the ship, moored with its sails furled. As we look through the open window across this placid, tranquil scene, the somber colors suggest a new and different sort of light in his work. However, here the theme of the open window is almost completely sublimated into the motif of the decorative border. Only the balustrade at the bottom suggests an architectural reference for the point of view from which the artist is recording his sensations. He had employed this decorative frame as early as Still Life with Aubergines (1911; colorplate 24), and it was originally part of another large, tapestry-like painting of 1936, The Nymph in the Forest, a picture that may well be a pendant for the present design.

Unlike Luxe, calme et volupté, here in Window in Tahiti the human figure has been banished, much as in the studio interiors of 1911. The foliage and clouds and the indications of a curtain on the left are of a curving pattern whose scale and weight is remarkably uniform throughout. One is reminded of certain of the Tangier landscapes of 1912, but now the design is firmer, more measured, more the result of reflection and meditation, whereas in the earlier tropical landscapes we are keenly aware of the artist trying to record, albeit in a stylized fashion, the immediacy of the scene before him. Much as with the Barnes version of Dance, Matisse has produced a composition summing up a continuity of experiences with the recurring motifs of his life's work. To a degree it is a less approachable painting than much that has gone before, but this Olympian attitude is understandable in the work of an artist now past his sixty-fifth birthday.

Painted 1939

MUSIC

Oil on canvas, 45 $1/4 \times 45 1/4''$ Albright-Knox Art Gallery, Buffalo, N.Y.

Two familiar motifs inherent in the art of Matisse are now distilled with marvelous restraint in another late masterpiece: that of the calming influence of music is here placed in the context of his repeated motif of the 1920s, a pair of female figures in either complementary or parallel attitudes. The female two-some was, in fact, the motif for some of his most splendid drawings of the Nice period. Later, this theme will be transformed once again in the 1947–48 series of women reading, but in the present picture the two women receive their most monumental, hieratic treatment.

As with many of Matisse's major compositions of this period, notably Pink Nude (1935; fig. 15), we possess photographs of progressive stages of this painting made while the artist worked out the problem of its design. In general these series of photographs indicate a progressive, logical, almost classicizing or archaizing process of simplification. He begins with a somewhat picturesque, even agitated series of poses, and gradually draws the whole together through a process of decorative rationalization. The original design of this Music resembled the contrasting poses of The Conservatory (1938; fig. 47), with the figures in even greater opposition. The completed picture rejects this idea in favor of a rather strict parallelism of pose between the two models, a challenging feat since they are so differently clothed. While there is no longer a specific indication of an Ingresque source in this design, as was the case with Woman with a Veil (colorplate 42) or Lady in Blue (1937; fig. 41), it is clear that Matisse's rather personal transformations of Neoclassic design in the immediately preceding period made possible the present strictness and clarity of structure. And now we find, in the solidly outlined women, a suggestive analogy with his monumental nude compositions of the period bracketed by the two versions of Le Luxe (1907) and the original but subsequently overpainted concept of the Bathers by the River (1910-17; colorplate 31). Most likely this resemblance with respect to a massive outline was not a conscious procedure with the artist, but rather a spontaneous reintegration of an earlier device into his later style. This is simply one more thread between the past and present that demonstrates the surprising unity of Matisse's career as, over the years, he explored so many different manners.

Built 1948-51

DOMINICAN CHAPEL OF THE ROSARY, VENCE

There is a temptation to see in this unique effort an exceptional, isolated incident in the artist's late career, an act of devotion on the part of an atheist, an ex-voto celebrating his recovery from the two serious surgical operations of 1941. Looking back over the artist's career, however, one is aware of keen architectural sensibilities on several levels. His repeated use from an early period of open windows or doors as a key constructive element in his compositions is but one indication; the great "Symphonic Interiors," environmental paintings in a strict sense, are another. The architectural ambitions of the Shchukin Dance and Music of 1910 (colorplates 19, 20) have already been commented on, and the Barnes murals, which Matisse considered completely comprehensible only as an architectural fragment, speak eloquently of his desire to move beyond the realm of easel painting. Here at Vence he had his one opportunity to create a total environment drawing together most of the mediums in which he had already worked. That this, his only architectural project, should have come so late in life is one of the few tragedies of his career, for one can well imagine what might have grown from this tentative beginning.

The details surrounding the commissioning and construction of the chapel, which was built under the architectural supervision of Auguste Perret, are recounted in detail by Alfred Barr (Matisse, pp. 279-88). No paintings are present, the role of color being assumed by the stained-glass windows, which establish the interior tonality in such a way that the visitor, if alone, has the sensation of literally walking into one of the artist's paintings, especially one of the large studio interiors. The mural decorations, notably the stations of the cross, are in glazed ceramic tile-architecturally fixed drawings whose shapes Matisse pondered with his customary deliberation. He also modeled the altar crucifix and in addition designed the vestments for the priests. In this context it should be remembered that Matisse had previously, in 1937, designed the sets and costumes for a ballet, Rouge et Noir, for the Ballet Russe de Monte Carlo. Here, appropriately enough, the background motifs of the Barnes Dance (and even the architectural lunettes) reappear, his vast mural decorations thus lending themselves as a real-life setting for dancers on a stage. This effort must, paradoxically, be recognized as a precedent for the Vence chapel. In the end it is the blue and yellow of the windows and the magical nature of the light which they admit to the simple, functional interior that dominate the entire ensemble, ensuring its unity and establishing the chapel as a unique contribution to the history of contemporary architecture. Here at Vence, Matisse would seem to have definitively transformed the artist's studio—seen as a personal visionary earthly paradise-into a sacred place for others whose devotion took an institutional and even public character totally different from his own.

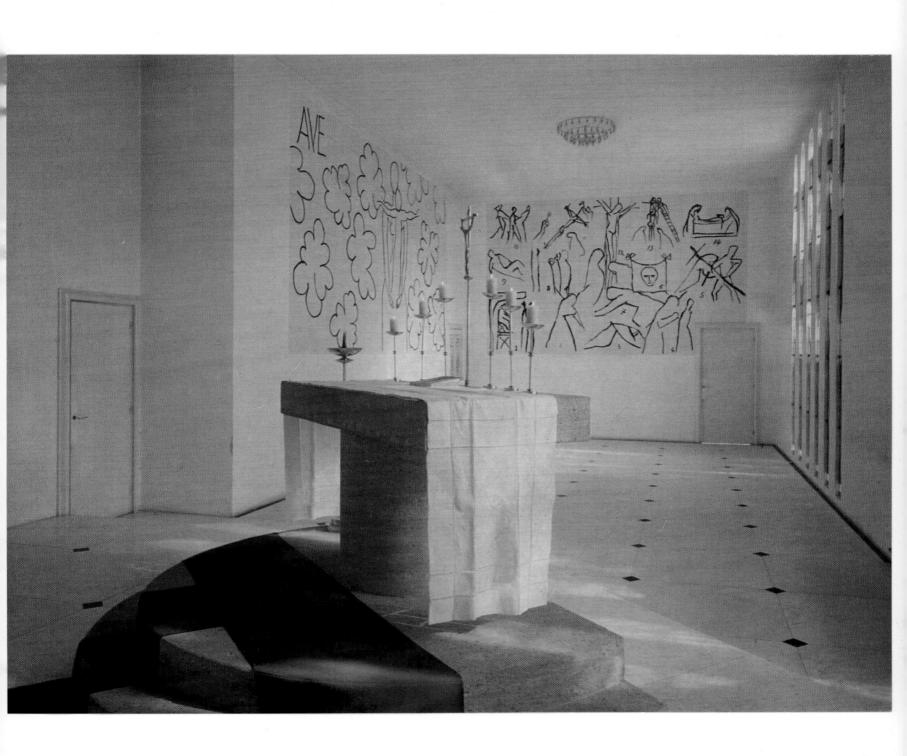

Painted 1952

THE SORROWS OF THE KING

Gouache on papier-découpé, 9' 7 1/4" × 12' 8"

Musée National d'Art Moderne, Paris

This picture is in effect the last great essentially pictorial effort of the artist, a thorough valedictory summation and interweaving of many themes developed and repeated over the years. It is also a leave-taking, in which the artist (here seen as the king, shrouded in black, himself holding the guitar rather than his brushes) bids farewell to his studio, to his female models, and to the themes of music and dance. With a vivid and masterful blending and contrasting of blues, greens, magentas, and yellows, Matisse brings together many compelling, even competing elements in his art. The result is almost Biblical, with marginal suggestions of such themes as David or even of Lot and his daughters. The universality of this picture's eloquence is virtually unparalleled even in the greatest moments of his career of more than sixty years. Matisse is here able not only to draw together many previously unrelated features of his own art but also subtly to allude to certain of his predecessors and contemporaries without recourse to specific quotation; Delacroix and Picasso come quickest to mind. Its medium, the prepainted sheets of paper cut out by the artist, almost as if the scissors were being used as a sculptor's tool, derives ultimately from the collages of Cubism as invented and perfected by Braque and Picasso a half century earlier. Here, in The Sorrows of the King, we have a symbolic collage, with the artist as selfrecognized painter laureate. Color and design were Matisse's primary materials, and here they reach their ultimate apotheosis. Other works, marvels of his stillflowering genius, were to follow in the two years of life remaining, but as these images moved on into different realms of decoration and near abstraction, this picture remains his definitive farewell to his own unique, earthly past. It is a self-portrait of himself and his art, but a world removed from the realistic orientation of his 1900 canvas that serves as the frontispiece of this volume. Like massive bookends, these two pictures bracket Matisse's career.

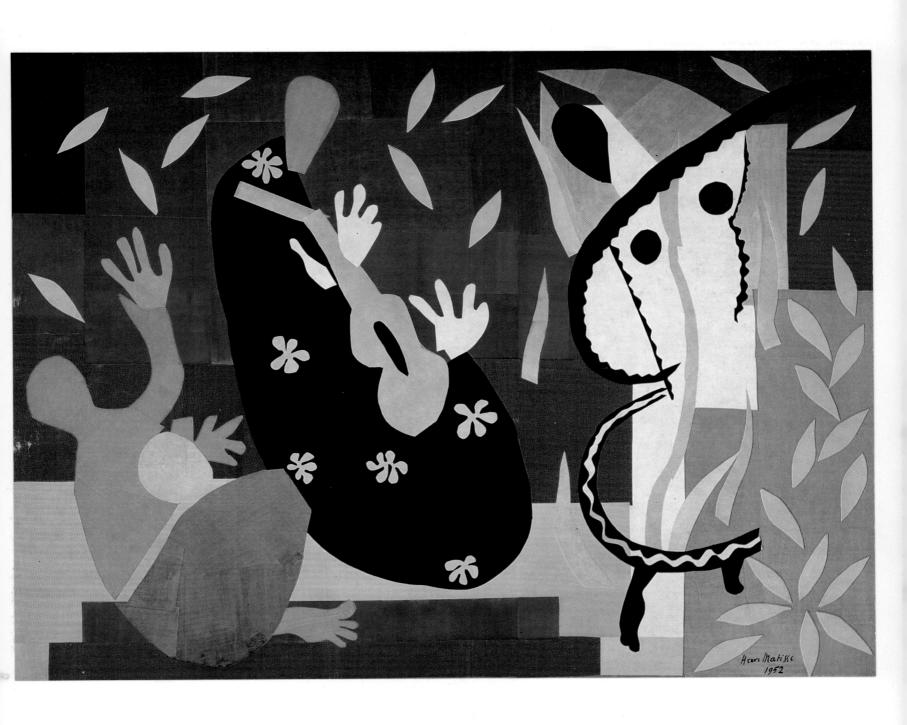

Painted 1953

THE SNAIL (L'ESCARGOT)

Gouache on papier-découpé, 9' 4 3/4" × 9' 5"

Tate Gallery, London

The works of Matisse subsequent to The Sorrows of the King (colorplate 47) form an interesting appendage to his career, one that points both to the possibilities of his own career going on indefinitely and also to the directions that later art would take beyond his own lifetime. In this fashion they incline frequently toward the abstract and even the transcendental. This composition of squarish and rectangular patches that organize themselves into a snail-like, spiral pattern has no precedent in his career. The tension between the angularity of the forms themselves and the imaginary receding curve which forms their unifying axis is a notable, totally unexpected effect. While it might be compared with the arabesques of the figures in the Barnes Dance and the way these are contrasted with their angular background, Matisse has here created a new synthesis. No doubt this picture will always be cited as a prototype for much large-scale abstract painting of the 1960s. However, there would seem to be no individual artist who ever literally followed either this motif or technique, though several have in fact utilized its novel square format, one which Matisse and his contemporaries almost never used. An exception in Matisse's work is the Music of 1939 (colorplate 45). With The Snail, Matisse was perhaps making a wry comment on Cubism (not so much as an art style as a journalistic slogan), but if this is the case it is only a minor component in the picture's underlying significance. Unlike many of his papiers-découpés of 1952-54, this seems not to be an architecturally oriented composition and remains a "picture." Hence its importance in the prehistory of present-day abstract art. However, in reaching toward a new world beyond the valedictory Sorrows of the King, Matisse would seem to be proceeding toward a transcendental as well as abstract art. Since this square painting, conspicuously featuring squarish forms, is titled The Snail, it is fair to assume that the imaginary circular motif was of considerable importance in the virtually archetypal geometric forms here displayed. Considering that his final work, the abstract mandala design for a rose window in memory of Abby Aldrich Rockefeller (Union Church, Pocantico Hills, New York), is a form universally found in Western and Eastern religions, it seems fair to see in this penultimate abstraction, The Snail, an instinctive striving for a final symbol of unity and concord. With this picture and the subsequent window design, Matisse has in fact reached beyond the earthly limits of his own art. The Snail thus stands on the threshold of another kind of existence as well as on the brink of another kind of art, one that he could perhaps not foresee but toward whose aims he was reaching at his death. The various works of Ellsworth Kelly, Kenneth Noland, and Frank Stella are instances of how Matisse's ultimate insights would later be fulfilled.

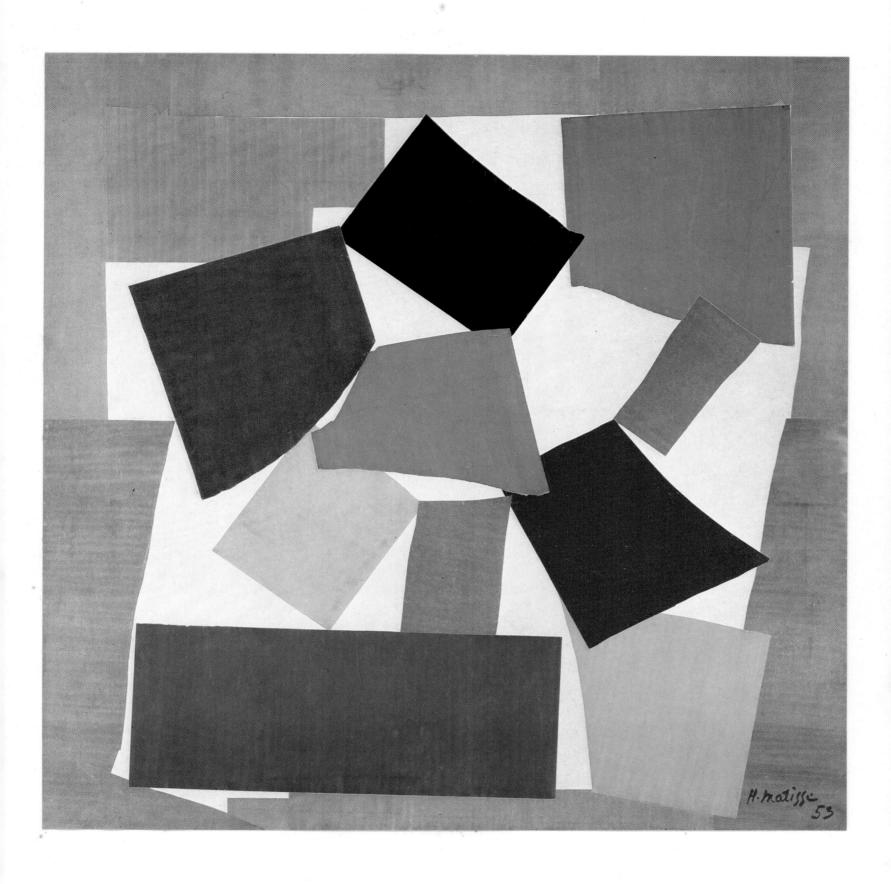

BIBLIOGRAPHIC NOTE

The literature on Matisse is bountiful, but does not yet provide the necessary catalogues raisonnés of the painting, sculpture, drawings, and graphics. These are currently being prepared by the painter's daughter, Mme Marguerite Duthuit. In the meantime, the basic work remains: Alfred H. Barr, Jr., Matisse: His Art and His Public, New York, 1951 (with a complete bibliography up to that date by Bernard Karpel). Time and again this remarkable volume has been singled out for praise as one of the landmarks of art-historical literature in the modern era, and twenty years after its publication it remains impressive, even though small changes in dates and minor bits of information are, quite naturally, now necessary. This study, published three years before the artist's death, benefited from the advice and counsel of Matisse and his family. Two other important studies were likewise based, at least in part, on direct testimony: Gaston Diehl, Matisse, Paris, 1954 (with commentaries on the illustrations by Agnès Humbert), and Raymond Escholier, Matisse ce vivant, Paris, 1956 (English translation: Matisse from the Life, London, n.d.). The casual as well as the serious student of Matisse will want to consult these three works, besides other general studies, special issues of magazines, and exhibition catalogues which are noted below. Matisse's writings, previously scattered, have been gathered in: Henri Matisse, Ecrits et propos sur l'art, edited and with notes and index by Dominique Fourcade, Paris 1972; based on work begun by Gaston Diehl, with the assistance of Françoise Nora.

The bibliography of writings on Matisse has been brought up to date twice, first in the catalogue of the retrospective exhibition organized by the UCLA Art Galleries, Los Angeles, 1966, pp. 173–80, and from that point onward by the catalogue of *Henri Matisse*, exposition du centenaire, Paris, 1970, the work of Pierre Schneider, pp. 305–6. One of the most useful selected bibliographies is to be found in Jacques Lassaigne, Matisse (Skira), 1959, pp. 125–28. This book is also one of the finer short studies of the artist. Of the older books, Albert C. Barnes and Violette de Mazia, The Art of Henri Matisse, New York, 1933, remains one of the most interesting, in part because of Barnes's importance as

a collector, in part because of the challenging, idiosyncratic views expressed. The earliest monograph was also published by a collector, the French Socialist Deputy Marcel Sembat, Matisse et son oeuvre, Paris, 1920, quickly followed by Elie Faure, Jules Romains, Charles Vildrac, and Léon Werth, Henri Matisse (Cahiers d'aujourd'hui), Paris, 1920 (2nd ed. 1923), a volume containing numerous reproductions of drawings and paintings, some of which have not appeared since. An even richer potpourri of early contemporary opinion, together with many reproductions, can be found in: Christian Zervos et al., Henri Matisse, Paris and New York, 1931, most of the material having come from a current issue of the magazine Cahiers d'art, no. 5-6, 1931, but with numerous additional halftone reproductions. Other special issues of magazines containing valuable material are: Le Point, XXI, 1939 (with Matisse's "Notes d'un peintre sur son dessin" and the "Souvenirs" of the Fauve painter Jean Puy, among other articles); Verve, VI, no. 21-22, 1948 (paintings done at Vence, 1944-48, with floral ornaments drawn especially for the presentation); Verve, IX, no. 35-36, 1958 (reproductions of papiers-découpés, 1950-54, with texts by Pierre Reverdy and Georges Duthuit, and a selection of later drawings); Art News Annual, no. 21, 1952 (interview with Matisse by Tériade, together with a fine collection of documentary photographs); XXe Siècle (special number: Hommage à Henri Matisse), Paris, 1970 (published on the occasion of the centennial exhibition at the Grand Palais).

Exhibition catalogues are a particularly fine source for illustrations of his work, familiar as well as unfamiliar. Alfred Barr's Matisse, His Art and His Public, 1951, was issued simultaneously with the Museum of Modern Art, New York, retrospective of that year, though a separate catalogue was also published. More recently, several large exhibitions have resulted in important catalogues: The Last Works of Henri Matisse, text by Monroe Wheeler, the Museum of Modern Art, New York, 1961; Henri Matisse, Retrospective 1966, texts by Jean Leymarie, Herbert Read, and William S. Lieberman, UCLA Art Council and Galleries, Los Angeles, 1966 (also shown in Chicago and Boston); Henri Matisse: 64

Paintings, text by Lawrence Gowing, the Museum of Modern Art, New York, 1966; Matisse, text by Lawrence Gowing, Hayward Gallery, the Arts Council of Great Britain, London, 1968; Henri Matisse, exposition du centenaire, text by Pierre Schneider, Paris, 1970; Matisse, l'oeuvre gravé, texts by Françoise Woimant and Jean Guichard-Meili, Bibliothèque Nationale, Paris, 1970; Matisse as Draughtsman, text by Victor I. Carlson, the Baltimore Museum of Art, 1971 (also shown in San Francisco and Chicago); Four Americans in Paris: The Collections of Gertrude Stein and Her Family, texts by Margaret Potter, Irene Gordon, Lucie M. Golson, Leon Katz, Douglas Cooper, and Ellen B. Hirshland (and including Gertrude Stein's "Portrait" of Matisse, pp. 99–101), the Museum of Modern Art, New York, 1970.

Matisse's sculpture was first seriously considered by Alfred Barr (op. cit.), but is now the subject of a separate monograph: Albert Elsen, The Sculpture of Henri Matisse, Abrams, New York, 1972, with important new discoveries. See also Alicia Legg, The Sculpture of Matisse, the Museum of Modern Art, New York, 1972. The drawings have not been systematically surveyed, except in Victor Carlson's catalogue for the Baltimore exhibition, 1971 (op. cit.). However, numerous volumes of reproductions of drawings from various periods have appeared, starting in 1920 with an album of fifty drawings selected by the artist (Paris, Bernheim-Jeune). Some of the more important publications in this area include: Waldemar George, Dessins de Henri Matisse, Paris, 1925; Christian Zervos, ed., Dessins de Matisse, Paris, 1936 (special number of Cahiers d'art, XI, no. 3-5); Louis Aragon, Henri Matisse, dessins: thèmes et variations, Paris, 1943; and Raoul-Jean Moulin, Henri Matisse: D awings and Paper Cut-outs, New York, 1969 (translated from the French edition of 1967).

As for Matisse's graphics, Carl Schniewind of the Art Institute of Chicago established but never published a catalogue of Matisse prints, and Mme Duthuit has also been engaged on a similar project. Thus the only major published work on the subject is William S. Lieberman's Matisse: Fifty Years of His Graphic Art, New York, 1956, and the same author's Etchings by Matisse, the Museum of Modern Art, New York, 1954. Likewise, there is no basic source where one may study Matisse's work as a designer of limited-edition books. Some but not all of the studies for the 1932 Mallarmé have been published in the catalogue The Cone Collection of Baltimore, Maryland, with a foreword by George Boas, 1934, plates 84–94. In 1957, Piper-Verlag, Munich, published a small-scale edition of Jazz; this was, however, incomplete, reproducing

only sixteen of the twenty plates, and only a part of the text. More recently Skira has reissued small-scale versions of the *Poésies de Stéphane Mallarmé*, 1932, and the *Florilège des amours de Ronsard*, 1948. While these are the largest collections of reproductions from these works, they nonetheless remain incomplete and do not reproduce (as could easily have been done) the typefaces or the page compositions as designed by Matisse, thus sharply limiting their value for the serious student.

Among other general works of a popular nature on Matisse, the following should be noted: Roger Fry, Henri Matisse, Paris and New York, 1935; Alexander Romm, Matisse: A Social Critique, New York, 1947 (translated from Russian editions of 1935–37); Clement Greenberg, Henri Matisse, New York, 1955; Alan Bowness, Matisse and the Nude, New York, 1968; and John Russell, The World of Matisse (Time-Life Library of Art), New York, 1969. Although some of these books are modest in length or format, each is significant because of its particular point of view. A more extensive, exceptionally personal attitude is represented by Louis Aragon, Henri Matisse; Roman, Gallimard, Paris, 1971 (English translation, New York, 1972).

The student of Matisse's art will, of course, want to refer to works on various movements with which the artist had contact. For Neo-Impressionism, the most useful compilation and summary is found in the exhibition catalogue Neo-Impressionism, text by Robert L. Herbert, the Solomon R. Guggenheim Museum, New York, 1968. There are several general studies on the Fauve movement, unique among them the one by Matisse's son-in-law, Georges Duthuit, The Fauvist Painters, New York, 1950. See also Jean Leymarie, Fauvism: Biographical and Critical Study, Paris, 1959, and Jean-Paul Crespelle, The Fauves, Neuchâtel and London, 1962. The vast literature on Cubism unfortunately does not deal with Matisse's relationship with the movement nor with the effect that it had, albeit marginally, in disrupting the careers of many of the Fauve painters around 1907-8.

Finally, there are two works that would not normally be cited as a part of the Matisse bibliography, yet whose formative influence on the present interpretation of the artist's work should be acknowledged: Frank Kermode, Romantic Image, London, 1957, New York, 1964; and Herbert Marcuse, Eros and Civilization, New York, 1955. Both of these works espouse an ideology that coincides with much of the underlying content of Matisse's art. If the similarities are fortuitous, they are nonetheless clarifying and exhilarating.